CROWN, ART, AND FANTASY A LIFE IN PICTURES

PRINCE MICHAEL OF GREECE

CROWN, ART, AND FANTASY A LIFE IN PICTURES

New York · Paris · London · Milan

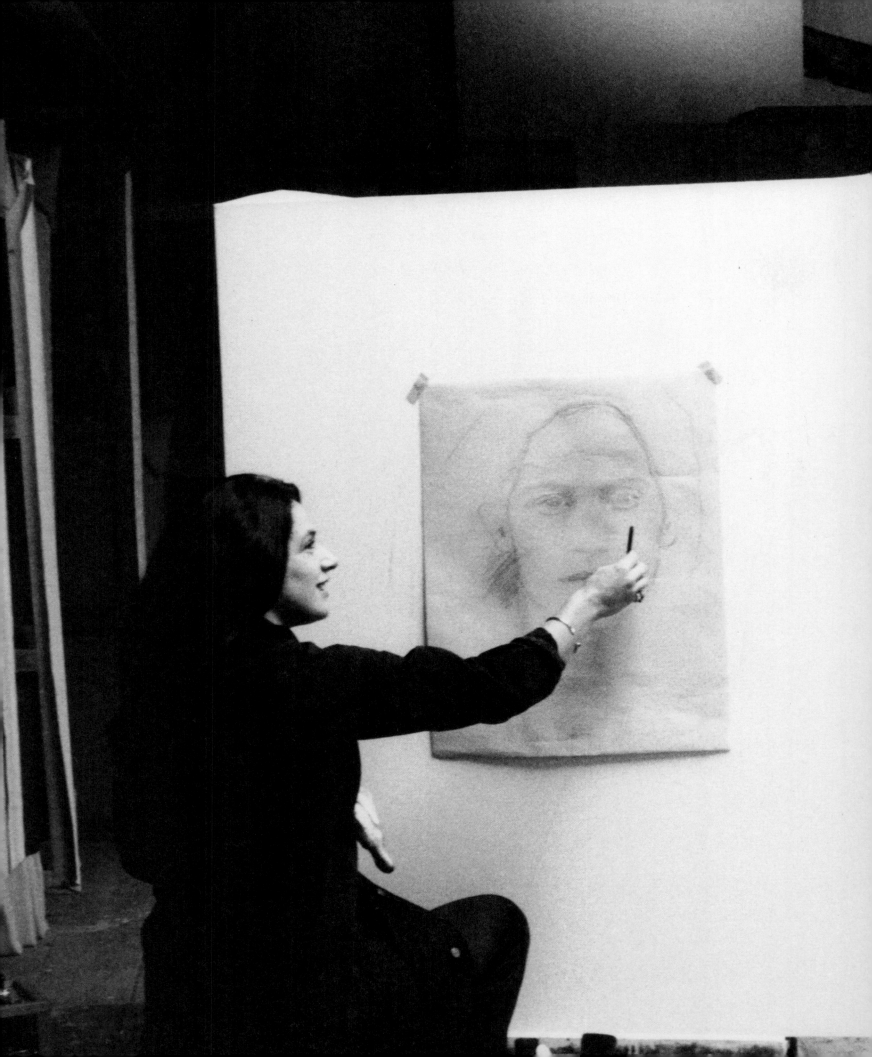

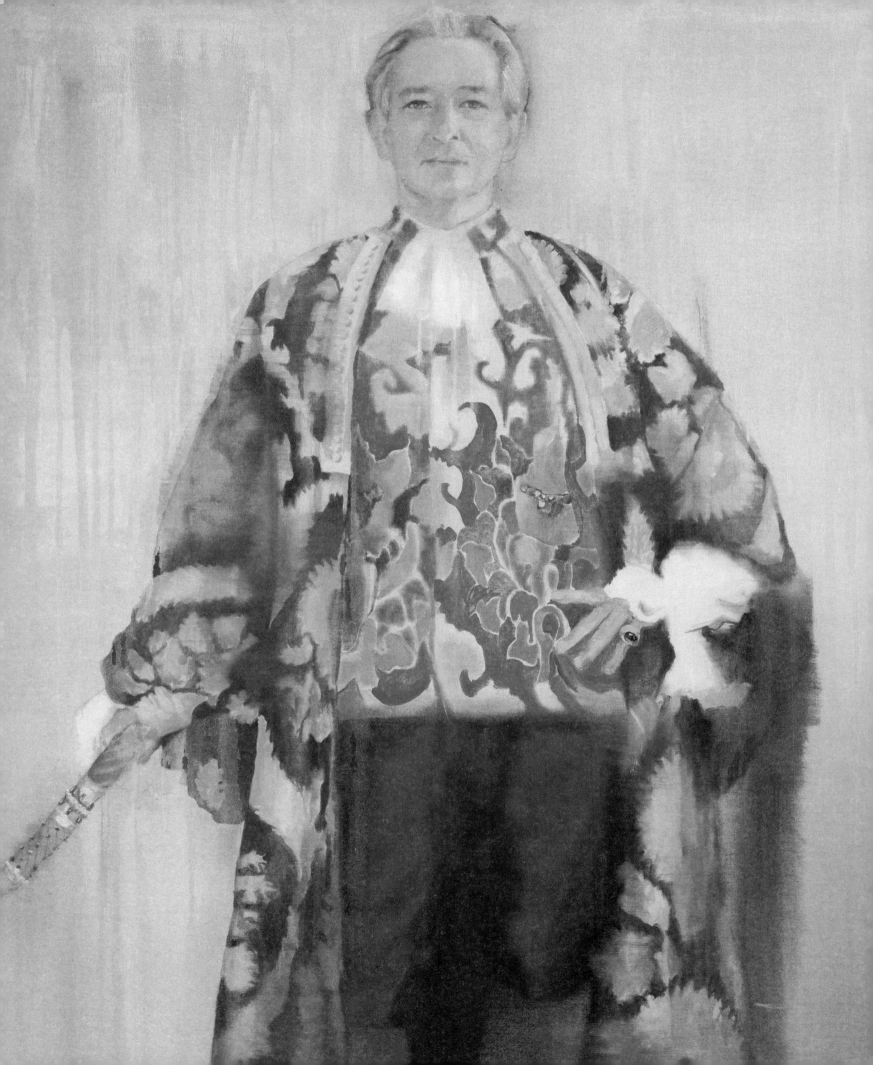

FOREWORD
BY HRH PRINCE MICHAEL OF GREECE

I am a man of image much more than a man of text. I prefer, by far, looking at images rather than reading. By images, I mostly refer to pictures. I have collected, I have inherited, many family photos. That is, photos of members of just about every dynasty in Europe from the nineteenth century and the first part of the twentieth century. It so happens that, through the game of alliances, we are related to almost all of the European royal world.

I also have a lot of photographs of my childhood during the Second World War. On top of this, I started to photograph with passion, much more than with talent. But my amateur photos are perhaps of interest because I have had the chance to have met many eminent people, to have traveled to beautiful countries, and to have found myself in historical circumstances. All this I have photographed over time. My wife, Marina, has also photographed these experiences, but with much more talent and professionalism than I have.

Above all, I have collected photos of my family members, resulting in a huge archive of photos from the middle of the nineteenth century until today. Not all of them are good. My wife tells me that a good part of them are to be thrown away, actually. But I keep them out of sentimentality. Then one day, I told myself that perhaps these could be of interest to someone other than me, or than my family or my friends, and I decided to make this book.

From the albums, which I keep in my writing studio in Athens, we have selected from thousands of pictures the images in this book. We cover the royal world of the nineteenth century and the first part of the twentieth century, my childhood and youth in Morocco, Spain, France, and in royal Greece up until my marriage. Then there is my family life: the birth of my children, then one fine day, their marriages, and finally, the birth of my grandchildren, who have such an important role in my life and in my photos.

There is also our professional life. We have lived in France, New York, and Greece. My profession as a writer and Marina's profession as an artist have brought us into contact with the entire art worlds of New York and Paris. Enchanting trips under exceptional circumstances through Latin America, the Middle East, and India have also allowed us to meet many people.

I love these pictures. I keep them, I file them, I caption them. Nothing entertains me as much as looking at them and seeing, thanks to the image, memories take shape, and the imagination runs wild. I hope it will be the same for anyone who sees this album. I wish you as much fun with my pictures as I have had myself.

Previous pages: Marina working in her studio in Paris, while I admire her and her work.

Opposite: My portrait by Marina. I am wearing the costume I invented for a masked ball given by Prince and Princess Michael of Kent in the gardens of Kensington Palace.

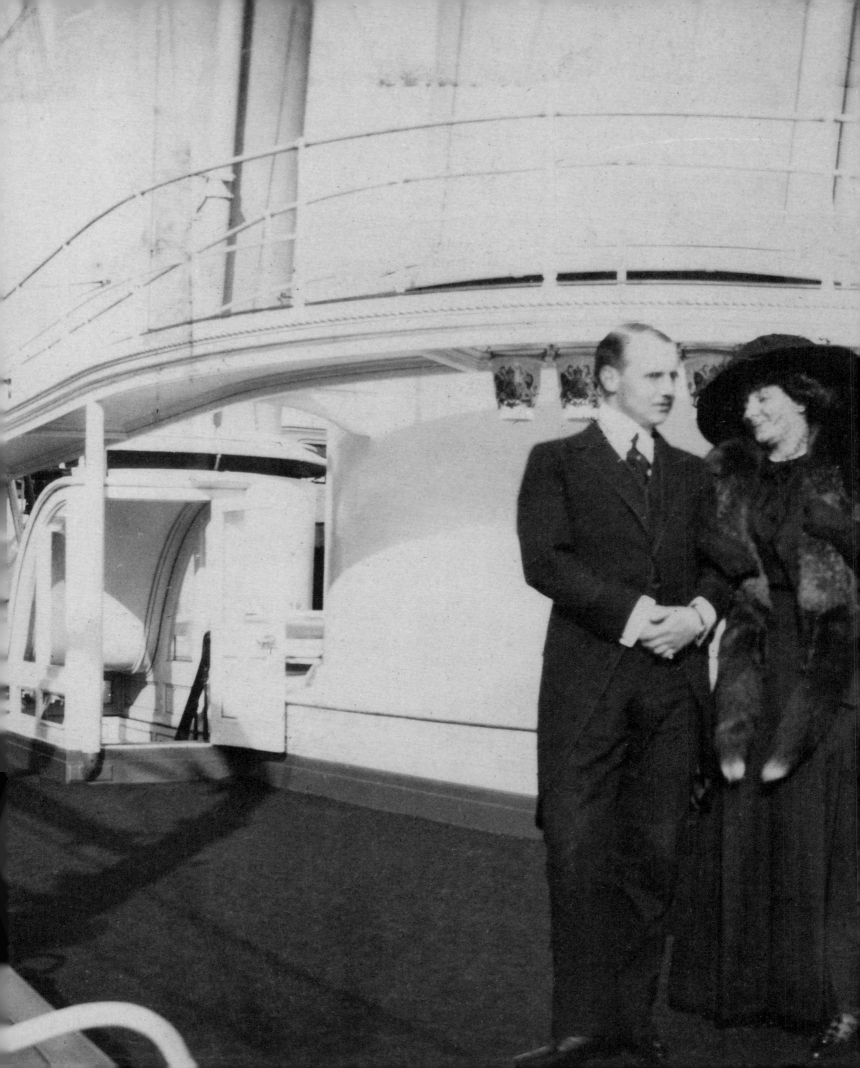

Justin Creedy Smith is a friend of mine and a professional photographer with whom we photographed many haunted castles.

The Countess of Paris, Isabelle d'Orleans-Bragance, the wife of my guardian. At that time, she was far from being my favourite aunt, yet the situation improved in her later days.

Some photographers, in and around the family. An unknown photographer immortalized my grandfather, the Duke of Guise, in his house of exile in Brussels.

The young Karl, Duke of Wurttemberg, was madly in love with my cousin Diane de France. He came to Portugal, where the family had their summer house, and finally succeeded in marrying her. He died in August 2022.

Within: Taking a photograph aboard either the royal British yacht or the Russian imperial yacht—I cannot determine which—is Queen Alexandra of England, Princess of Denmark, the sister of my grandfather George I of Greece. Next to her is her sister, the princess dowager Maria Feodorovna of Russia. With a top hat, an unknown gentleman. Then a grand duke of Russia, possibly Mikhail Alexandrovich. Then my father, Christopher of Greece, with his sister-in-law, Princess George of Greece, born Marie Bonaparte, a distinguished psychoanalyst and pupil of Freud.

Our son-in-law, Nicolas, photographing from the sea his sons Tigran and Darius, our grandchildren, diving.

Justin Creedy Smith photographed the Queen of Denmark in Fredensborg castle for an article I wrote about the restoration of one of the Amalienborg palaces.

My wife, Marina, in my eyes the best photographer I have ever met.

My daughter Olga is an excellent photographer.

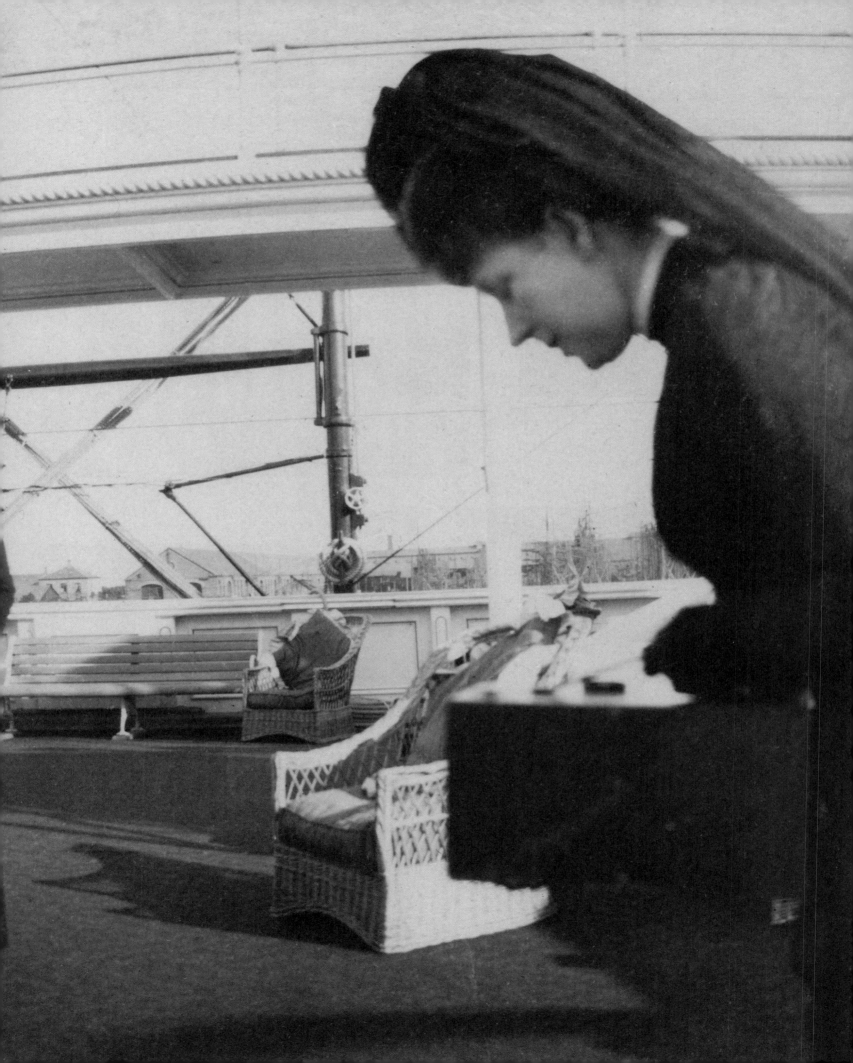

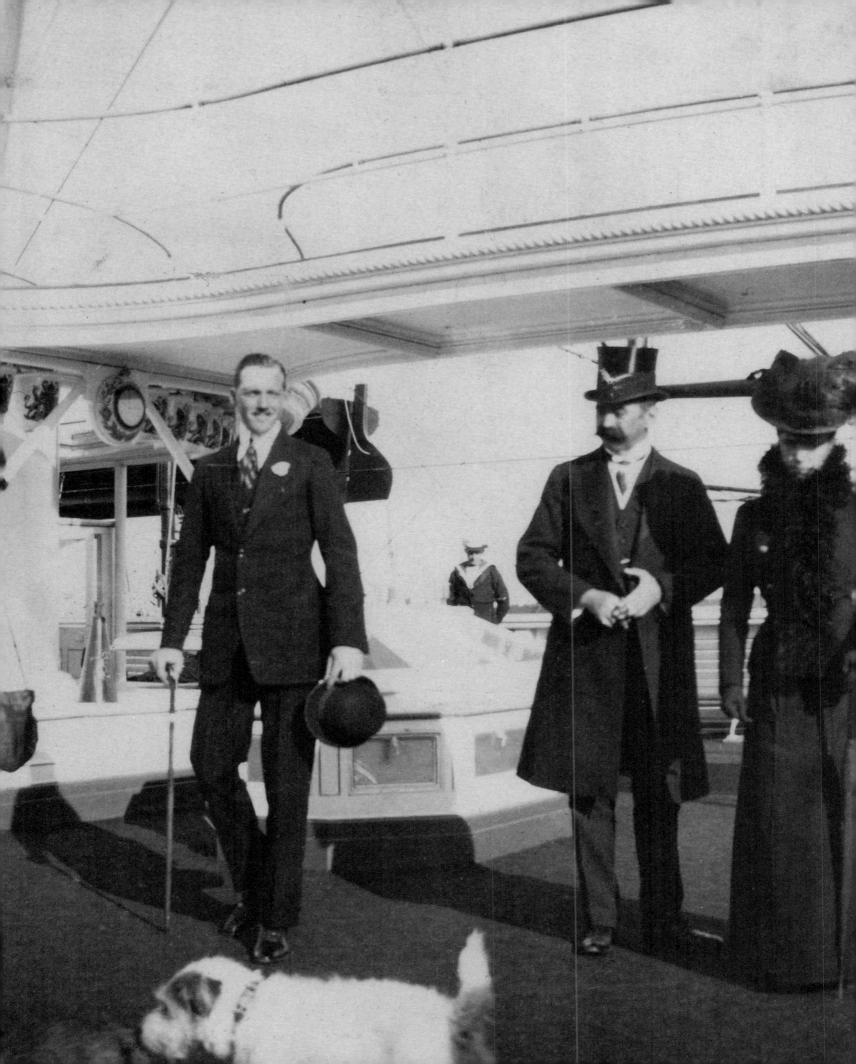

INTRODUCTION
BY THE DUCHESS OF AOSTA, OLGA, MY DAUGHTER

I hate being photographed. My father is always snapping; he thinks he is undetected, even invisible, and that we will not notice as he furtively takes out his camera for a quick snap. He takes photos all the time and everywhere, caring less about light and composition and more about capturing the moment. He has a need to document everything around him: the moment in time, its place in history, great or small. My mother is also a snapper but she, conversely, is all about creating the perfect ethereal, dreamy photo—capturing the best light, the right angle, an interesting domestic scene, or a beautiful landscape.

My father is a highly organized person. He has always documented everything around him, writing a diary every day and devoting a lot of his time and precious brainpower to organizing all his photographs, meticulously recording the name of every person pictured, the place, the date, everything. Amongst family members his unique skills are greatly appreciated. It is my father's favorite sport to arrive at a relative's house and head for the attic to rifle through their old photographs, his hands extending like tentacles toward the dusty drawers. He spends hours sorting the photographs, invaluable historical documents rediscovered, which would otherwise have lain forgotten.

As a consequence of this passion, my father is able to identify the place and name everyone in most photographs of European royalty, even going many generations back. Being related to most royal families, he is openly welcomed, a trusted insider, even a cozy librarian. At times, though, he is also feared as a raconteur who knows one story too many of the naughty escapades of his ancestors. His mythic attic quests have sometimes left hosts a little wobbly on their feet, having discovered not only some previously unbeknown proclivities of a cherished ancestor, but also, very often, a literal ghost of times past, the diaphanous type with whom my father has heart-to-hearts up in those attics—conversations which he is happy to share.

This book had to exist. My father has made so many beautifully crafted albums in his life, with so much passion and knowledge, which combine historical images with my father's own quirky photographs and my mother's beautiful and artistic ones. In these albums he has given life back to these old black-and-white photographs that not many people cared about, and created a space to showcase my parents' highly individual way of capturing everything around them, long before the days of Instagram and the like. This book reflects them: totally unique, wild, funny, intelligent, generous, kind, extravagant, and creative as they are in their life. Anyone who knows them, knows this is them.

Marina has been my best portraitist, either in painting or in photography.

HRH PRINCE MICHAEL OF GREECE
GENEALOGICAL TREE

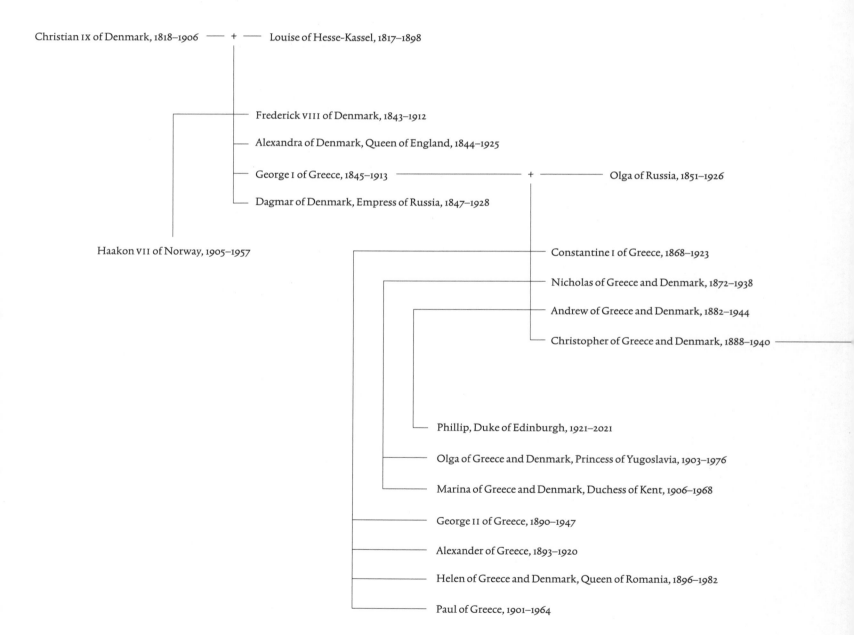

Christian IX of Denmark, 1818–1906 ——— + ——— Louise of Hesse-Kassel, 1817–1898

Frederick VIII of Denmark, 1843–1912

Alexandra of Denmark, Queen of England, 1844–1925

George I of Greece, 1845–1913 ——————————— + ——————— Olga of Russia, 1851–1926

Dagmar of Denmark, Empress of Russia, 1847–1928

Haakon VII of Norway, 1905–1957

Constantine I of Greece, 1868–1923

Nicholas of Greece and Denmark, 1872–1938

Andrew of Greece and Denmark, 1882–1944

Christopher of Greece and Denmark, 1888–1940 ———

Phillip, Duke of Edinburgh, 1921–2021

Olga of Greece and Denmark, Princess of Yugoslavia, 1903–1976

Marina of Greece and Denmark, Duchess of Kent, 1906–1968

George II of Greece, 1890–1947

Alexander of Greece, 1893–1920

Helen of Greece and Denmark, Queen of Romania, 1896–1982

Paul of Greece, 1901–1964

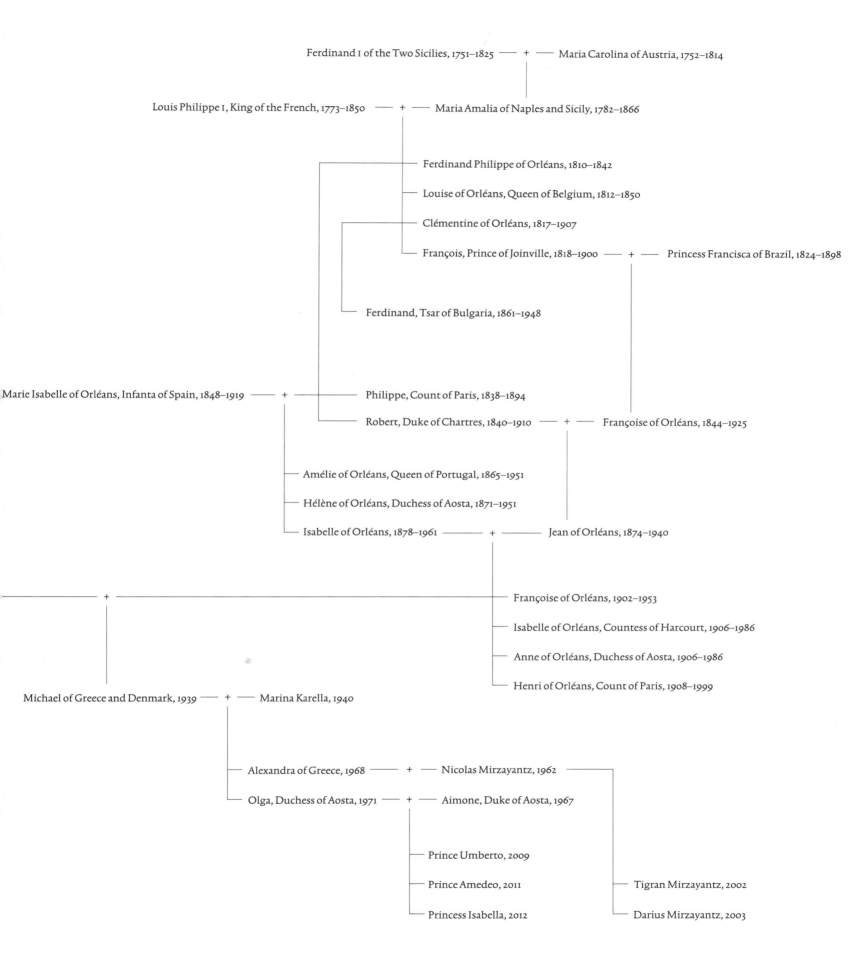

Ferdinand I of the Two Sicilies, 1751–1825 ——— + ——— Maria Carolina of Austria, 1752–1814

Louis Philippe I, King of the French, 1773–1850 ——— + ——— Maria Amalia of Naples and Sicily, 1782–1866

Ferdinand Philippe of Orléans, 1810–1842

Louise of Orléans, Queen of Belgium, 1812–1850

Clémentine of Orléans, 1817–1907

François, Prince of Joinville, 1818–1900 ——— + ——— Princess Francisca of Brazil, 1824–1898

Ferdinand, Tsar of Bulgaria, 1861–1948

Marie Isabelle of Orléans, Infanta of Spain, 1848–1919 ——— + ——— Philippe, Count of Paris, 1838–1894

Robert, Duke of Chartres, 1840–1910 ——— + ——— Françoise of Orléans, 1844–1925

Amélie of Orléans, Queen of Portugal, 1865–1951

Hélène of Orléans, Duchess of Aosta, 1871–1951

Isabelle of Orléans, 1878–1961 ——— + ——— Jean of Orléans, 1874–1940

Françoise of Orléans, 1902–1953

Isabelle of Orléans, Countess of Harcourt, 1906–1986

Anne of Orléans, Duchess of Aosta, 1906–1986

Henri of Orléans, Count of Paris, 1908–1999

Michael of Greece and Denmark, 1939 ——— + ——— Marina Karella, 1940

Alexandra of Greece, 1968 ——— + ——— Nicolas Mirzayantz, 1962

Olga, Duchess of Aosta, 1971 ——— + ——— Aimone, Duke of Aosta, 1967

Prince Umberto, 2009

Prince Amedeo, 2011

Princess Isabella, 2012

Tigran Mirzayantz, 2002

Darius Mirzayantz, 2003

CHAPTER ONE
MY FAMILY 1848–1939

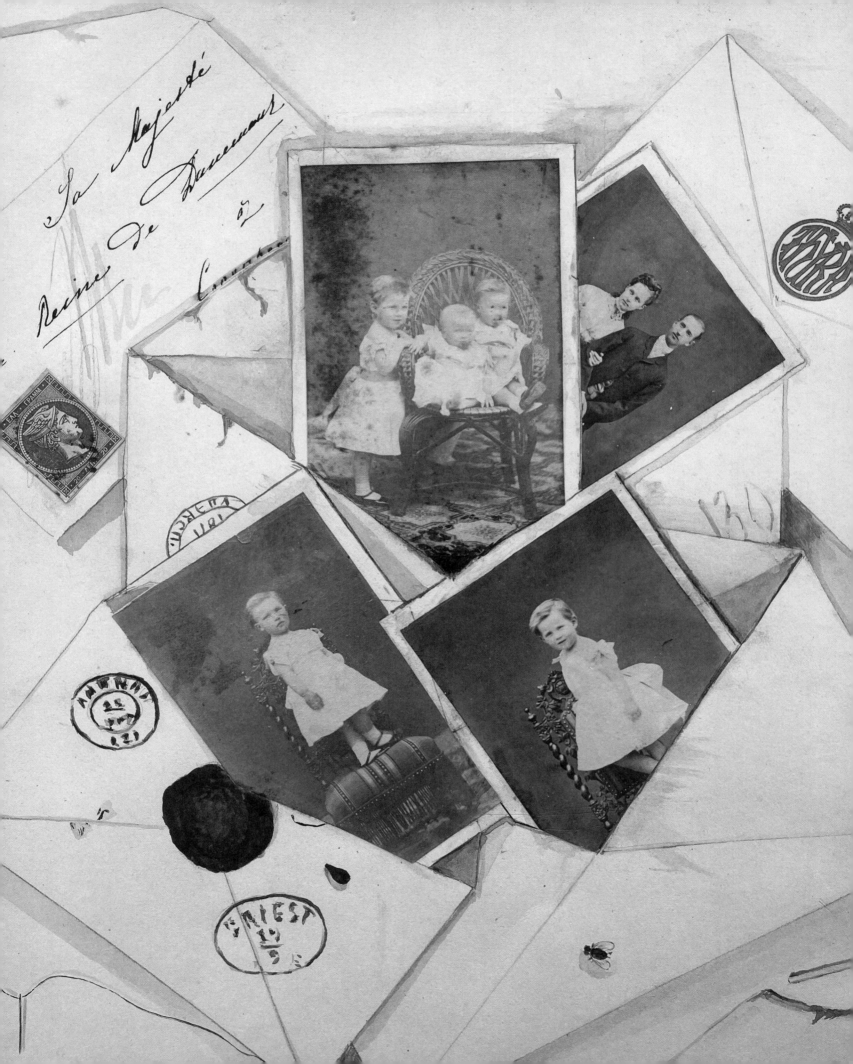

Just to paint a picture—I won't go into genealogical details because you'd be instantly lost: My father was Prince Christopher of Greece. My mother was princess Françoise of France. My grandfather King George I of Greece was born Prince William of Denmark, and he married Grand Duchess Olga Konstantinovna of Russia. My French grandmother was the daughter of the infanta Isabella of Spain. Her two sisters respectively married the King of Portugal and the Duke of Aosta from the Italian royal family. The first Queen of Belgium was a member of my mother's family, just as the first King of Bulgaria had a French mother. My first cousin Helen, Princess of Greece, married the King of Romania. The only daughter of my first cousin King Alexander of Greece married the King of Yugoslavia.

We descend from the Kings of Naples and from the heroic Queen Louisa of Prussia, the Emperors of Austria, and, before that, the Holy Roman Empire are our ancestors. My grandfather George I's sister Alexandra married King Edward VII of England, and his oldest sister, Dagmar, became the empress Maria Feodorovna of Russia. The Kings of Norway belong to a branch of our Danish family.

In short, all European royalties were related to one another, and, by default, so am I related to them all.

A page from my grandmother Olga of Greece's scrapbook. Scrapbooking was a very popular pastime in the late nineteenth century. Enthusiasts often proved to be genuine artists, like my grandmother, so this scrapbook is made of collages she composed herself. Some family photos feature in them. Here I can make out a photo—you can only see a third of it—showing Queen Olga and her husband, my grandfather King George I, and then photos of royal children. The envelopes are from Her Majesty the Queen of Denmark, to which my grandmother added monograms and, on many of the pages, framing flowers or landscapes in skilfully executed watercolour. Ultimately they are quite original and unique for this type of work.

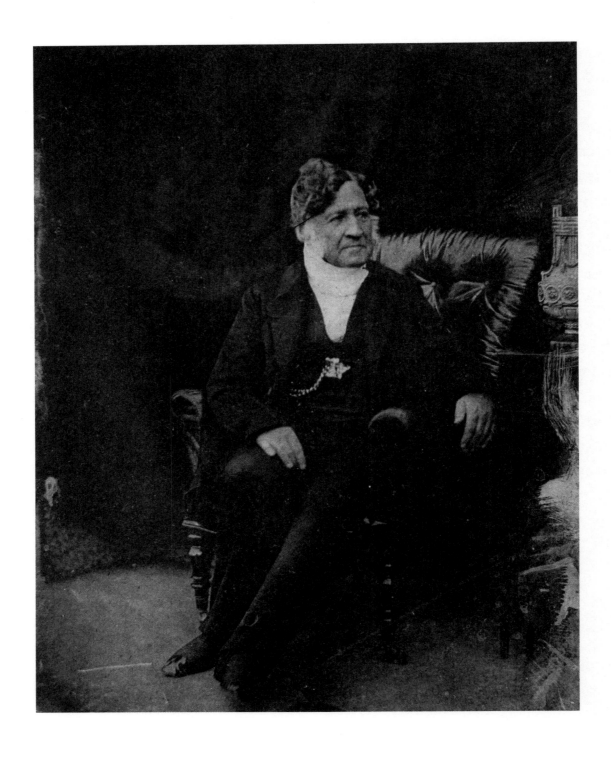

King Louis Philippe of France, my favourite ancestor. He is pictured in this old photo while in his final exile in England after being driven out by the 1848 revolution. Nicknamed the Bourgeois King for his simplicity, his reign brought eighteen years of peace and prosperity to France but also a certain amount of boredom. However, his life had been a prodigious web of adventures, upheavals, and unexpected encounters. Somehow I feel very close to him.

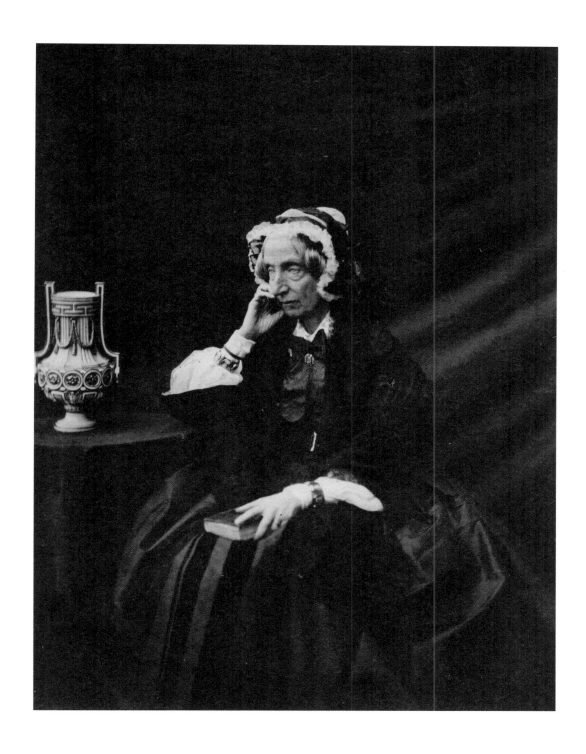

His wife, Maria Amalia of Naples and Sicily. Through her mother, she was niece of Marie Antoinette and grand-daughter of the great Empress Maria Theresa. She came from an eminently conservative family and agreed to marry a prince who had been a general in the French Revolutionary Army. From the long lineage of the House of Orléans, I can safely say that they were the only couple who remained faithful and in love until the end. They had several children, all of them beautiful and amiable. Together they made an endlessly inspiring and likeable family.

An English princess, Victoria Eugenie of Battenberg. Behind her is one of the Indian servants whom Queen Victoria had taken into her service after Disraeli, her prime minister, had made her Empress of India. Indeed, one of them was to become her favourite. This little girl was the daughter of one of Victoria's daughters and a Battenberg prince. She was Empress Eugenie's goddaughter and would one day marry King Alfonso XIII of Spain. We knew her as Aunt Ena, and I remember her very well. She was a very impressive, very affable woman.

A miniature by Hau of my grandmother Olga and her younger sister Vera, seated. Both were grand duchesses of Russia, daughters of Grand Duke Konstantin Nikolayevich and the beautiful Grand Duchess Alexandra Iosifovna. They grew up partly in the wonderful Pavlovsk Palace, which belonged to their father, near St Petersburg, and partly in unimaginable splendour in another architectural marvel of the city itself, the Marble Palace.

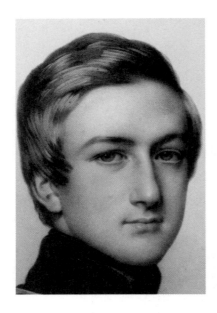

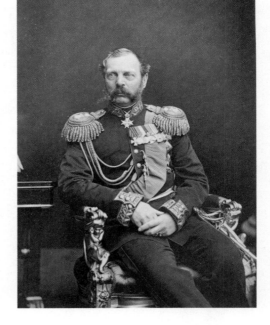

My great-grandfather Robert d'Orléans, Duke of Chartres. He had wanted to sign up for the French Army during the Franco-Prussian War of 1870. The Republic refused to let him do so. He therefore adopted an alias and signed up anonymously to fight.

A cousin by marriage of my grandmother Olga of Russia, Grand Duchess Maria Pavlovna of Russia, born a Princess of Mecklenburg. She was elegantly beautiful, rich, owned the finest collection of jewellery in the Empire, and was the true queen of St Petersburg society. She also had a sharp tongue and was accused of being rather scheming. Admired by many, she was somewhat feared by the family.

Robert's uncle Henri d'Orléans, Duke of Aumale. The *grand homme* of the family, he was a soldier, a member of the Académie Française, and a billionaire. He had inherited a vast fortune thanks to the mysterious death of his godfather, the Prince of Condé. He amassed in his castle of Chantilly, which he entirely rebuilt, the most important private collection in France: paintings, watercolours, and manuscripts, including the *Très Riches Heures du duc de Berry*.

Emperor Alexander II, brother of my great-grandfather Konstantin Nikolayevich, who encouraged him in his wish to bring democracy to the Russian Empire. Just as he was about to enact a constitution, he was assassinated. As a result, his son Alexander III and his grandson Nicholas II reverted to fierce conservatism, which would lead to the 1917 Revolution.

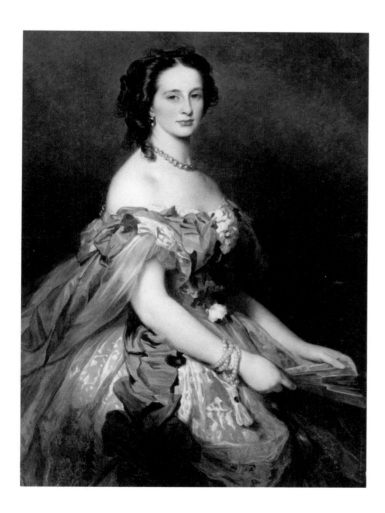

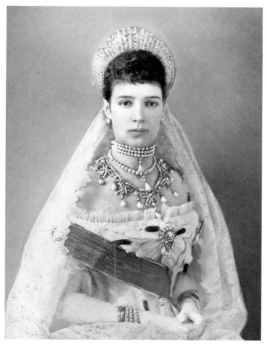

Princess Charlotte (Carlotta) of Belgium, Empress of Mexico. Through her mother, who was a princess of Orléans, she was first cousin to my great-grandparents. Her destiny was a tragic one: after her husband was executed, she went mad, and remained so for sixty years until she died, almost three decades into the twentieth century.

This teenager with a strange, heavy look in his eyes is none other than the Archduke Rudolf of Austria, heir to the throne and protagonist of the mysterious tragedy at Mayerling, where he and his mistress Mary Vetsera were found dead from gunshot wounds. Whether it was suicide or murder, nobody ever knew.

The Winterhalter portrait of my great-grandmother Grand Duchess Alexandra Iosifovna of Russia, a great beauty who was often cheated upon by her husband.

The imposing and beautiful portrait is of the sister of my grandfather George I of Greece, Princess Dagmar of Denmark, who through marriage became Empress Maria Feodorovna of Russia. A *grande dame* if ever there was one, she was regal and affable, and could win over anyone who encountered her. Here, she is wearing unimaginably precious jewellery—such as this diamond necklace and tiara—without any sense of affectation. She survived the Revolution but never wanted to accept that her son Nicholas II and his family were assassinated, instead believing that they had escaped and were in hiding somewhere.

Pictured against a photographer's backdrop, seated in a pretend gondola, are the Duke and Duchess of Montpensier, my French great-great-grandparents. He was the scheming patriarch of the family. She was a Spanish infanta, which allowed her husband to plot to take possession of the Spanish throne. Opposite them, their eldest granddaughter, my great aunt Amélie of France, later Queen Consort of Portugal. Behind them, their son, the Duke of Galliera, who was a rogue.

The princes and princesses of Orléans at the burial of their ancestor, Queen Maria Amalia. They are posing in the grounds of the Château of Claremont, the former sovereign's last home, as if in a Visconti film.

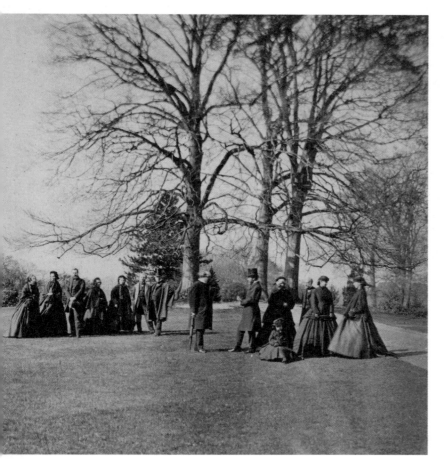

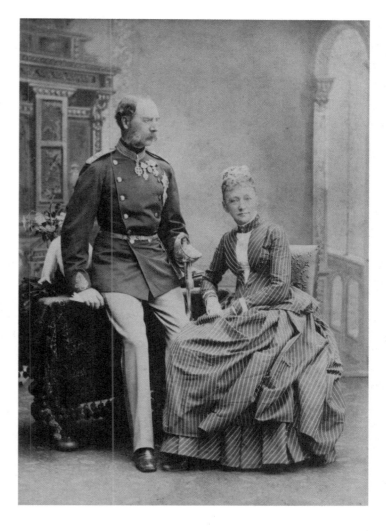

Grand Duke Dmitri of Russia—my first cousin, who was more than fifty years older than me—as a young boy. He was the son of Grand Duke Paul and Alexandra of Greece, my father's sister, who died giving birth to him. He was one of Rasputin's three assassins. He had a turbulent life and was for some time Coco Chanel's lover.

My paternal great-grandparents King Christian IX and Queen Louise of Denmark. Their reign started badly as they were unpopular for being German, but it ended in the glory of great popularity because they had become Danish through and through, in their own hearts as well as those of their subjects.

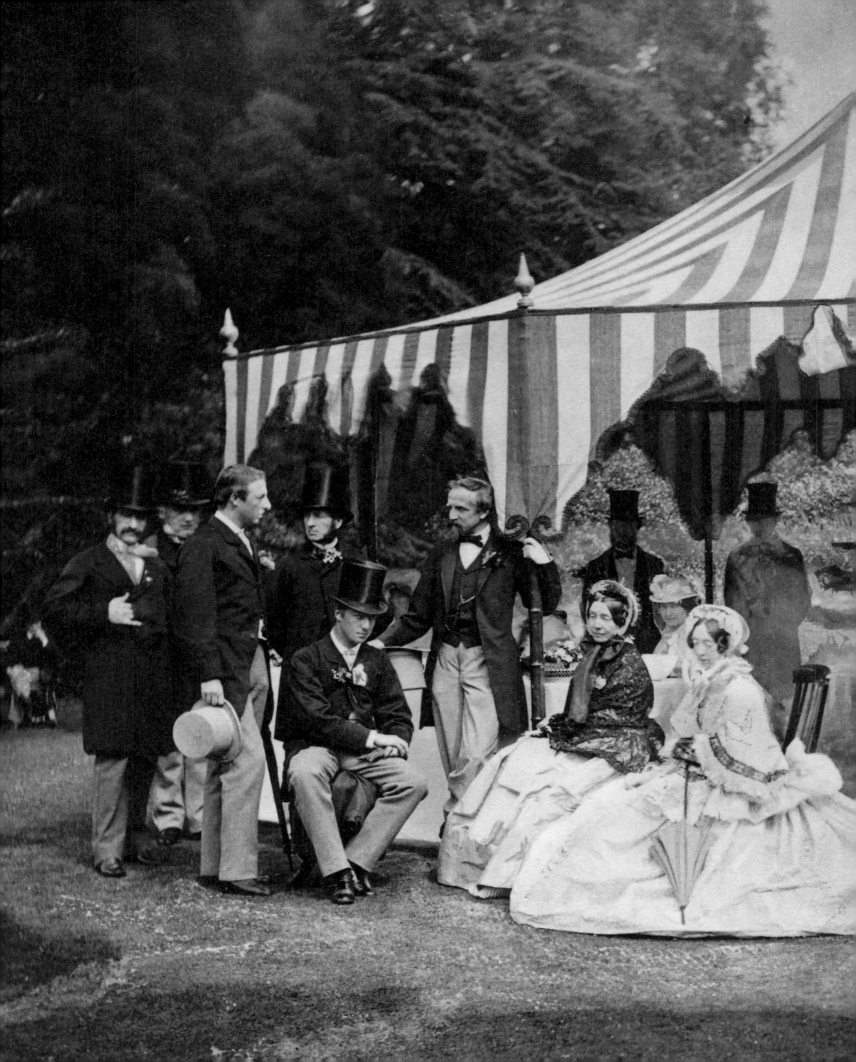

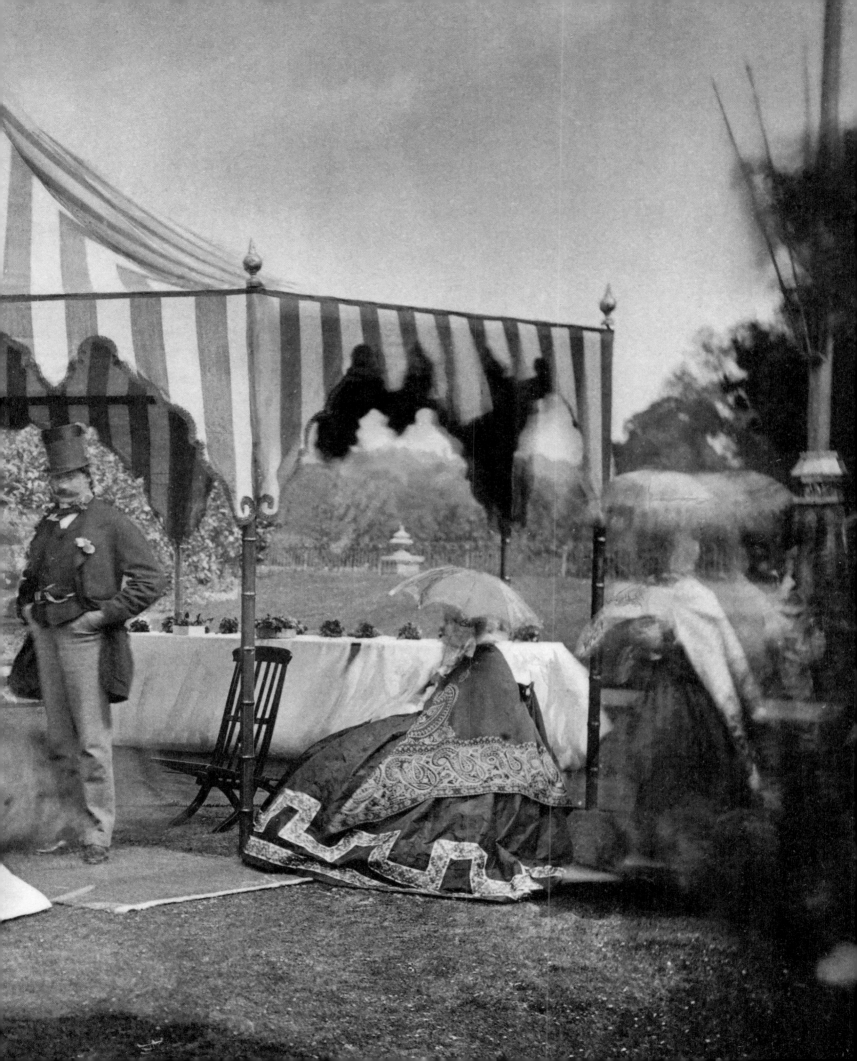

Previous pages: This beautifully posed and composed photo shows, in the middle, Henri d'Orléans, Duke of Aumale, surrounded by members of his entourage. Sitting in a top hat and standing in profile are two of his sons, probably the Prince of Condé and the Duke of Guise. Despite his immense wealth and fame, the Duke of Aumale had the misfortune of losing all of his children when they were still in the flower of youth. He attributed this tragedy to the fact that he had inherited his vast fortune through a murder: that of their distant uncle, the Prince of Condé. Consequently he did not want to leave the crowning glory of this inheritance—the Château of Chantilly, which he had reconstructed—to his family, to spare them from the curse, and so he instead bequeathed this architectural masterpiece to the Institut de France. This photo and the others that accompany it were to end up in an album that was sold to raise money for charity.

Maria of Bavaria, Queen of Naples. She was the sister of Empress Elisabeth of Austria and just as beautiful. During the wars that culminated in Italian unification, she defended her kingdom from attacks by Garibaldi and the Piedmontese troops much more successfully than did her husband, King Francis II. In particular, she was the heroine of the dramatic siege of the city of Gaeta, the last fragment of her kingdom. The rest of her life was spent in exile, with episodes that remain eminently mysterious.

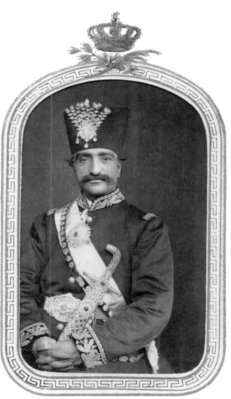

Elisabeth of Bavaria, Empress of Austria—the famous and sublime "Sisi." Beautiful, romantic, unhappy, and tragic, since she was assassinated on a quayside in Geneva.

My great-grandfather Grand Duke Konstantin Nikolayevich, brother of Alexander II. A great admiral of Russia. An intelligent, cultivated, and profoundly liberal man who fell out of favour with his nephew, Tsar Alexander III, precisely because of that liberalism.

Mademoiselle d'Artois, the granddaughter of King Charles X of France, and daughter of the murdered Duke of Berry. She married the Duke of Parma, who was likewise assassinated. The unification of Italy caused her to lose her throne.

Nadir Shah, Shah of Persia. Like a good number of other Iranian rulers, he was assassinated. He is wearing a sumptuous aigrette, an ornament studded with diamonds. There are diamonds on his belt and his sword. These jewels belonged to the famous treasure that still belongs to Iran, but which was in fact stolen by the Shah from Mughal India when he claimed a victory in war there.

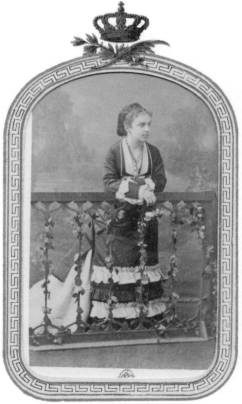

King Ludwig II of Bavaria, the romantic monarch, hero of countless documentaries, films, and books, with his then fiancée, his first cousin Sophie of Bavaria. His inclinations were not toward women, however, and he soon broke off the engagement. Sophie would go on to marry my distant uncle Ferdinand d'Orléans, Duke of Alençon.

My grandmother Grand Duchess Olga, future Queen of Greece, as a child.

King Alfonso XII of Spain with his first wife and first cousin, my great-great-aunt, Infanta Mercedes d'Orléans. Their mothers—Isabella II and Infanta María Luisa Fernanda, Duchess of Montpensier, respectively—were sisters, and had totally fallen out with each other. Isabella II forbade her son Alfonso to go anywhere near her sister's home. The first thing that the young, intrepid man did was to jump over the wall, and there in the grounds he discovered a ravishing young woman, whom he realised was his first cousin Mercedes. He fell in love with her. Queen Isabella, furious, forbade the marriage; then she softened. Their marriage was the reconciliation of the two sisters, and the whole of Spain was jubilant. However, Queen Mercedes died of tuberculosis very soon afterwards, leaving her husband inconsolable.

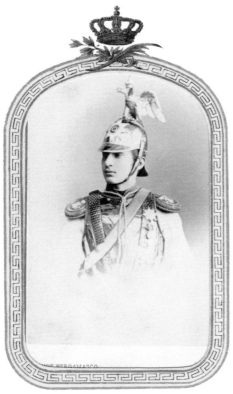

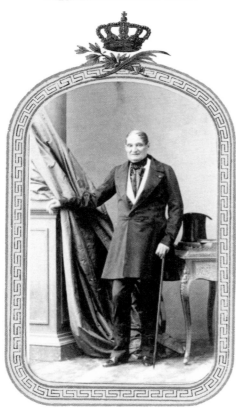

Grand Duke Nicholas Konstantinovich of Russia, my grandmother Olga's brother, and the shame of the family. He was accused of having stolen some diamonds from his mother's icons to give to his American mistress, Fanny Lear. I wrote an entire book to prove he was innocent. That research, which led me to discover the existence of a more romantic, more adventurous great-uncle than we'd ever imagined, came to be titled *The White Nights of St Petersburg*.

Jérôme Bonaparte, King of Westphalia. He was Napoleon's youngest brother. He survived all the others. He died just as the era of photography was born. In fact, he was a sort of frivolous playboy—not very intelligent, but harmless. He was an ancestor of the current Prince Napoleon.

My paternal great-grandparents, King Christian IX and Queen Louise of Denmark, in their youth.

Maria Christina of the Two Sicilies, Queen of Spain, last wife of King Ferdinand VII, and mother of his children Isabella II and Infanta María Luisa Fernanda. She is therefore my great-great-grandmother. As a widow, she had a lover, a bodyguard called Munoz, whom she created Duke of Riansares and with whom she had several children.

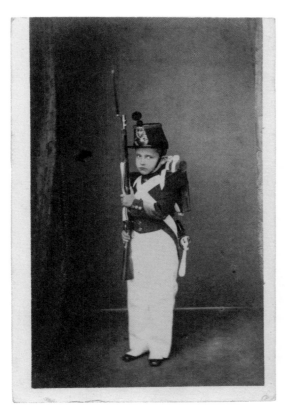

Ferdinand of Saxe-Coburg, first Tsar of Bulgaria. He was the son of Clémentine d'Orléans and thus our distant uncle. The family didn't much like him, hence this caricature drawn by his cousin, my grandfather Jean d'Orléans.

One of the little princes of Naples, sons of King Ferdinand II. While he led with a progressive reputation early in his reign, Ferdinand was nicknamed El Rey Bomba—"King Bomb"—in the wake of his violent response to revolutionary unrest in 1848.

Jean d'Orléans as a teenager, with an enormous feathered hat. Later, when he got married, he received the title Duke of Guise. He became head of the House of France. We all look a bit like him, with his downturned brown eyes.

Louise of Sweden, Queen of Denmark, caricatured by Jean d'Orléans, Duke of Guise. Forbidden by the Republic to serve in the French Army, my grandfather had signed up for the Danish Army, which brought him into contact with the royal family and in particular the future queen, whom he caricatured. She was no beauty, but was enormously wealthy—to the point that when she arrived in Denmark and was asked to show her jewels, she had so many that she covered a whole billiard table with them.

In Louis XIV costume, King Leopold II of Belgium, first cousin of my great-grandparents. He ruled Belgium for almost half a century, and came to be known as the *roi-bâtisseur*—the "Builder King"—after his prolific investment in architecture and public works.

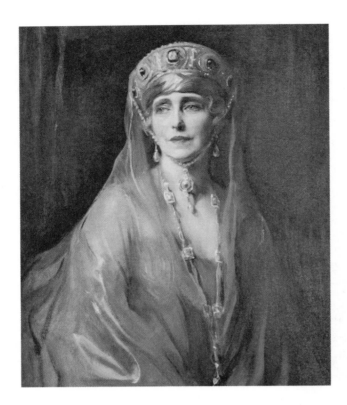

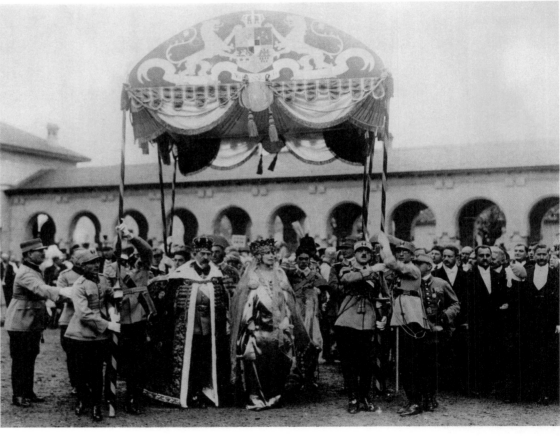

Princess Marie of Edinburgh, Queen of Romania, by the portraitist László. She was a beautiful
queen of the theatre, dogged and audacious. She had married Ferdinand, Crown Prince and then
King of Romania, who was not the brightest bulb in the chandelier. She dominated him completely
and had multiple affairs. At the end of the First World War, she attended the Peace Conferences in
person, and through her gall and charm induced the great powers to agree to enlarge Romania, her
kingdom, by about half... by taking from Hungary. She was a theatrical, legendary character.

One of the most brilliant performances that she staged was her and her husband
King Ferdinand's coronation, which she organised in the historical capital, Alba Iulia.
She designed her own and her husband's costumes herself, as well as their crowns.

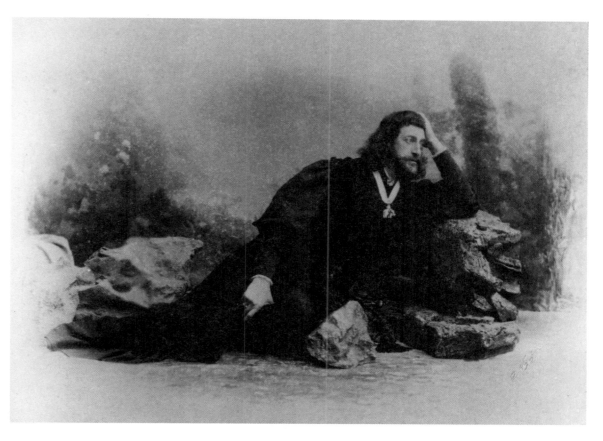

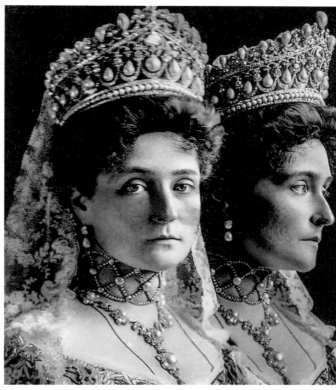

Grand Duke Konstantin Konstantinovich, my grandmother Olga's brother and my great-uncle. He was of course in the army, like all grand dukes, but he was also a remarkably cultivated man. A poet, he wrote elegies that his great friend Tchaikovsky set to music. He not only translated *Hamlet* into Russian, but played the role in the court theatre, as shown in this photo.

Princess Alix of Hesse, Empress Alexandra Feodorovna of Russia. Aunt Alix. She had married my father's first cousin, the last tsar, Nicholas II. The imperial family didn't like her. She detested pomp and ceremony. Wearing this immense tiara and this court costume was torture for her. As everyone knows, she was assassinated with her husband and their five children at Ekaterinburg in 1918, by the Bolsheviks.

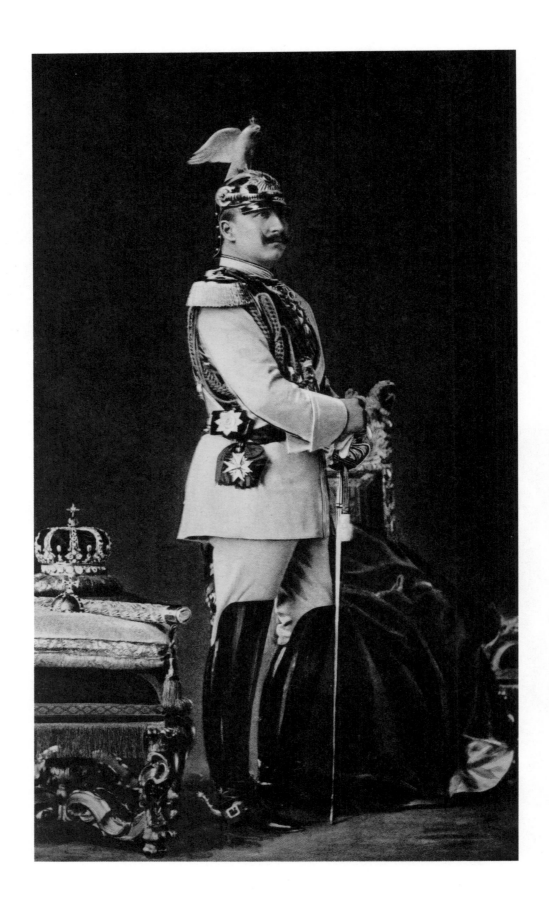

Wilhelm II, Emperor of Germany. This photo is dedicated to his brother-in-law and my uncle, King Constantine of Greece. Yet he was hated by the Greek side of the family because we were originally Danish, and during the Second Schleswig War, Wilhelm II's grandfather Wilhelm I had gobbled up a third of Denmark.

Whatever his reputation tells us, I believe he did not trigger the First World War. On the contrary, he was just a pawn of the dark forces who wanted that conflict to happen. However, he acquired that reputation because of his bragging, and the warlike attitude that he liked to adopt to hide his profound physical inhibitions.

King Carlos I of Portugal with his wife, my great-aunt Amélie of France, sister of my grandmother, whom I knew well in my childhood. They are in a royal carriage exactly as they would be the day an assassin stepped up onto the carriage's footboard and shot the King and his eldest son point-blank. It was a tragedy that my great-aunt would never be able to forget, and that she relived in the period of delirium that preceded her death.

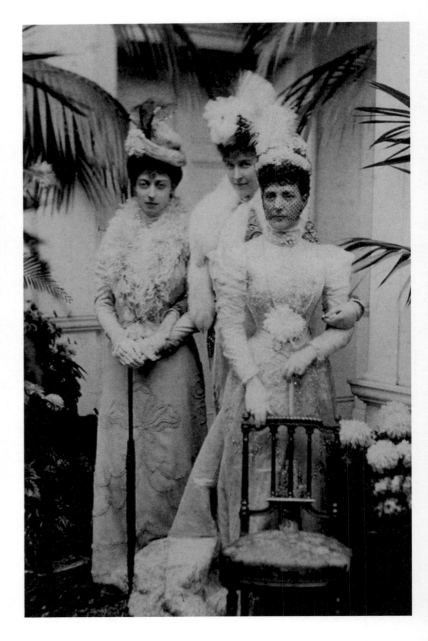

Grand Duchess Elizabeth Feodorovna of Russia, Aunt Ella, sister of the last Tsarina. She had married Grand Duke Sergei of Russia and would spend her summers here in the Mikhailovsky Palace, where my whole family would visit them. She was renowned for her beauty and elegance, and would not hesitate to change her jewellery several times during court balls. After her husband was killed by an anarchist's bomb, she renounced her worldly wealth and set up a religious order, becoming a nun. She was brutally assassinated during the Revolution.

Britain's Queen Alexandra, born Princess of Denmark, and sister of my grandfather George I. Next to her, her daughter Victoria, who never married, and behind her, the sister of my French grandmother, Hélène of France, Duchess of Aosta. Aunt Tylene had been engaged to Queen Alexandra's son, the Duke of Clarence, but their different religions had prevented their marriage. Still, Alexandra had always regretted that the marriage had never taken place, and continued to be friendly toward Aunt Tylene.

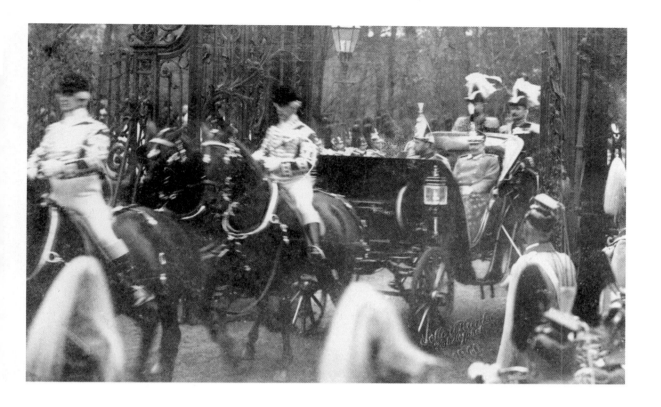

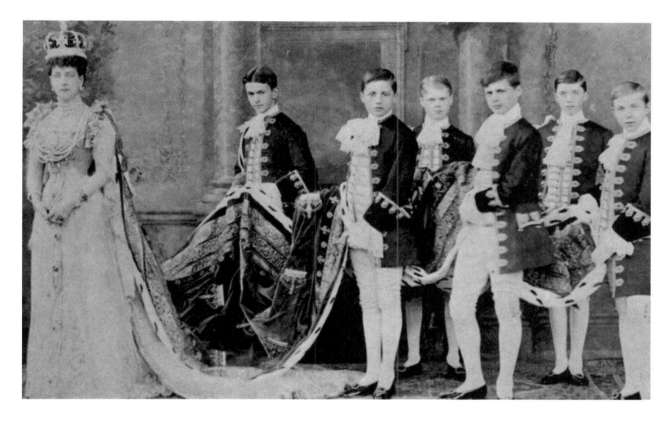

Tsar Nicholas II in Prussian uniform during an official visit to Berlin, sitting next to his host, Emperor Wilhelm II. The two emperors didn't much like each other but put up with one another for political reasons. We know that the 1914 war broke out largely because Russia mobilised against Germany. However, at the last moment, Nicholas II—terrified by what he was about to unleash—sought to cancel the mobilisation and prevent the outbreak of war. His ministers would not let him.

Queen Alexandra during her coronation, with her husband, Edward VII, who succeeded his mother, Queen Victoria, in 1901. At the centre of her crown is the world's most famous diamond, the Koh I Noor. At around sixty years old, she still looked incredibly youthful and her beauty still dazzled her contemporaries. As was often the case, she was late on the day of her coronation, to the point that her husband Edward VII, who had been waiting forever and was renowned for his impatience, ran into her dressing room to shout: "Alix, do you or do you not want to be crowned?"

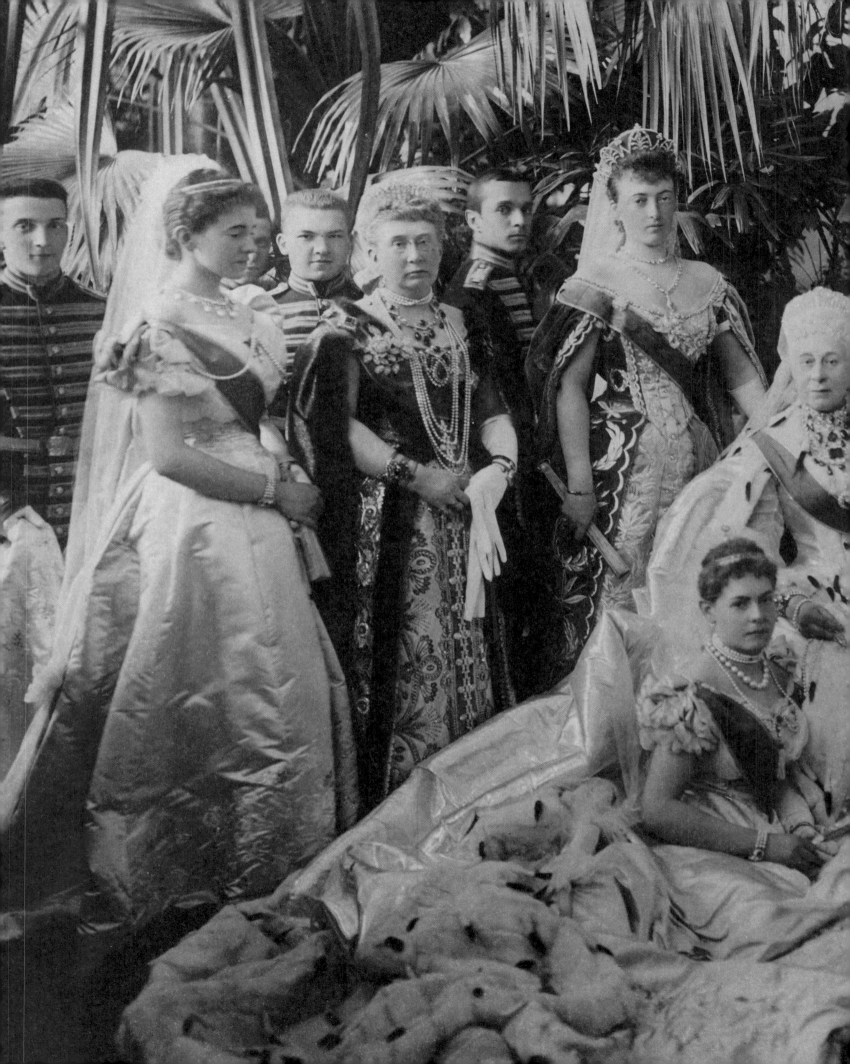

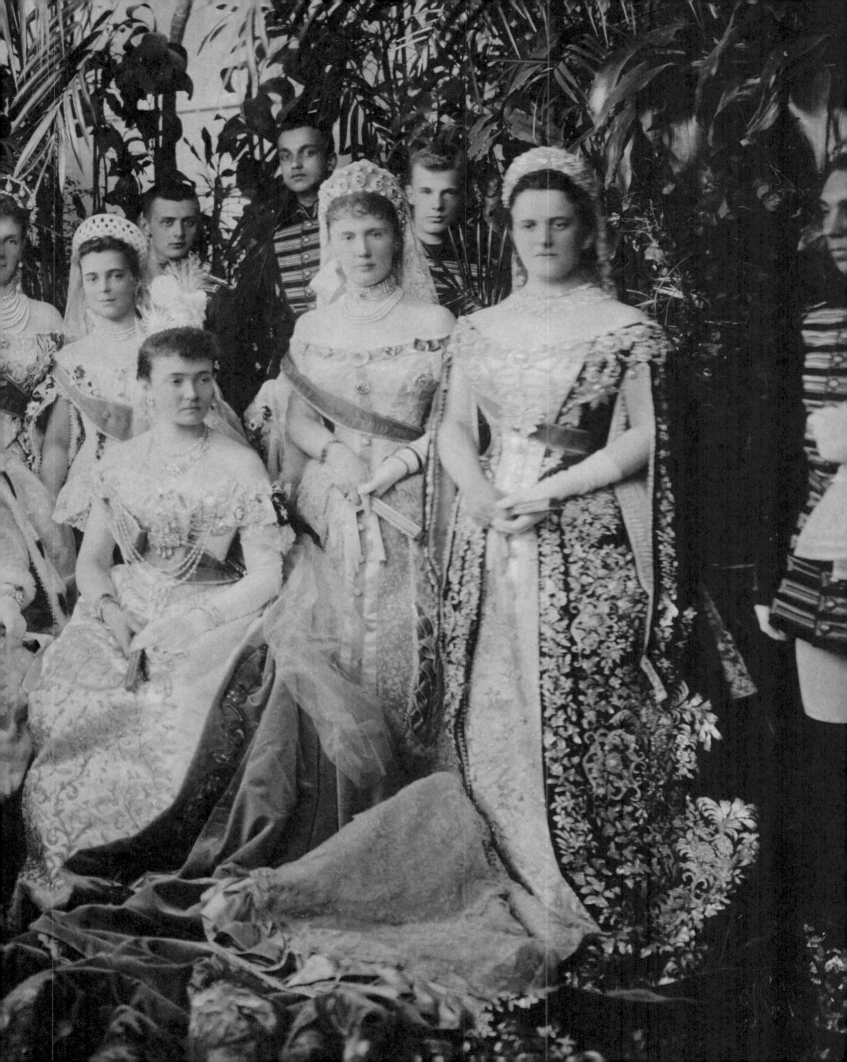

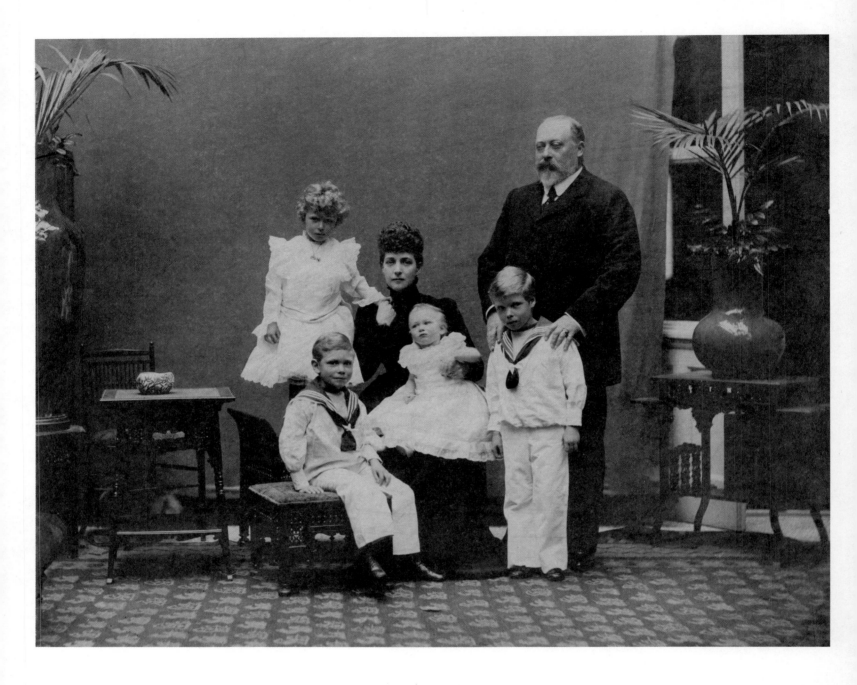

Previous pages: During the coronation of Tsar Nicholas II in Moscow, which was surrounded by an unparalleled level of grand pomp and splendour, the guests were photographed in groups. In the middle of this image is my great-grandmother Grand Duchess Alexandra Iosifovna, henceforth the doyenne of the family, covered in enormous jewels. Behind her and to the left, wearing spectacles, is her youngest daughter, Vera, my great-aunt, very intelligent but certainly no beauty. She is with her two daughters, one next to her and the other at Alexandra's feet. On the left just behind Alexandra is a cousin, Grand Duchess Anastasia Mikhailovna, wife of the Grand Duke of Mecklenburg. On the other side is Grand Duchess Maria Pavlovna, Queen of St Petersburg, with her daughter, Aunt Helen, who was to marry my father's brother, Uncle Nicholas. Next, also standing, is Grand Duchess Elisabeth Mavrikievna, wife of my great-uncle Grand Duke Konstantin Konstantinovich. I haven't managed to identify the last lady in the line-up. Sitting next to the Grand Duchess is the wife of the British representative at the coronation, the Duchess of Connaught, a daughter-in-law of Queen Victoria. Behind are the pages who were tasked with attending to the princes and princesses.

Edward VII, Queen Alexandra, and their grandchildren. In front of Edward VII is the future Edward VIII, Duke of Windsor. The little girl is the Princess Royal. Next, on Queen Alexandra's lap, is the future Duke of Gloucester, and sitting on a stool is the future King George VI, Queen Elizabeth II's father.

My maternal great-grandmother Françoise d'Orléans, Duchess of Chartres. She had married her first cousin, the Duke of Chartres. She was the daughter of the Prince of Joinville, the wonderful son of Louis-Philippe, a brilliant watercolourist and sailor, and of a Brazilian princess. She too was a very skilled painter, and left, among other things, about a hundred watercolours depicting every imaginable type of mushroom.

My grandfather Jean d'Orléans, future Duke of Guise, flanked by his two sisters. The eldest, on the right, is Marie d'Orléans, who would marry Prince Valdemar of Denmark. On the left is her younger sister, Marguerite d'Orléans, future Duchess of Magenta. This original, highly posed photo was taken by their father, the Duke of Chartres, a very talented amateur photographer.

My grandfather George I during a stay in Denmark, the country where he was born. Every summer, he and his whole family would travel there to spend their holidays at the residence of his parents, King Christian IX and Queen Louise. Like all Danish royalty, my Lutheran grandfather never abandoned his original religion after becoming King of Greece, even though he was now the defender of the Orthodox faith. He very discreetly installed a Lutheran chapel inside his palace in Athens, along with a chaplain. When he left Denmark to reign over Greece, it was predicted that he would soon be driven out of such a volatile country, and everyone felt sorry for him in advance. In fact, he reigned for fifty years, which earned him the absolute record for political longevity in the whole of Greece's history.

Grand Duchess Xenia Alexandrovna of Russia. She was my father's first cousin and married one of her cousins, Grand Duke Alexander. She posed in a salon of an imperial palace in front of the portrait of our ancestor Catherine the Great. She escaped during the Revolution and lived for a long time in exile in England, in a "grace and favour" apartment granted to her by King George V.

My great-grandfather Christian IX of Denmark playing cards with his three daughters:
the Russian Empress Maria Feodorovna, face on; the British Queen Alexandra, in
profile; and Aunt Thyra, Princess of Hanover and Duchess of Cumberland.

Breakfast in summer at the Danish court. From left to right: my grandfather George I; his brother, the future King Frederick VIII of Denmark; their sister, the Russian Empress; their father, Christian IX of Denmark; their other sister Thyra, Princess of Hanover; then Grand Duke Michael of Russia. The tall young man standing behind must be the future King Christian X of Denmark. Every summer, Christian IX and Queen Louise would bring their children, children-in-law, and grandchildren together—about fifty princes and princesses. There were the sovereigns of Greece, Denmark, Russia, and the United Kingdom. Everyone, old or young, adored these gatherings, which my father described in his memoirs.

The exception was Christian IX's son-in-law, Britain's King Edward VII, who was bored to death in Denmark. He far preferred going to visit his brother-in-law George I in Greece, hence this photo of him taking breakfast in the Royal Palace in Athens. During these informal gatherings, through his discussions with the Tsar or the British King, my grandfather George I would achieve great advances in Greece's affairs. For that reason he was his kingdom's best public-relations asset, enabling Greece to gain numerous advantages.

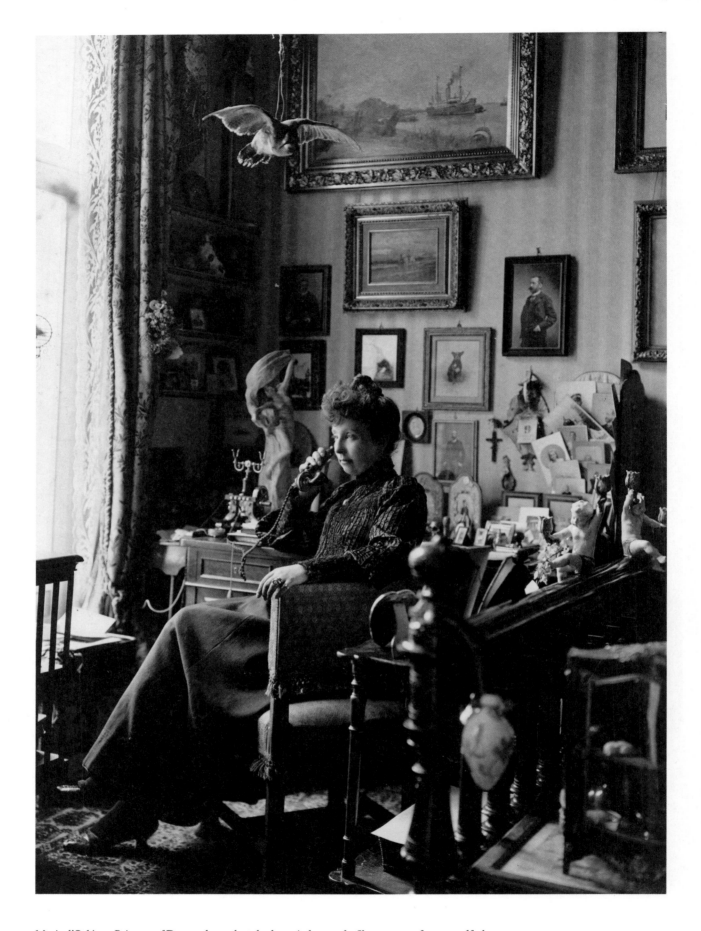

Marie d'Orléans, Princess of Denmark, on the telephone in her study. She was one of my grandfather the Duke of Guise's sisters, and was the most intelligent and unconventional of the siblings. She painted fabulously, in particular drawing a lot of animals immortalised in Copenhagen porcelain. She had herself photographed riding side-saddle on a bull. She was the honorary chief to the firefighters of Copenhagen. Whenever a fire alarm was sounded, she would get up from any court banquet, swap her tiara for a fireman's helmet, and head straight to the location of the fire to help and give advice.

My paternal great-grandmother, Grand Duchess Alexandra Iosifovna, in her private salon in the Pavlovsk Palace, the architectural masterpiece that belonged to her husband. Although much loved by her grandchildren, including my father, and although very beautiful and elegant, she was a rather narrow-minded woman and did not make her husband or sons happy.

This very romantic, evocative photo shows Grand Duke Konstantin Konstantinovich, my grandmother Queen Olga's brother, riding in a horse-drawn carriage in the vast grounds of his residence, Pavlovsk Palace.

Overleaf: One of those extraordinary family gatherings in the summer in Denmark, with a good number of Europe's royal families. Political alliances would be discreetly forged there. From left to right: an unknown young man; my grandfather George I with his two sisters, the Empress of Russia and the British Queen; then, seated, their mother, Queen Louise of Denmark, who was playing host to all these young folk; next to her, her youngest daughter, Thyra, Princess of Hanover. On the sofa is my father's first cousin, Britain's future King George V with his wife the future Queen Mary and, between them, a princess I cannot identify. Sitting on the ground are, from left to right: Grand Duke Michael of Russia; his sister Olga; two presumably Danish princesses; and the future King Christian X of Denmark. They were all brothers, sisters, brothers- or sisters-in-law, cousins, nephews, or nieces to one another.

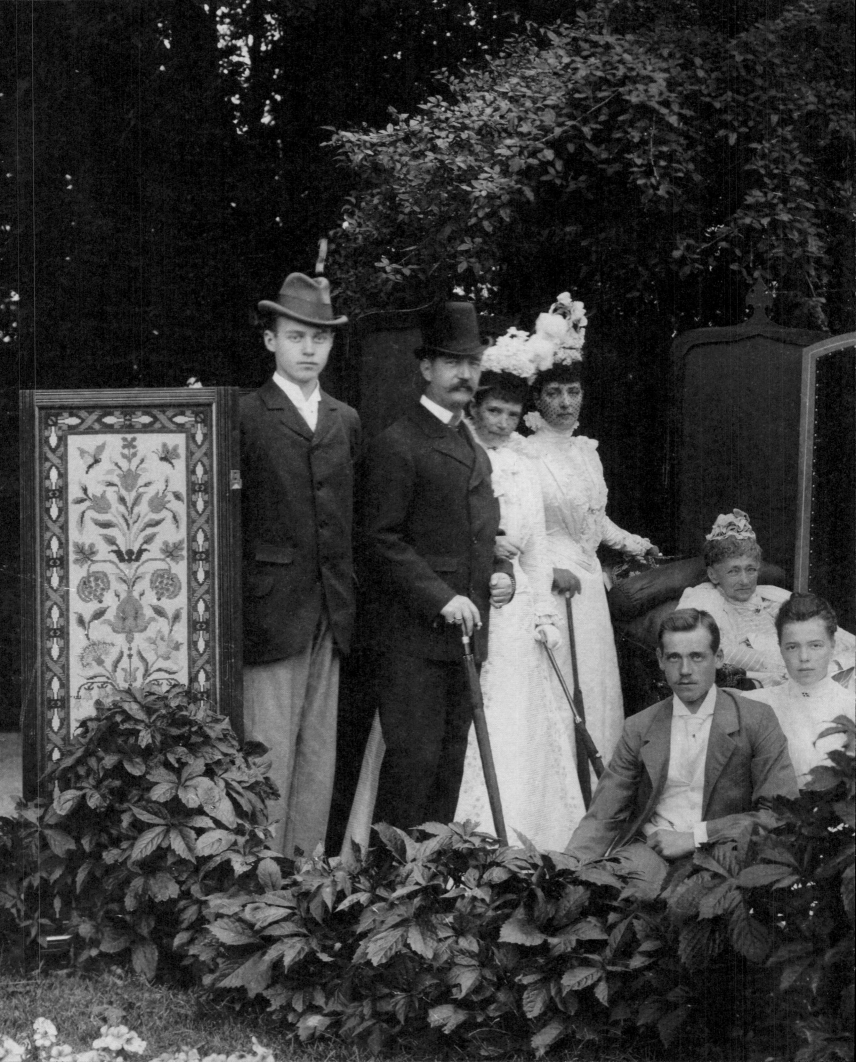

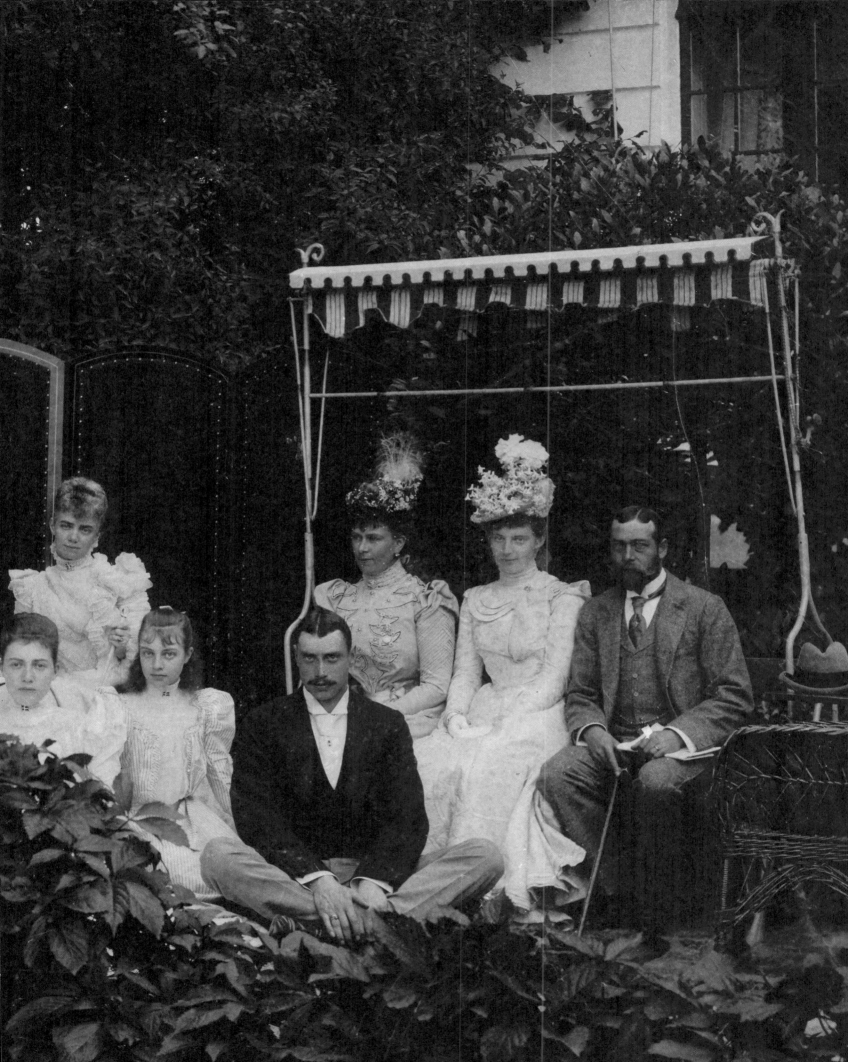

The marriage of my grandmother the Duchess of Guise's sister Louise of France to Prince Carlos of Bourbon-Two Sicilies, infante of Spain. Since the bride's husband, the Duke of Orléans, head of the House of France, was in exile, the ceremony was held in England on his Wood Norton estate. The bride's brother and sister, my grandmother Isabelle and her brother Ferdinand, Duke of Montpensier.

Members of probably the Spanish court, secretly smoking in an alcove.

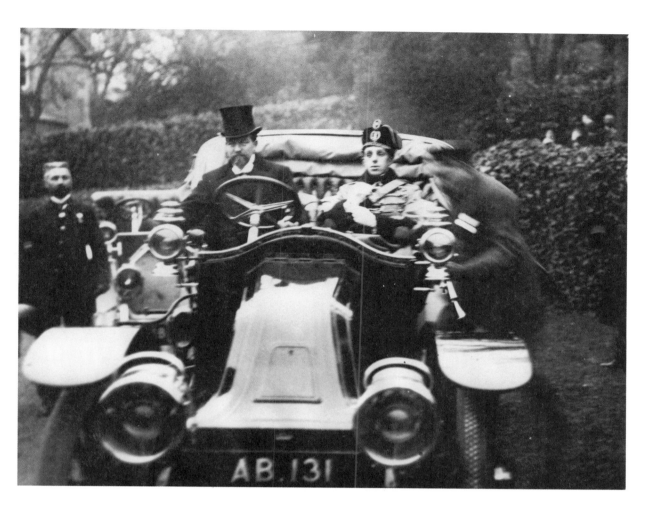

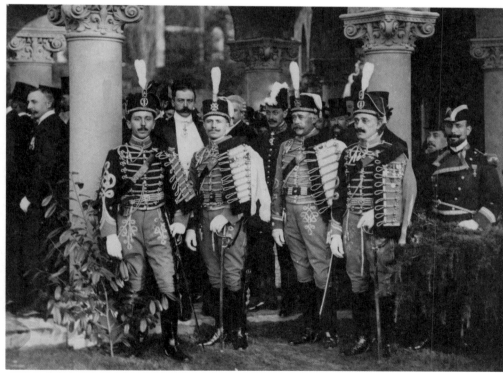

The royal officials and aides-de-camps.

The Duke of Orléans driving his guest of honour, King Alfonso XIII of Spain.

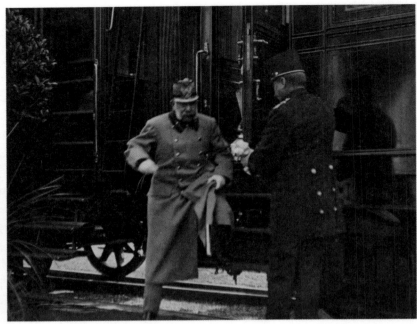

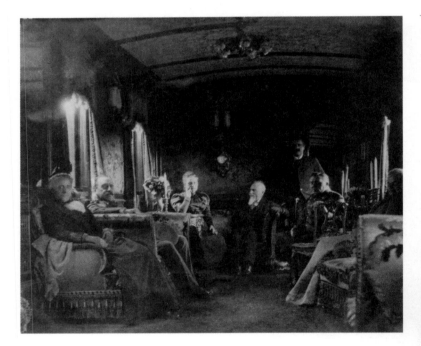

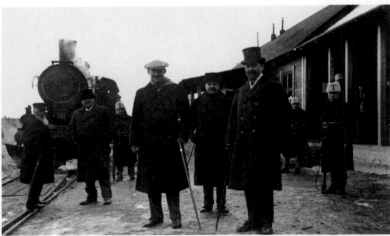

In a setting of imitation railway carriages, another of the Denmark get-togethers. From left to right, I can identify George I, my grandfather; his sister Queen Alexandra; probably their mother, Queen Louise of Denmark; then my grandmother Queen Olga. Standing in sailor suits are my uncle Nicholas of Greece, then some British princes. I think the last sailor, at the window, is my uncle George of Greece.

Queen Olga and her entourage in the Russian imperial train. Every year, my grandmother would leave Greece and borrow the Greek royal yacht *Amfitriti* to go to Odesa, where the Russian imperial train was waiting to carry her gently up to the capital. She spent three months there, staying with her numerous Russian relatives.

Austrian Emperor Franz Josef alighting from his private train, probably arriving for the marriage of his nephew and heir Archduke Charles, the future emperor, to Princess Zita of Bourbon-Parma. Since we are descendants of Marie Antoinette's sister Queen Caroline of Naples, we are related to the House of Austria, although the two families are not particularly close.

My father, Christopher, on the station platform at Kiev (now Kyiv) with the Russian Prime Minister Stolypin, who would be assassinated during a performance at the Kiev Opera House. My father, whom my grandmother thought of as Russian, spoke the language and would accompany her every year in her visits to the imperial family. He was therefore on the closest of terms with the last Tsar and his family until the Revolution.

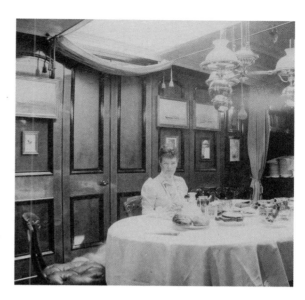

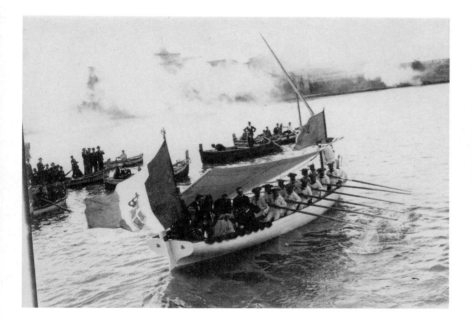

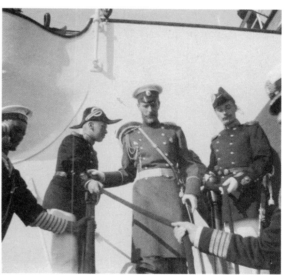

My grandmother Olga with my uncle King Constantine, welcoming the lady dressed all in black, who is none other than Empress Eugenie. She lived to a great age and my father had the chance to get to know her well. She would travel every summer, regularly coming to Greece, and my family just as regularly hosted her (even though my French family obviously detested her, since Napoleon III had stolen the Orléans fortune).

Empress Maria Feodorovna of Russia, my great-aunt, in the dining room of the imperial yacht *Polar Star*. The Russian court was by far the most sumptuous in Europe, having the benefit of the limitless resources of the imperial fortune. It was also a way to prove to Europe the greatness of the Russian Empire.

In a boat and to the sound of gun salutes, my great-aunt Hélène of France, Duchess of Aosta, is shown leaving Palermo, where she had been visiting her elder brother Philippe, Duke of Orléans. The family had inherited a large villa in the outskirts of the old city of Palermo, called the Palazzo d'Orléans, from our ancestor Queen Maria Amalia. My parents would get married there, as would my uncle, the Count of Paris; my grandfather the Duke of Guise was exiled from France, so family weddings could not take place in his country.

Again on board an imperial yacht, but probably the one belonging to Tsar Nicholas II, is his uncle Grand Duke Sergei. He was not a pleasant character. Strict and unlikeable, even within the family. He married the beautiful Elisabeth of Hesse, the Tsarina's sister, and was killed during the Revolution by an anarchist bomb when he was governor-general of Moscow. He wasn't much missed.

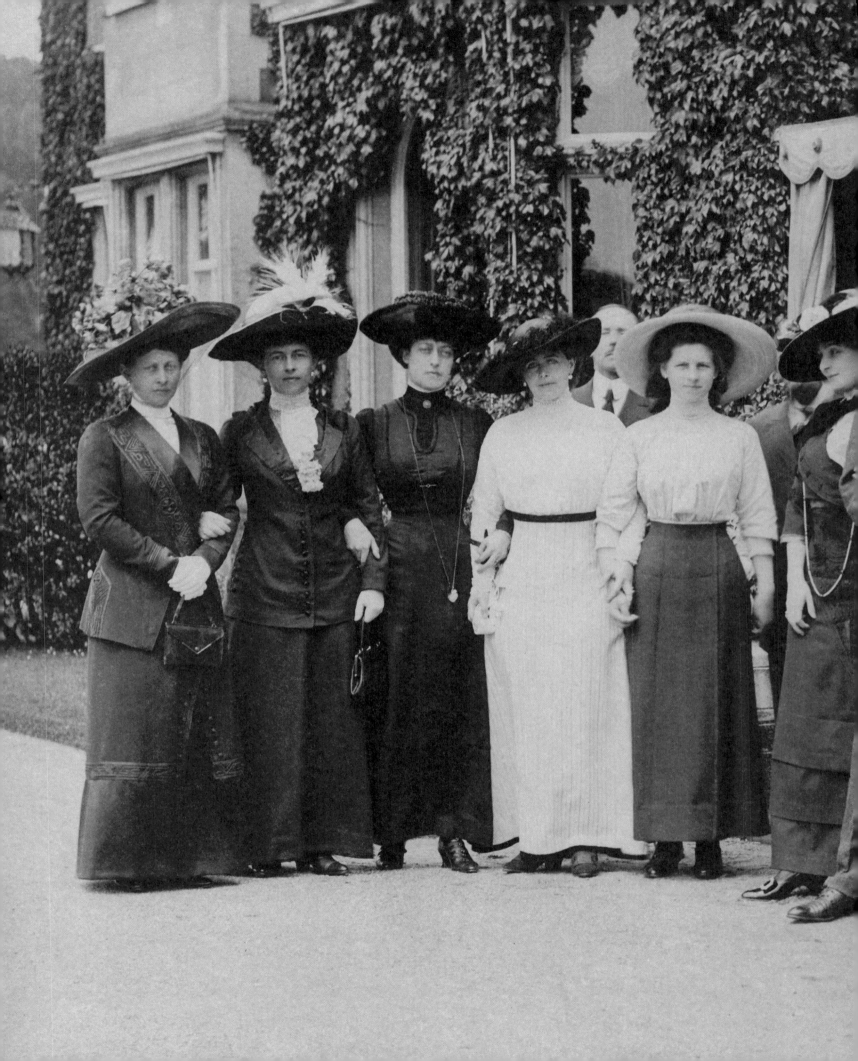

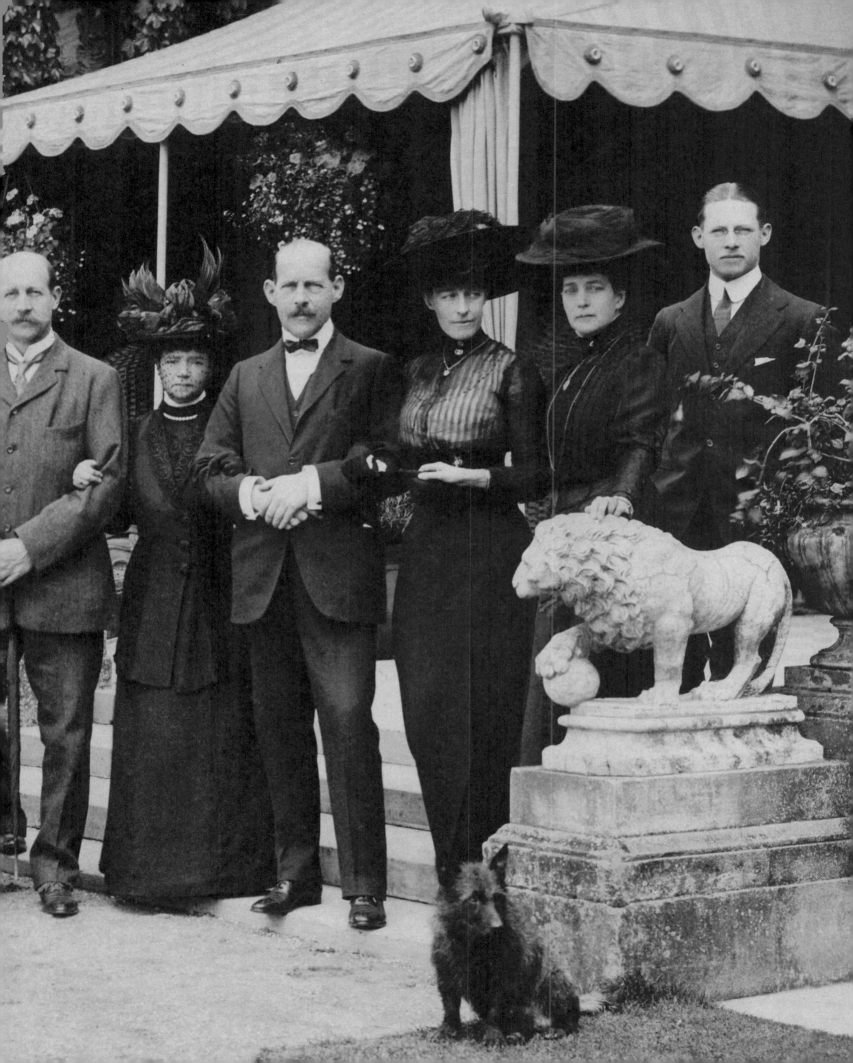

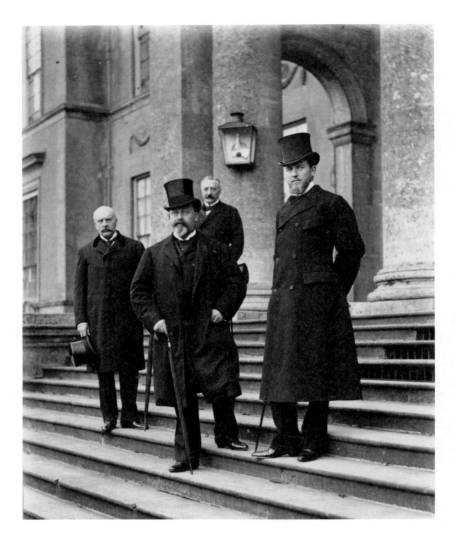

The Prince of Wales, later Edward VII, visiting Philippe, Duke of Orléans, to offer his condolences upon the death of his father, the Count of Paris. The setting is Stowe House, a huge neoclassical pile belonging to the Duke of Buckingham, which the exiled Count of Paris had rented.

Previous pages: A big family reunion, this time not in Denmark but in England, on the Sandringham estate, at the invitation of Queen Alexandra, Edward VII's widow. From left to right: two Prussian princesses, Margaret Landgravine of Hesse and Sophie, Crown Princess of Greece. They were granddaughters of Queen Victoria. Then the British Princess Victoria, unmarried daughter of Queen Alexandra. In white, the British-born Queen of Romania, née Princess Marie, another of Victoria's granddaughters. Then Princess Helen of Greece, future Queen of Romania. Tall and sporting a moustache, my uncle George of Greece, my father's brother, with his wife Marie Bonaparte on his arm. Also moustached is my father's elder brother, Crown Prince Constantine of Greece, and between them is their aunt, Empress Maria Feodorovna of Russia, sister of Queen Alexandra. After Prince Constantine is my great-aunt Hélène d'Orléans, Duchess of Aosta, who was always being invited to the British court, where she was much in favour. Lastly, their host, Queen Alexandra, and next to her, my first cousin Prince George, the future George II of Greece. At that period, all the royal families were interrelated. Now, with morganatic marriages and the influx of non-royals marrying royals, these relationships seem like something out of a novel.

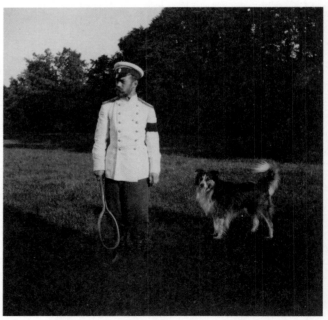

Nicholas II, last tsar of Russia, playing tennis in some imperial palace grounds. It was Queen Olga, my grandmother, who took this photo of her nephew. Like many royals, she always had her Kodak close at hand, and thus left us glimpses of private life in the imperial court.

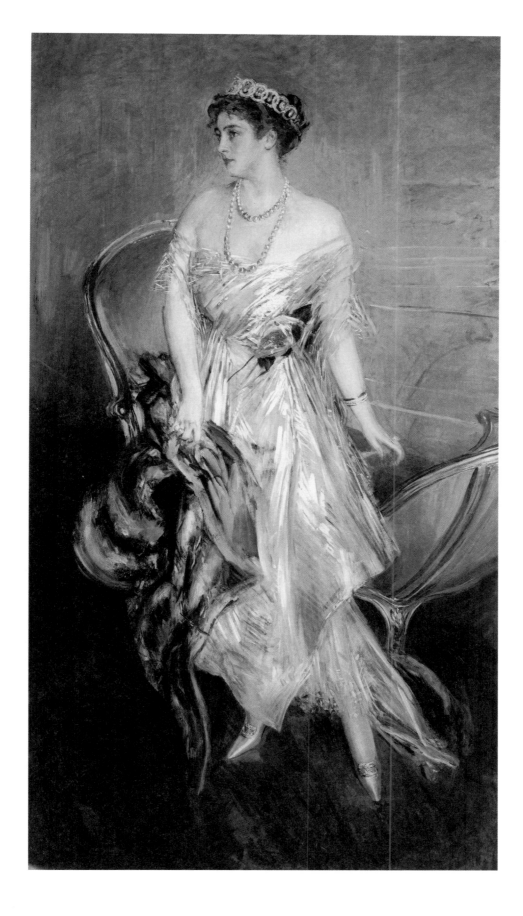

Painted by the famous Italian portraitist Boldoni is Anastasia Stewart—Mrs. Leeds and, afterwards, Princess Christopher of Greece. American-born, she was my father's first wife, and for a long time I believed her to have been of noble stock. The truth is that she was a risk-taker, and we never knew anything about her origins or her true age. She married several very wealthy men and chose a crown for her last one. She would order so much jewellery from Cartier in Paris that she had her own private room there. Her first husbands had made her extremely rich. A few years after her very happy marriage to my father, she died of cancer.

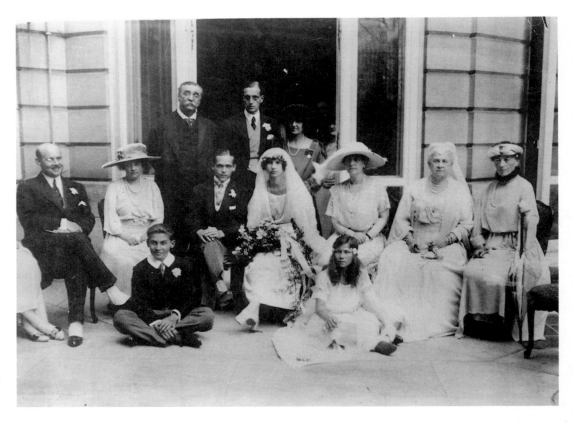

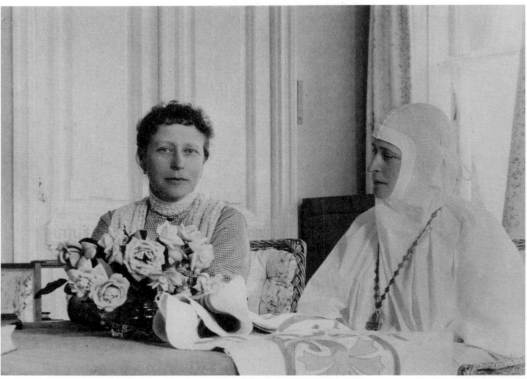

An odd occasion. My father's first marriage was to Anastasia Stewart, Mrs. Leeds. Her previous marriage had produced an extremely wealthy son, William Leeds. He married my father's niece, Xenia of Russia; this is their wedding photo. From left to right: my father, Christopher; his wife at the time, the former Mrs. Leeds; the bride and groom, William Leeds and Xenia of Russia; the mother of the bride, my father's sister Maria of Greece, Grand Duchess of Russia by marriage to Grand Duke George Mikhailovich; then the bride's grandmother Queen Olga, my grandmother; and Grand Duchess Anastasia of Russia, Grand Duchess of Mecklenburg. Behind, Roland Bonaparte, father of Prince George of Greece's wife Marie Bonaparte; then Grand Duke Dmitri, my first cousin. Sitting on the floor are the pageboy and bridesmaid, Peter and Eugenie of Greece, my first cousins—the children of my uncle George and Marie Bonaparte.

Two sisters, two princesses of Hesse-Darmstadt. The nun is the Grand Duchess Elisabeth of Russia, widow of Grand Duke Sergei, who would be assassinated during the Revolution. Her sister is Victoria of Hesse, Princess Louis of Battenberg, grandmother of Prince Philip, Duke of Edinburgh. Princess Victoria would often go to Russia, where her sisters the Empress and Grand Duchess Elisabeth lived. She was there when the First World War broke out. She wanted to flee to England as quickly as possible, via Sweden, and her sister the Empress said to her: "Don't take your jewellery, it'll weigh you down. Leave it here, it'll be safe." She left. The war pursued its course, the Russian Revolution followed on from it, and all her jewels disappeared in the turbulence.

My beloved grandmother Isabelle of France, Duchess of Guise. After my mother's death, when I was 14, my grandmother looked after me a lot. She would always welcome me into her house in Larache in Spanish Morocco. She had a major influence on me and passed her wonderful philosophy of life on to me. She taught me to love life and be completely free, which doesn't mean doing stupid things. Freedom, yes, but coupled with principles and iron discipline.

Two children who would later be married. Here, my father, Christopher, with my grandmother Queen Olga. They are on the deck of the ship that carried them every year to Russia, where Queen Olga would visit her extensive imperial family.

On a beach, my mother, Françoise, with my grandfather Jean d'Orléans, Duke of Guise.

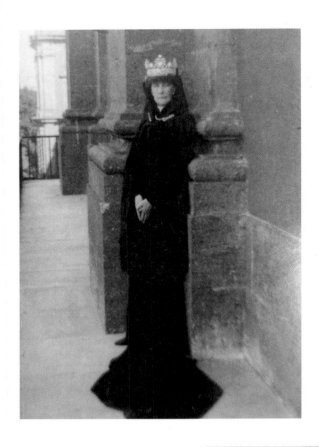

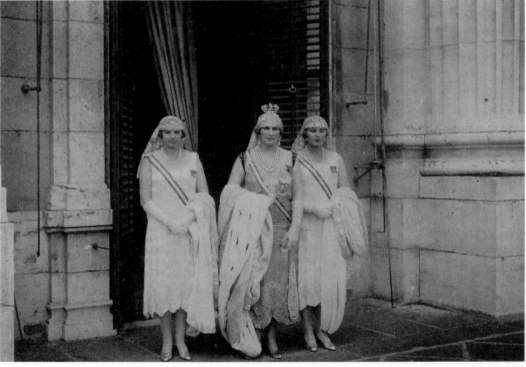

Hélène of France, Duchess of Aosta, in evening dress, wearing the famous Aosta diamond tiara. This photo was taken during the war at the Royal Palace of Capodimonte in Naples, where my great-aunt resided. She is wearing the outfit that she would choose to visit Pope Pius XI in the Vatican. It must be said, Aunt Hélène was deeply fascist. A close friend of Benito Mussolini, she was involved in no small amount of plotting. In any case, she was rather feared by everyone, and the King of Italy had begged her to leave Rome and go to live in Naples, far from the court and government.

The Queen of Spain, Victoria Eugenie of Battenberg, wife of Alfonso XIII, with her two daughters, the Infantas Beatriz and María Cristina, at the Royal Palace in Madrid. The Queen is wearing a small diamond crown, a gift from her husband Alfonso XIII. She wasn't particularly popular in Spain. Her husband cheated on her extensively and then left her during the Revolution that saw off the monarchy, during which she had a very difficult time.

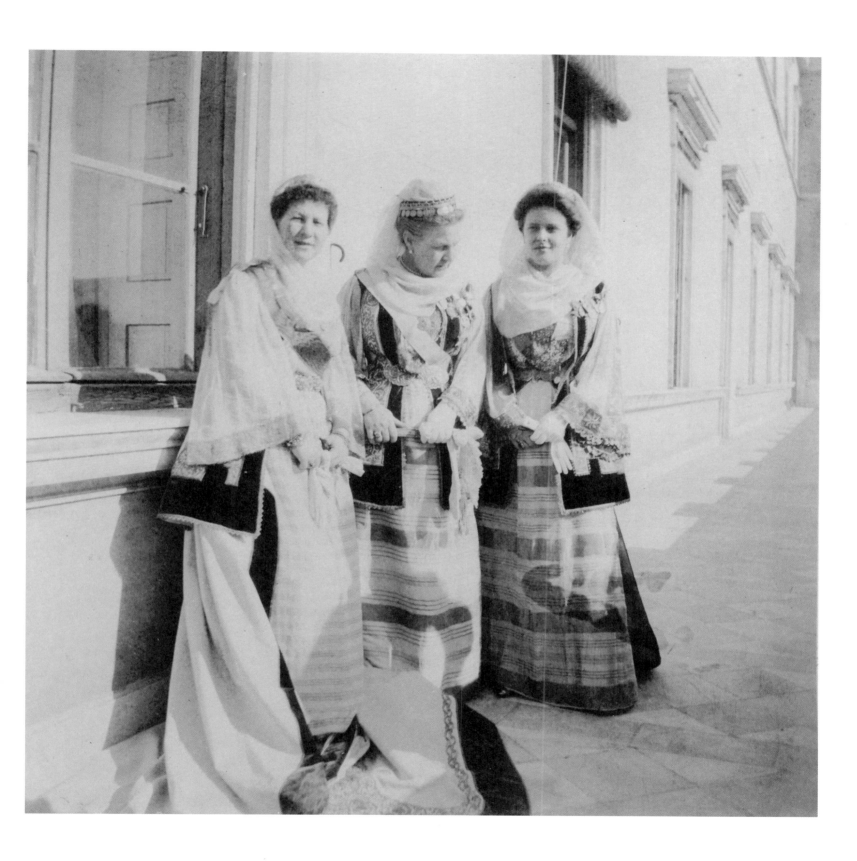

My grandmother Queen Olga, between her daughter Aunt Maria of Greece, Grand Duchess of Russia, and her daughter-in-law, Princess Andrew of Greece, née Alice of Battenberg, who was the future mother of Prince Philip, Duke of Edinburgh. These ladies, photographed on the terrace of the Royal Palace in Athens, are wearing court dress designed by Queen Olga and inspired by traditional Greek costume. Despite these outfits, however, the Greek court couldn't have been more friendly and was quite casual.

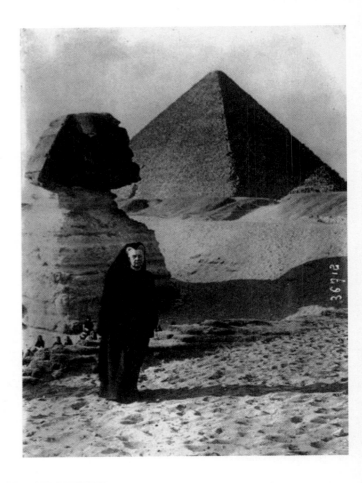

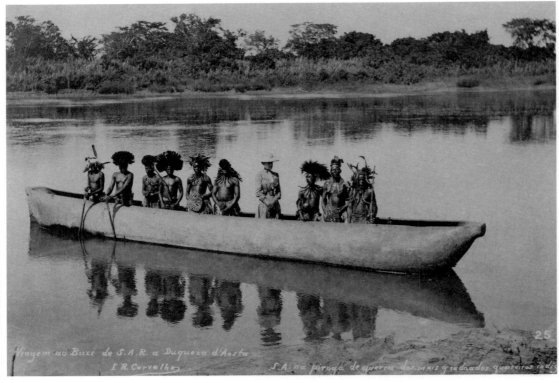

Travels to far-away places. The Duchess of Aosta, during one of her expeditions in sub-Saharan Africa. Aunt Tylene, like many in the Orléans family, was an enthusiastic traveller and even an explorer. She left very interesting diaries and photos from her African expeditions. There were also rumours that during her travels, she had no hesitation in doing a touch of spying for the benefit of Italy, her new homeland.

My grandmother Queen Olga in front of the Great Pyramid and the Sphinx in Egypt. I know nothing about this trip, but the photo of this *grande dame* in her widow's veil in front of the Sphinx is not without charm.

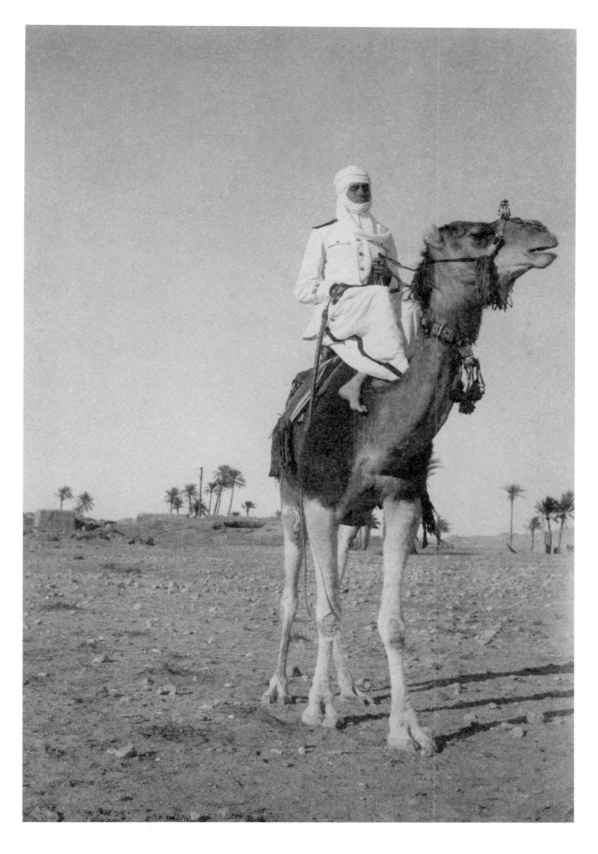

Aunt Hélène's eldest son, Amedeo of Savoy, future Duke of Aosta, during his military service in Libya when it became an Italian colony. Uncly Bouby, as the family called him, would become by far the most popular person in the Italian royal family. Being very likeable, sporty, extremely cheerful, open-minded, natural, and full of charm, everyone fell for him. The public adored him.

Overleaf: Naples. The wedding of the Duke of Puglia and future Duke of Aosta, Amedeo of Savoy, and my mother's sister, his first cousin, Anne of France. The bride's and groom's parents—my grandmother the Duchess of Guise, the bride's mother, and Emanuele Filiberto, Duke of Aosta, the groom's father—in a horse-drawn carriage going under the entrance archway of the Royal Palace in Naples where the reception was to take place. The Duke of Aosta and my grandmother were thus brother- and sister-in-law. They had great respect and fondness for one another and wrote to each other often. Duke Emanuele Filiberto had been the great victor of the Italian Army during the First World War. He was a collector and bibliophile, and a very independent man with a huge personality. His marriage to Hélène of France was more than a little open.

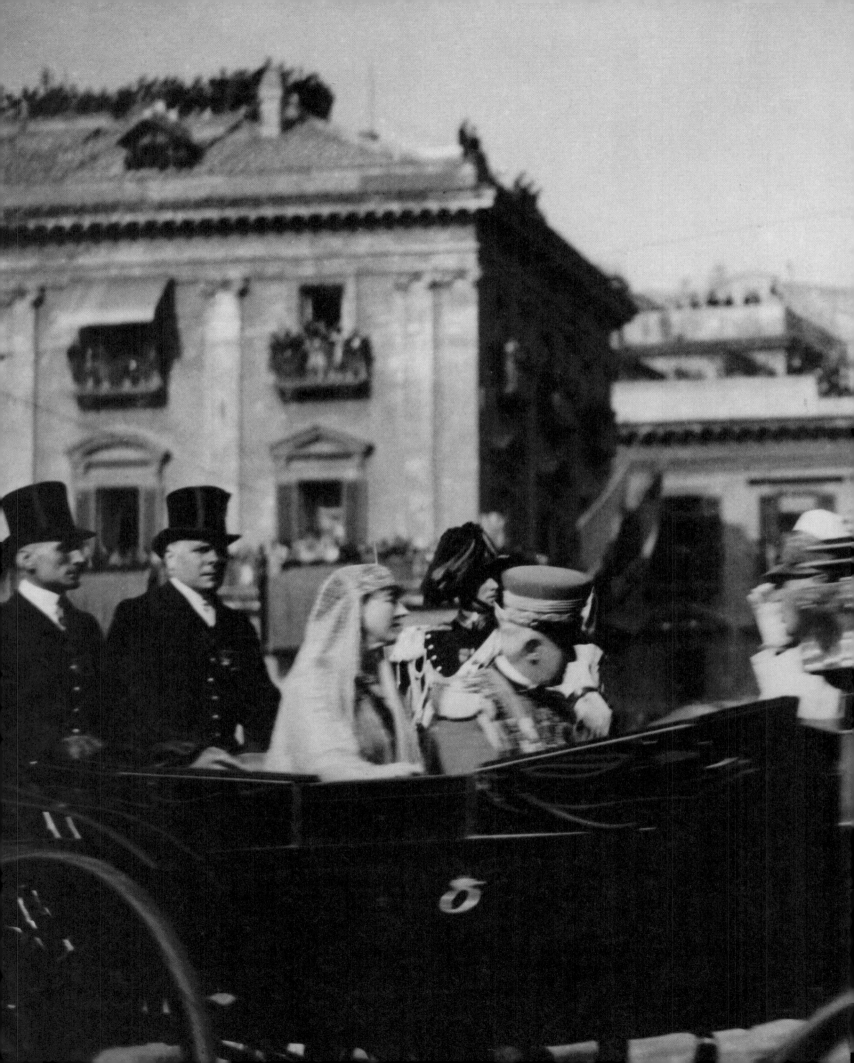

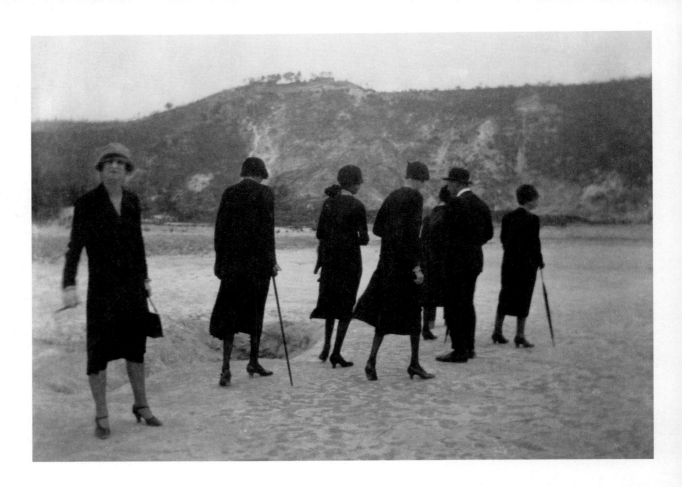

Princesses of Orléans, of the House of France, on a beach. I'm certain that two of the princesses are my mother, Françoise, and her sister Anne. I find this photo amusing because it displays the House of Orléans' famous chicken legs, which I have unfortunately inherited. But also, albeit blurred, it reveals the matchless elegance of the women on my mother's side of the family.

The Count of Paris, my uncle, with members of my Greek family. On the left, Prince George of Greece, my father's brother. Opposite, my two first cousins, two Kings of Greece, George II and Paul I. My parents' marriage had brought the two families together: France and Greece.

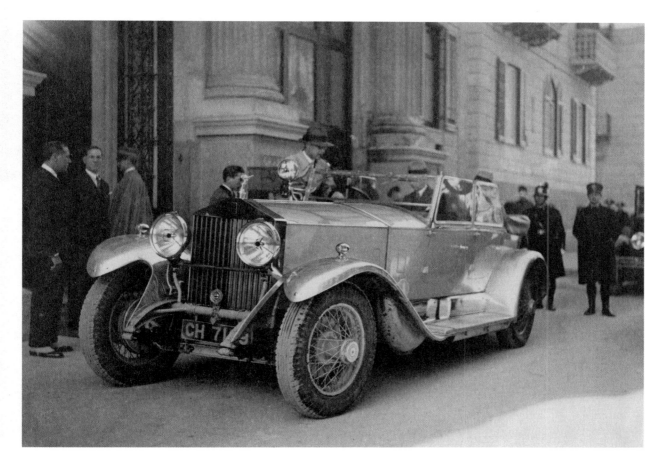

My father, Christopher, Prince of Greece and Denmark. Always elegant and admirably dressed, he loved classic cars, like this sumptuous Rolls-Royce in which he would set off on honeymoon after his marriage to my mother.

Overleaf: The wedding in Palermo of the Count of Paris, Henri, my uncle, and Princess Isabelle of Orléans-Braganza. It was a huge ceremony and moreover a gathering of royalists who came by boat, with the directors of Action Française, Charles Maurras and Léon Daudet, at the front. In the photo are the Count of Paris and his mother, my grandmother the Duchess of Guise, very proud and very happy. Behind my grandfather, the Duke of Guise with his sister-in-law Queen Amélie of Portugal. Behind them, Infante Carlos of Spain with the mother of the Countess of Paris, Princess Pedro of Orléans-Braganza. Then, in the left corner, my grandmother's sister, Infanta Louise.

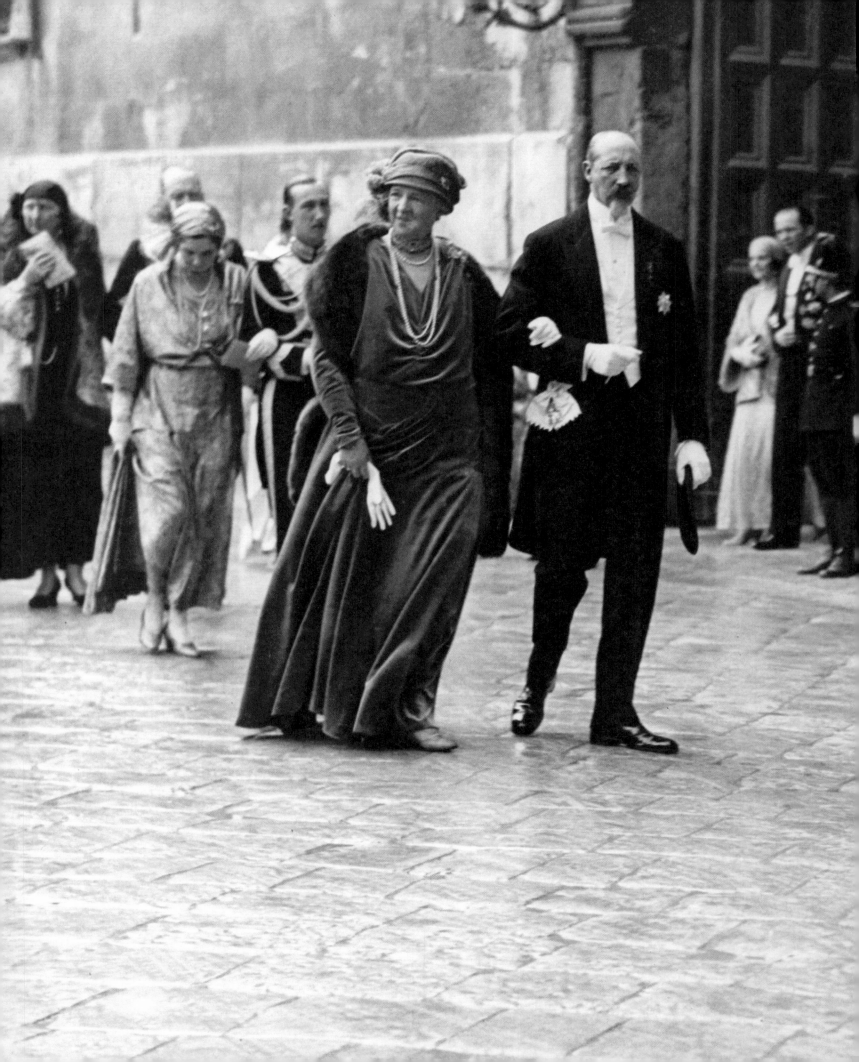

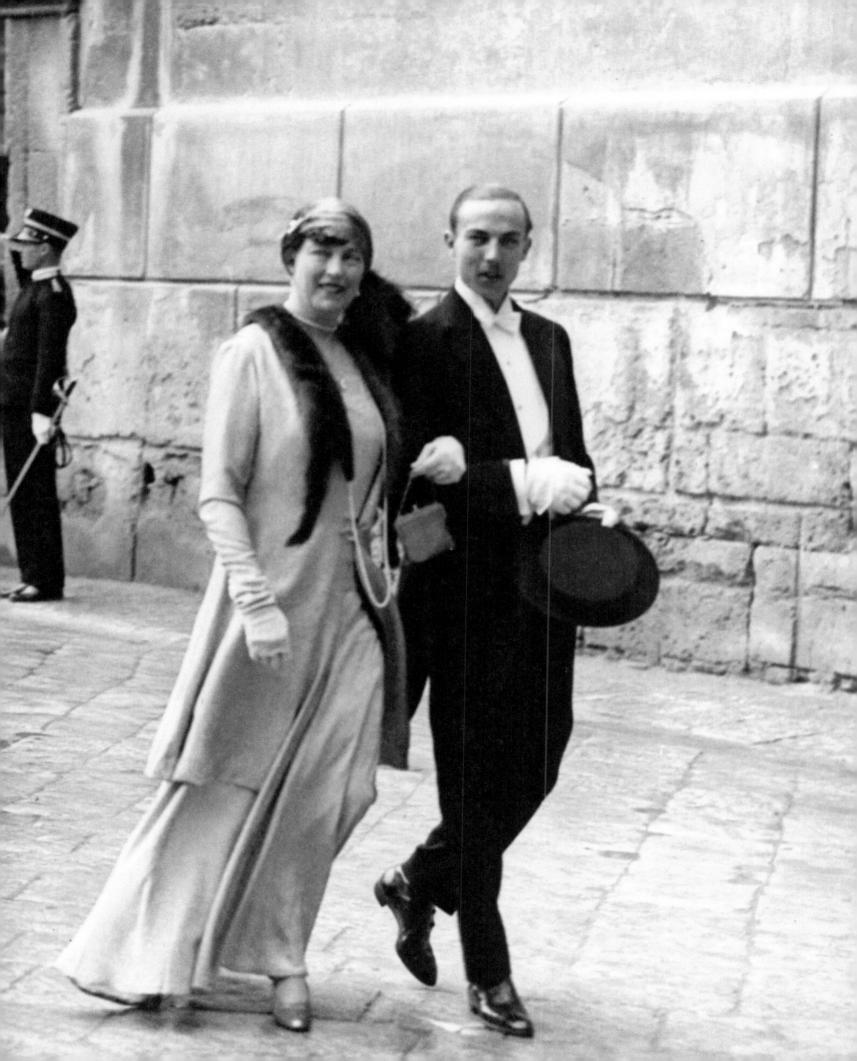

My grandmother Isabelle of France, Duchess of Guise. A picture of beauty and elegance. She had an extraordinary, strong personality. She charmed everyone and made an unforgettable impression on me.

Françoise of France, princess Christophe of Greece, my mother, in great court dress. She wears a turquoise and diamond set copied from the Fabergé set. She was beautiful, intelligent, charitable, generous, very romantic, and gentle, but she had an iron character. She was extremely secretive, a quality I think I inherited from her as we are both capricorns. She was born on Christmas Day, a symbol that suits her so well.

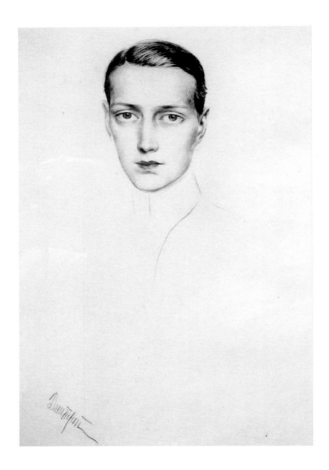

The Grand Duke of Russia Dimitri Pavlovich, my first cousin as son of Alexandra of Greece, my father's sister. My mother said that he was one of the two most beautiful men she had ever known in her life. Orphaned at a very young age, he was not happy in the family. A very independent character, he was one of the three assassins of Rasputin. Then in exile, he led a rather agitated life. He married an American woman, also an incomparable beauty. They had a son, Paul Romanov, who for thirty years was the mayor of Palm Beach. In the meantime, he had an affair with Coco Chanel.

Amedeo of Savoy, Duke of Aosta, first cousin and brother-in-law of my mother, in front of the castle of Miramare, which he occupied near Trieste. He was a great sportsman, proficient at swimming and riding a horse, and was the great seducer of the family.

My mother on a beach in Italy. Like her sisters, she was athletic and rode a horse beautifully. She swam, she walked, and that's how she always kept her youthful figure.

King George II of Greece, at that time in exile and staying with his sister Helen the Queen of Romania, with two of his nephews: Helen's son Michael, the future King of Romania; and Philipp of Greece, the future Duke of Edinburgh.

My parents, Françoise and Christophe, during a cruise.

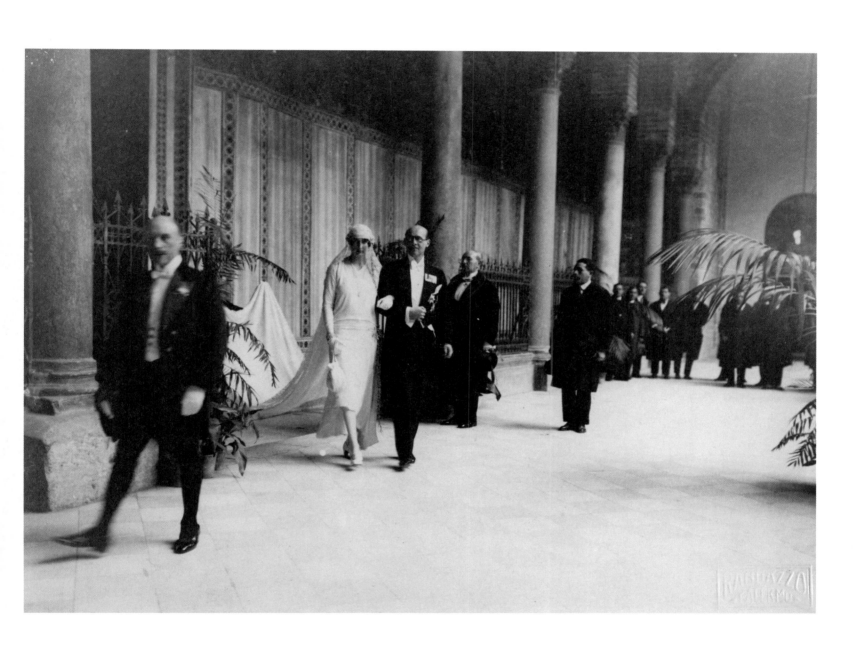

The wedding of my parents in Palermo, February 11, 1929. They are leaving the Capella Palatina in the old palace.

My grandmother the Duchess of Guise in Cairo with Sultana Melek, widow of Sultan Hussein of Egypt. She was a welcoming *grande dame* and became a friend of my mother and grandmother. My grandmother had rushed to Cairo because Aunt Anne, my mother's sister, had fallen ill there, and so seriously so that the newspapers had announced her death. She always kept the cuttings announcing her death, thinking they would bring her good luck.

Children of the House of France, the son and daughter of the Duke and Duchess of Guise—that is, my mother and her brother and sisters. From left to right, Anne, Duchess of Aosta; my mother, Princess of Greece; Isabelle, Countess of Harcourt then Princess Murat; and Henri, Count of Paris. They all got along well and shared a deep bond. This photo was taken at the Manoir d'Anjou, on the outskirts of Brussels, my grandfather the Duke of Guise's vast residence during his exile from France.

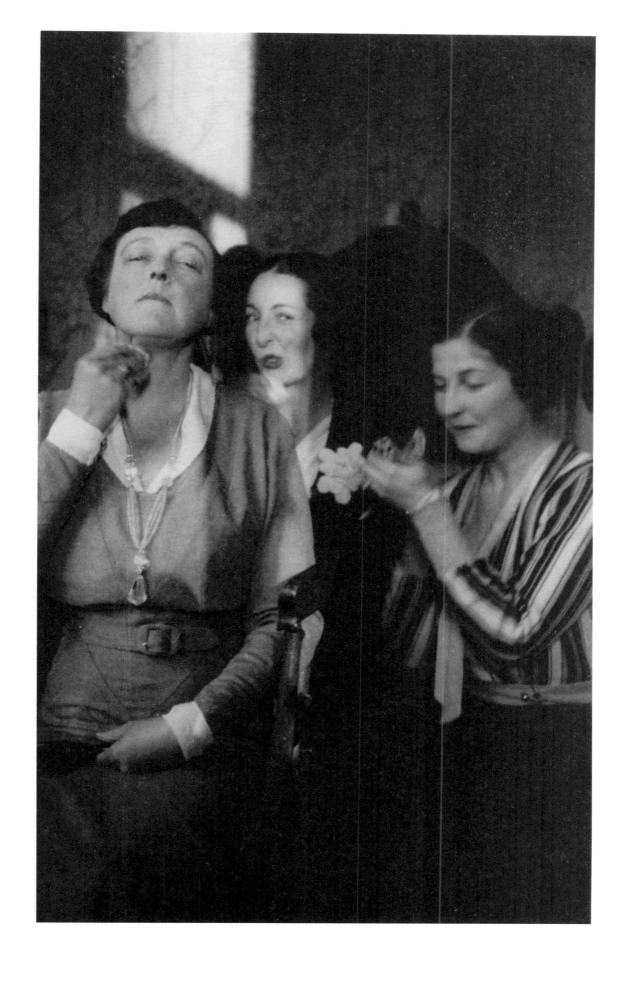

A private scene of ladies re-applying their makeup. My grandmother the Duchess of Guise, my mother, Françoise, and their daughter-in-law and sister-in-law the Countess of Paris, Isabelle of Orléans-Braganza—Aunt Bebelle.

Personal family photos. Amedeo, Duke of Aosta, with his first cousin, my aunt, Anne of France, on the terrace of Miramare Castle, their residence near Trieste.

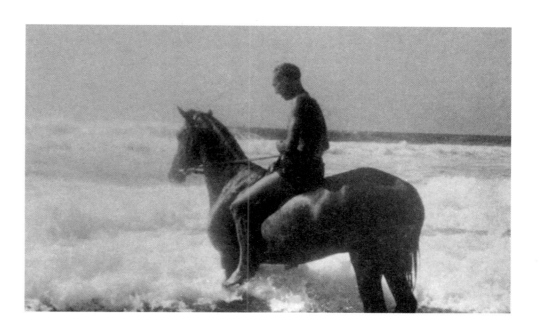

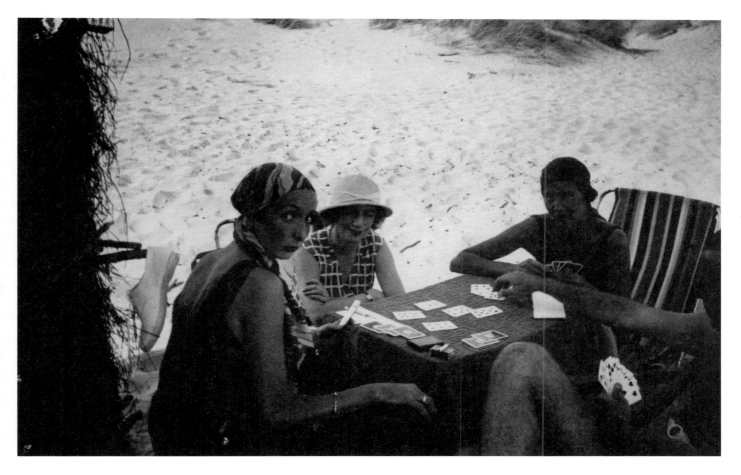

My uncle Henri, Count of Paris, going into the sea on horseback. This photo was taken in Larache, in Spanish Morocco, where we all took refuge during the Second World War.

My mother playing cards with her friends, including Marquise Malaspina opposite her, on the beach at Castel Porziano, an enormous estate that belonged to the Italian royal family, who lent it to them.

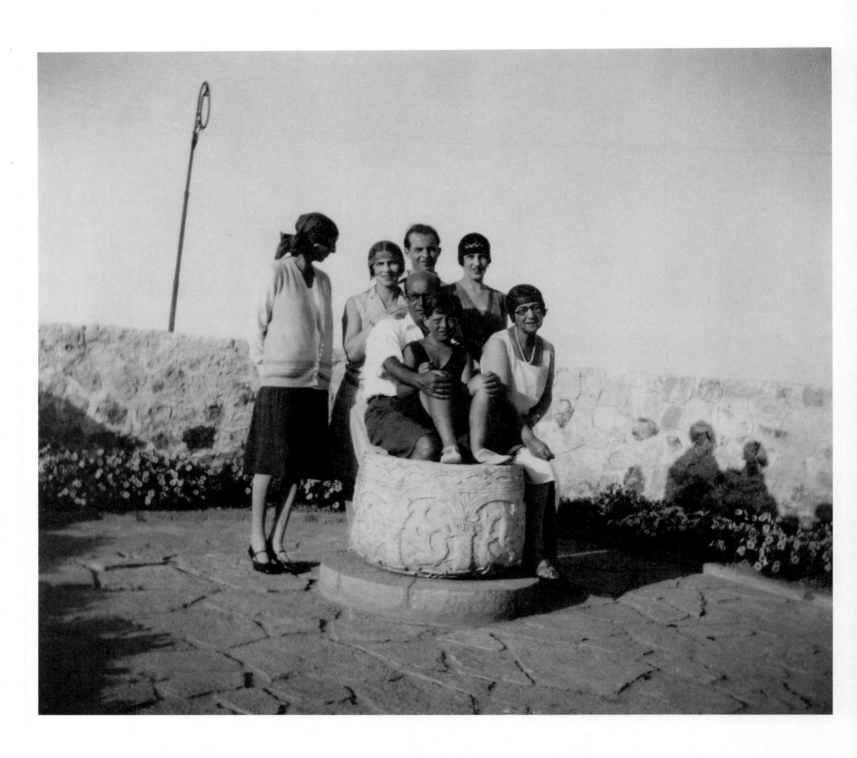

A get-together in Romania of the Greek royal family. From left to right: my mother; Helen of Greece, Queen of Romania, who hosted these gatherings; her nephew Paul, future King of Greece; and his sister Irene of Greece, future Duchess of Aosta. In the foreground are my father, Christopher, with his nephew Michael, the future King of Romania, on his lap, and his sister Maria of Greece, widow of Grand Duke George of Russia.

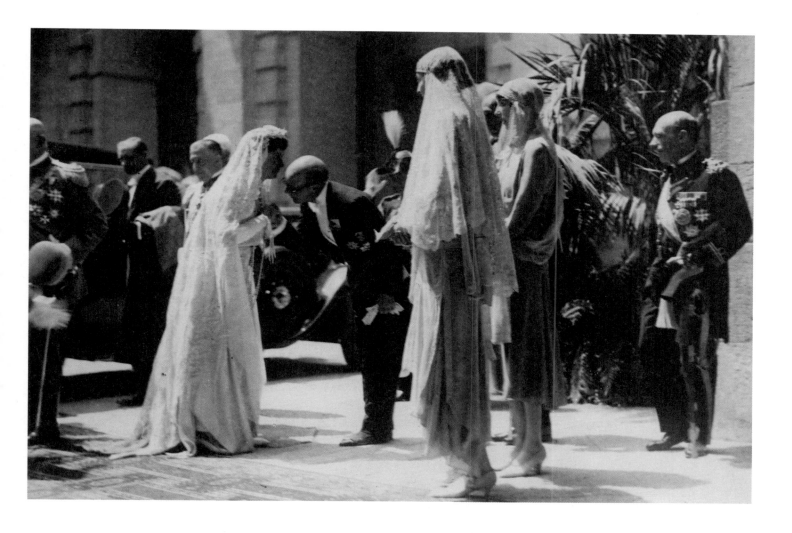

The baptism of Princess Margherita of Savoy, my first cousin, in the palace of Capodimonte. From left to right: Helen, Queen of Italy, being greeted by my father; then the two sisters, Anne of France, who was Princess Margherita's mother, and my mother. At the back, the Duke of Bergamo, a young prince of the House of Savoy.

My parents attending Sunday mass at the Church of St Louis of the French in Rome. My mother had remained Catholic, and my father, who was Orthodox, had no hesitation in following her into Catholicism. My mother had a profound and generous religious devotion, focused on charity and self-sacrifice.

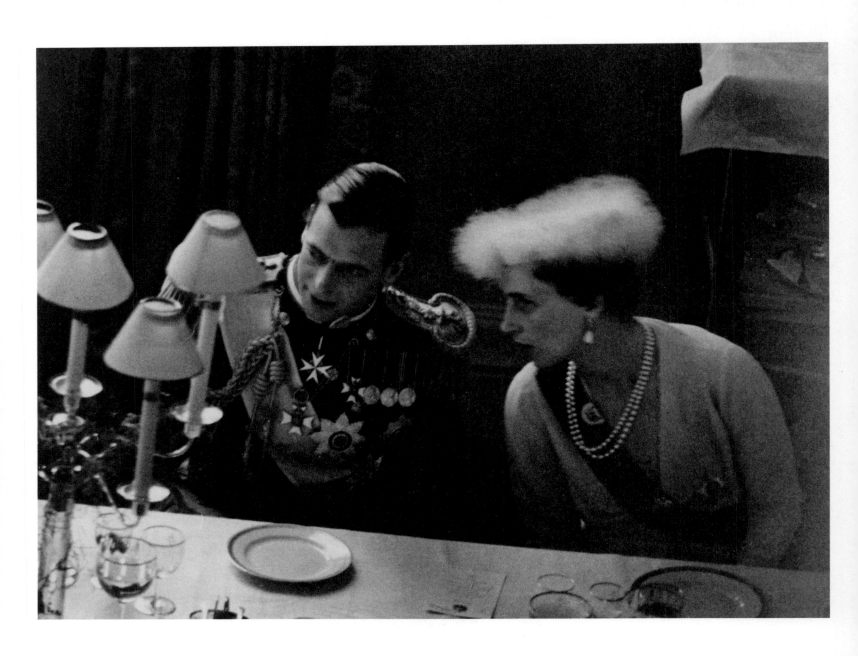

The wedding, at the Royal Palace in Athens, of Crown Prince Paul of Greece to Princess Frederica of Hanover, later King and Queen of Greece. It was in 1938, shortly before the war, and was one of the last great gatherings of European royalty. The two photos were taken at the lunch in the Royal Palace, which followed the religious ceremony. The Duke of Kent, who was married to Marina of Greece, with his sister-in-law Olga of Greece, wife of the Prince Regent Paul of Yugoslavia.

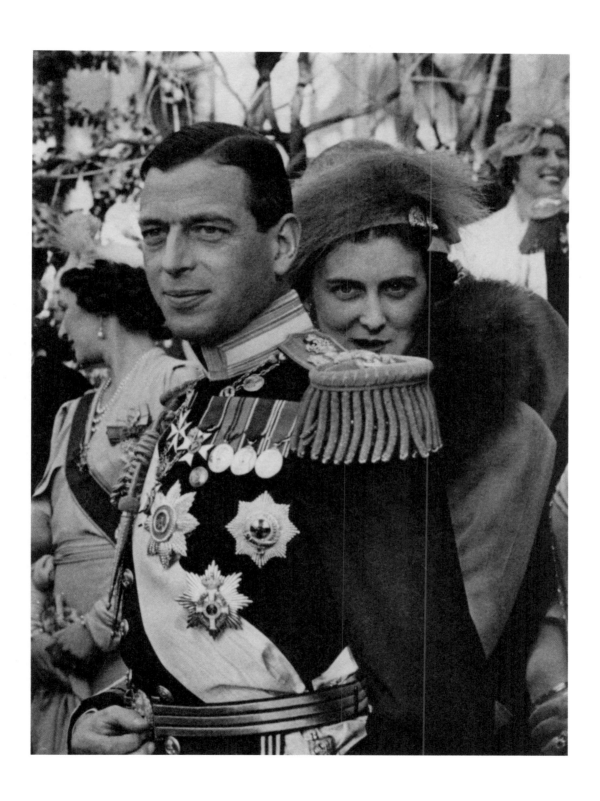

The Duke and Duchess of Kent: the British Prince Edward, Eddy, with Marina of Greece. Both of them were good-looking and elegant, and they formed by far the most glamorous couple of the British royal family. These two photos are by the famous Greek photographer and artist Nelly.

Overleaf: Family photos at the Acropolis in Athens just before the war. My parents—my father, and my mother with a flower in her buttonhole—with their nieces, King Constantine's three daughters: Irene, Duchess of Aosta; Helen, Queen of Romania; and Aunt Catherine, their youngest sister. This photo is rather exceptional because I can't imagine all these princes and princesses of Greece visiting the Acropolis, which they'd known ever since they were born; perhaps it was to show it to my mother, who was the last to have joined the family.

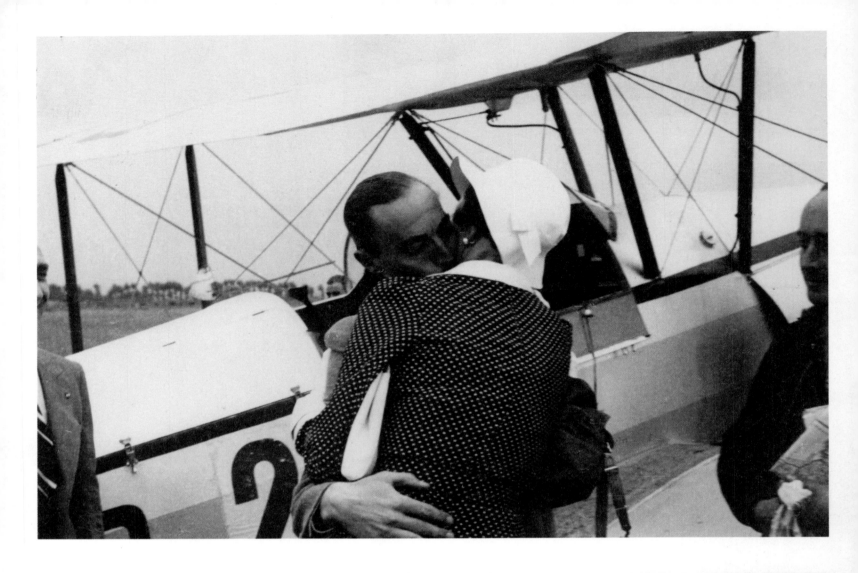

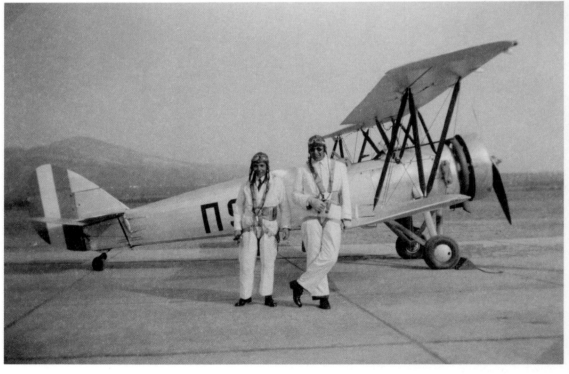

Royal sport. In front of his plane, my uncle the Count of Paris kissing his sister, my mother, Françoise. I think she was his favourite sister.

In front of his plane, Crown Prince Paul of Greece, the future king.

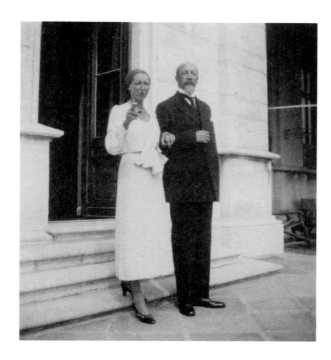

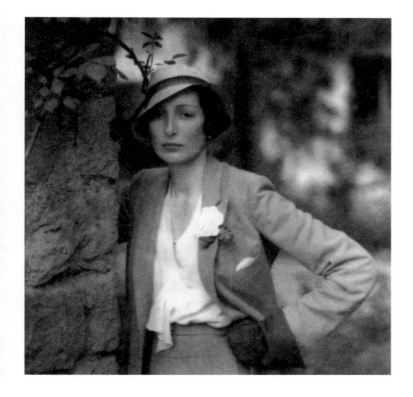

My parents with members of their family. My mother with her father, the Duke of Guise. They got on very well indeed: both of them were very reserved, with very rich and rather private personalities, but infinitely good.

A wonderful photo of my mother, Françoise, in Rome by the famous photographer George Hoyningen-Huene. All her elegance, grace, and nobility come across in this portrait.

My father with his two nieces: Helen of Greece, Queen of Romania; and Irene of Greece, Duchess of Aosta. Both of them adored my father, finding him kind, funny, open-minded, tolerant and generous. He made them laugh and at the same time he was always there to listen, to comfort and encourage them.

CHAPTER TWO
MY BEGINNINGS 1940–1965

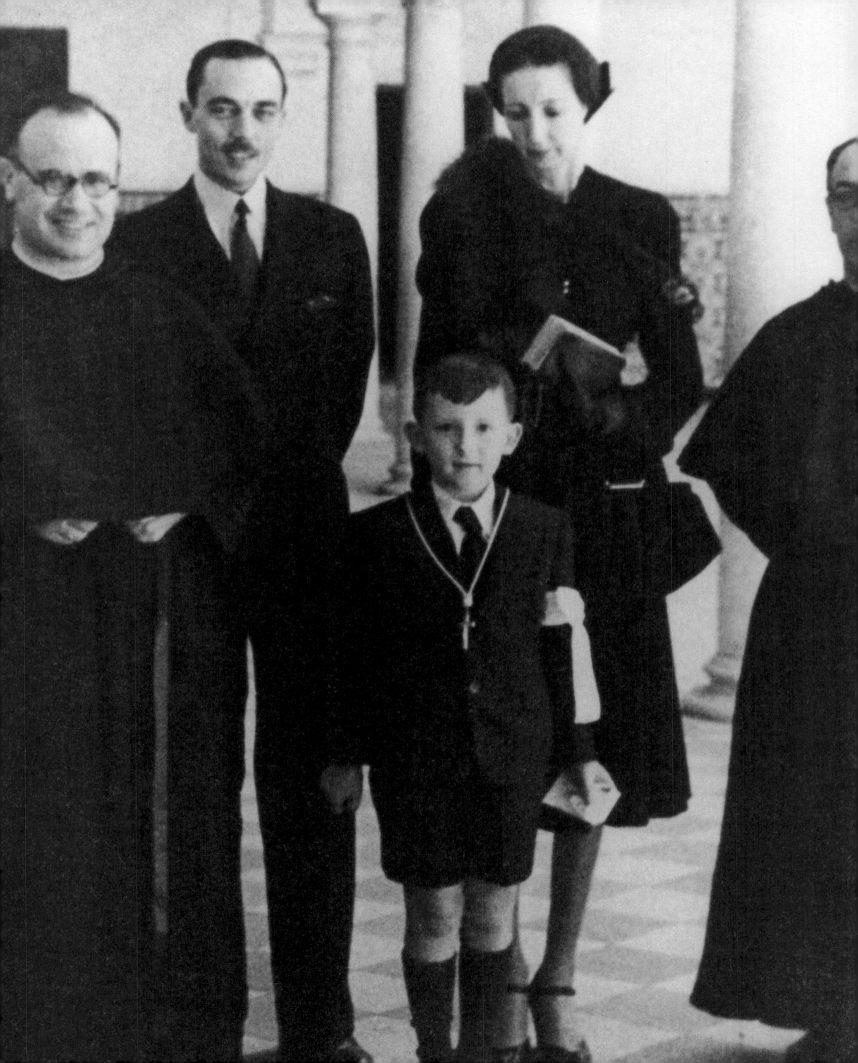

I was born on January 7, 1939, in Rome, where my parents lived. A year later, my father passed away in Athens. Several months later, King George II of Greece warned my mother that the Italians would attack Greece and that she should leave Italy. We went to Spanish Morocco, where my maternal grandmother had a home. At the end of the Second World War, my grandmother announced to us that because of the war she didn't have any money and that she could no longer feed us. Thus, everyone left. My mother and I moved into a hotel in Málaga—God only knows why she chose that town. My first school was a Spanish one. Then, with the war having abated, my mother decided to return to France, her home country. We landed in Paris in 1948 and I was enrolled in a French school. Several years later, my mother passed away. I was fourteen years old.

My uncle, the Count of Paris, became my guardian, and I went to live with him and his family—with eleven children—in Louveciennes. From being an only child I suddenly became one of a large family. It took me several months to settle in, and then I started having a lot of fun. Thanks to my uncle and aunt, I especially began meeting many personalities and royals we were related to. At that time I was finishing school, and passed my exams with high honors. I enrolled at Sciences Po, and graduated in 1960. The day following my graduation, I went to Greece, my home country, which had been the plan for a long time. I soon started my military service. I thus went from a French university to Greek barracks without any period of transition. However, this lengthy time in the military—four years—not only allowed me to discover the army, but also the Greek people. Through meeting boys from all over the country and from all social classes, I learned more about my fellow citizens than any lessons could have taught me. At the same time, with my paternal family having welcomed me with open arms, I arrived into a living monarchy. I became acquainted with life at court, official ceremonies, and especially huge family reunions, because King Paul and Queen Frederika were incredibly generous and hosted all of royal Europe. Weddings, birthdays, burials, official visits—I had the opportunity to meet nearly all the world's royal families.

Málaga, 1949. My uncle, the Count of Paris, came to be with my mother and me for my confirmation. With us are the Father Superior of the Augustinians and, on the right, my teacher Padre Silverio. Like a good Spaniard, instead of teaching me grammar which I was resistant to learning, Padre Silverio would tell me about the horrors of the Civil War that had taken place in Málaga and which he had witnessed. Thanks to which I would tremble with fear when I crossed the school courtyard afterwards, at a time of day when it was deserted.

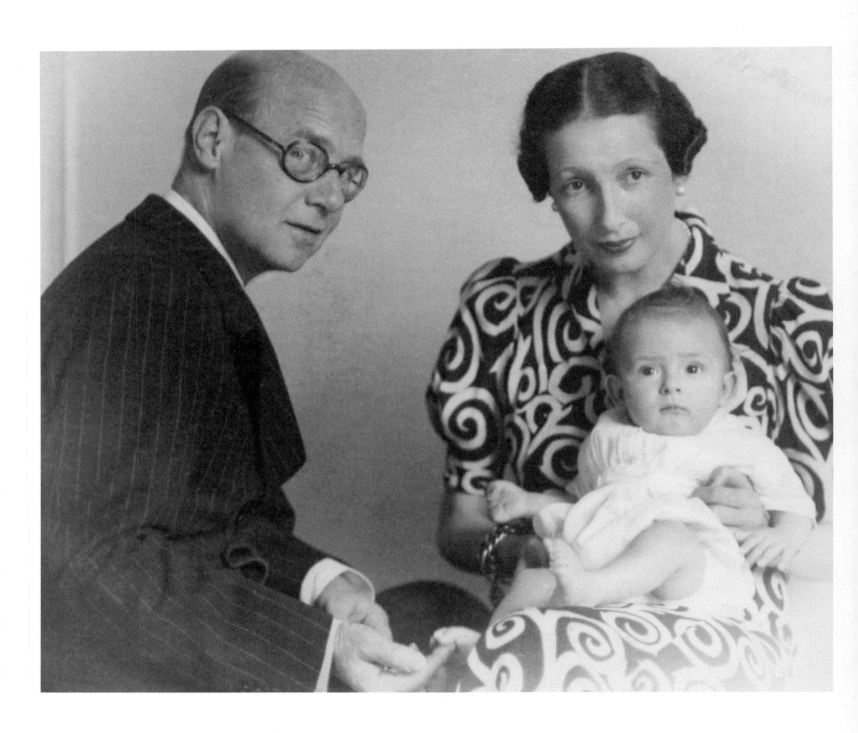

My parents and myself, just a few months old, in Rome, where I was born. On my birth, Mussolini sent a telegram of congratulations to my parents, which my mother, who was antifascist and liberal, instantly tore up—very frustratingly for me, as I'd have liked to have kept it if only for posterity.

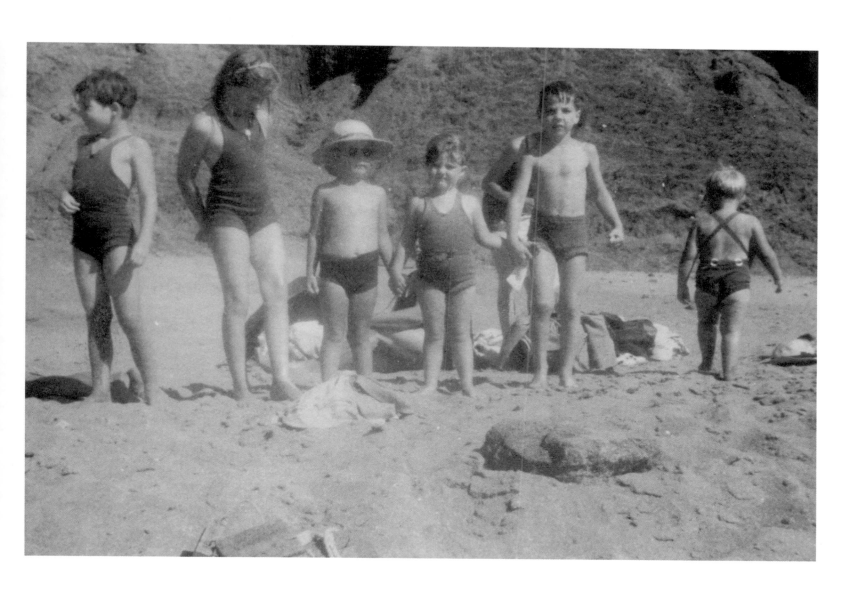

Larache in Spanish Morocco during the war. The whole family had taken refuge in my grandmother's extensive residence. We'd go to the beach. The one in the colonial hat is me, and I'm with my first cousins, the princesses and prince of France: Hélène, Isabelle, Anne, François and, facing away from the camera, Diane. Being the same age as Anne and Diane, I was basically brought up with them.

My father's sister, the very intelligent and charming Aunt Miny, widow of Grand Duke George of Russia, who was to be assassinated by revolutionaries. She is posing in front of her car just before the war. My father and the whole family were extremely fond of her.

Larache, in Spanish Morocco, during the Second World War. My mother and myself on Tortolio, her favourite horse. My mother was an excellent horsewoman and tried to pass her passion for riding on to me. Without success. But I didn't dislike being taken riding by her.

In Málaga. My mother had taken me to a fair and had us photographed in this fictive scene with my governess, Marcelle. I hated posing in that thing.

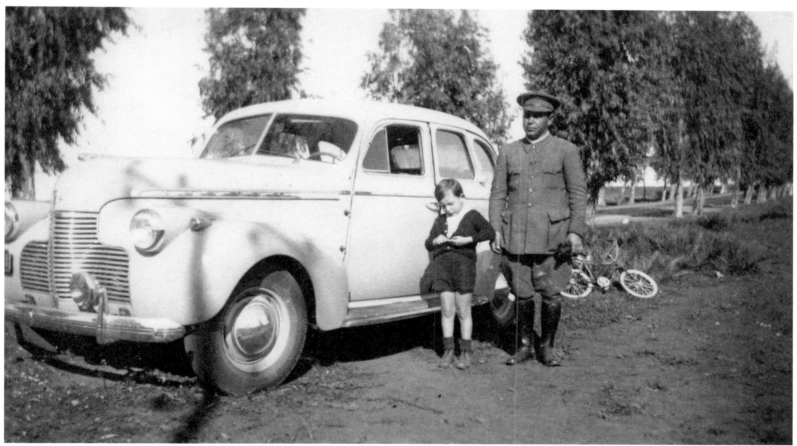

Me with Mathias, my grandmother's trusty chauffeur. We would go out on long drives through the Moroccan countryside, which I found I absolutely loved. Much later, when I was in my teens, I would come back to Morocco and continue these exhilarating drives with my grandmother, this time with myself at the wheel, going through the desert, delighted to plunge into those magnificent natural settings.

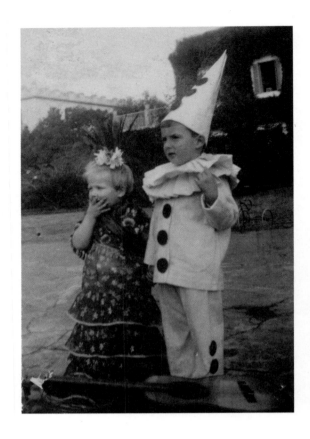

Me and my cousin Diane of France in dressing-up garb. During that sad period, our parents would try to distract us. They were the ones who also gave us lessons, replacing our absent teachers. My mother taught drawing and gave excellent marks to everyone. I think my grandmother was stricter. She taught history and didn't always give good marks.

Málaga, Andalusia, 1944–8. We left Morocco one day and crossed the Strait of Gibraltar in a ferry. I was very sick on the crossing. Then we took a bus from Algesiras to Málaga. There, I was thrilled to discover "houses on wheels": trams, which I'd never seen before. And so we lived for four years in the Hotel Miramar, by the sea. I was enrolled at the Augustinian school, which was the first school I attended.

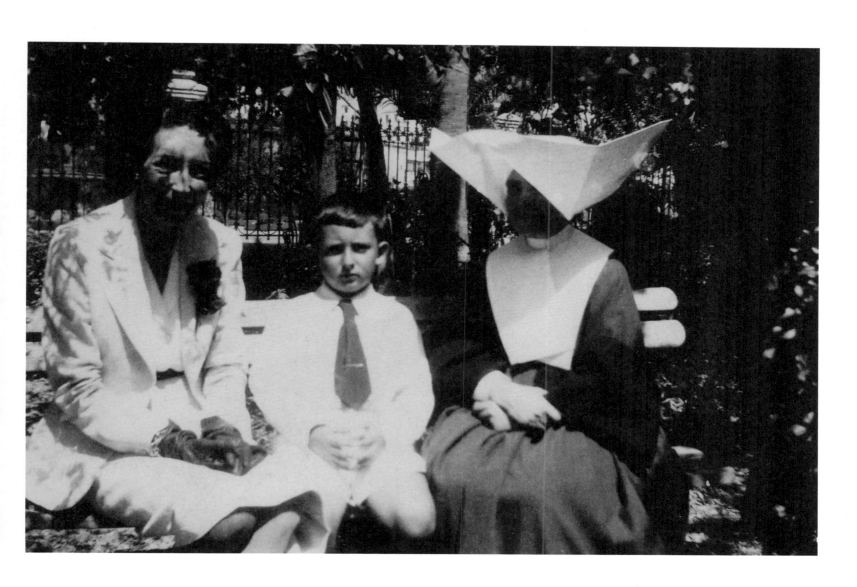

My mother and me with the "Little Mother"—that is, the Mother Superior of the Sisters of St. Vincent de Paul at the Hospital Noble. My mother grew very fond of this eminent nun, who was tolerant, open-minded, charitable, and intelligent, and she often visited her. While they talked, the other nuns would take me to their recreation room, put some Spanish dances on the old gramophone, and teach me Malagueñas and Sevillanas, swirling their skirts, with their rosaries and cornets swinging freely, and punctuating the music with resounding shouts of "Olé."

The result of my dancing lessons from the nuns was that I performed in a charity festival in Málaga. Though I say so myself, it was a great success.

A truly extraordinary photo. Lee Miller was a stunningly beautiful woman and above all an excellent and very daring photographer. Man Ray's lover for many years, during the Second World War she became the first female photographer on the front line. She thus left unforgettable images of the conflict. I don't know how she managed to go into Romania at the time when the Nazis had left the country and the Soviets were replacing them. For a while, they kept the monarchy. That was how Lee Miller took this photo of Queen Helen of Romania, Princess of Greece, my first cousin, in Peleş Castle near Bucharest. On the walls you can see the traces of paintings and objects that were removed to shelter them from the bombing. The Queen is on the balcony of the great hall. A few weeks later, she and her son King Michael would be driven out by the Communists, narrowly escaping death.

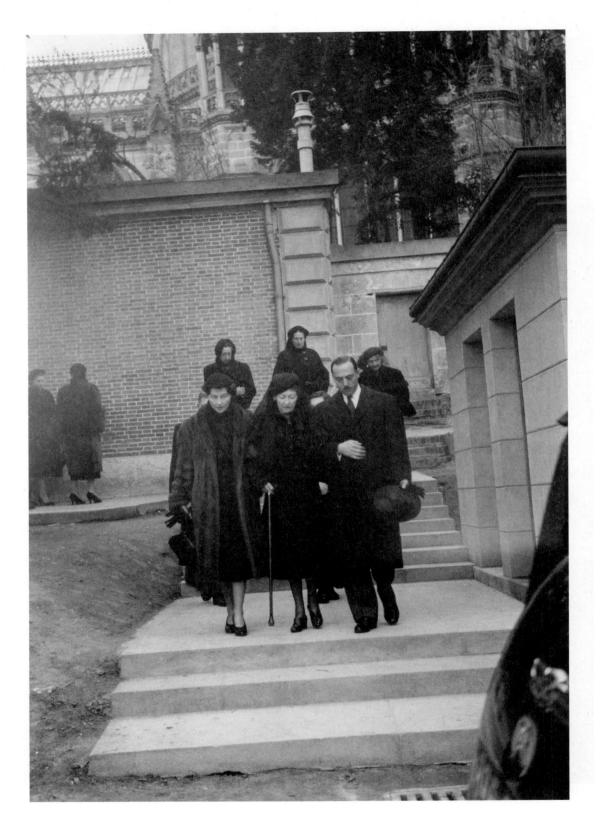

One evening in early February 1953, my mother fell ill and was confined to bed. I never knew exactly what was wrong with her, except that it got worse and worse as the days went by. I carried on living my schoolboy life but saw her less and less. One evening, on 25 February, as I came out of school, I saw that our butler Robert was waiting for me with our little Simca—something that had never happened before. He had to take me back. I realised that my mother was dead. I saw her in her bedroom, covered with a gauze veil. I had no brothers or sisters. I now had no parents either. I was on my own. That sounds dramatic, and maybe it was. In any case, it made me grow up and shaped me hugely. Then so many people, starting with my family, were so kind and welcoming toward me. This photo shows my mother's funeral in the House of Orléans's funerary chapel in Dreux: my grandmother, who came over immediately from Morocco, and the Count and Countess of Paris. I must be behind them.

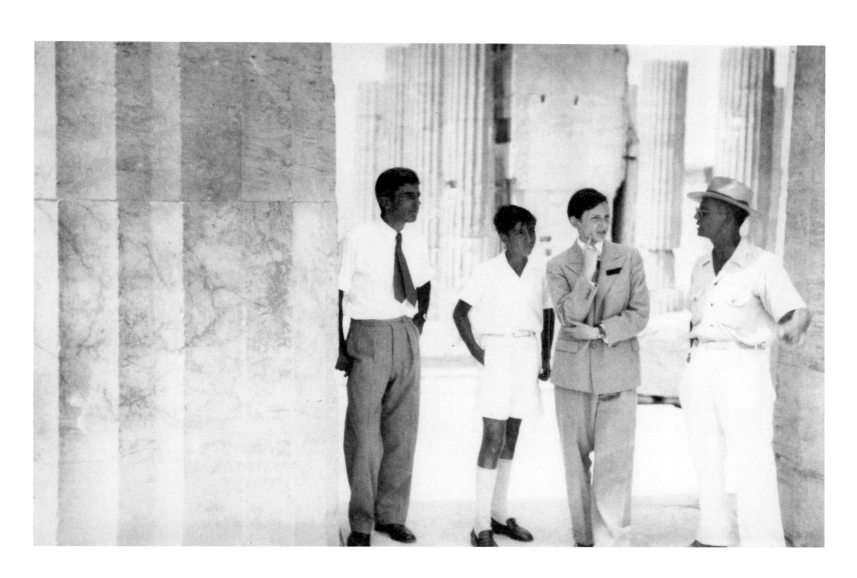

In spring 1953, my uncle and I had brought my mother's coffin to Greece to have it interred in the royal cemetery, on a wooded hill on the Tatoi estate. That was the first time I'd visited my country. I took advantage of the trip by visiting the Acropolis. The photo shows me there with a guide as well as George Levidis, son of the Grand Marshall of the court, and his English tutor, who had come with me. Of course I loved the Greece that I was beginning to glimpse. But the encounter left me perplexed—even though the royal family, King Paul, Queen Frederica and their children couldn't have been kinder or more welcoming.

My beloved cousin Isabelle d'Harcourt, Princess Louis Murat, during her honeymoon in India, holding a baby leopard.

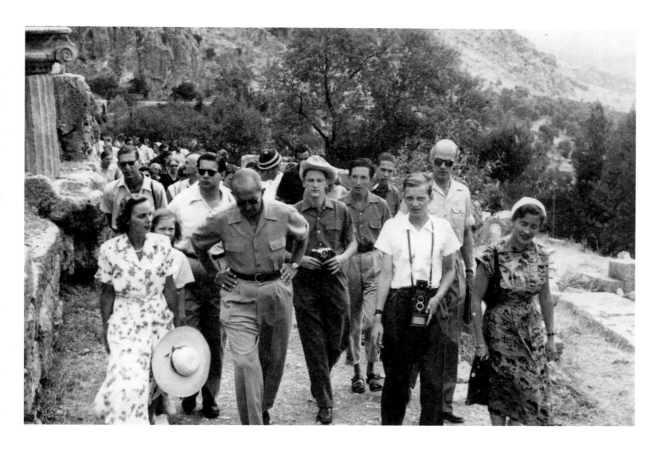

In this photo I must be coming back from Greece on the Cruise of the Kings in 1954. Queen Frederica had had the idea of getting Greece out of its slump by intensively developing tourism through an event that would attract attention. So a cruise ship was hired and all the kings and queens of Europe were invited. They came running. Obviously the event attracted media from across the world, thanks to which Greek tourism was launched. Meanwhile, we had spent eleven magical days being taken from one place to another. King Paul leading the royal tourists in the ruins of Delphi. Next to him, Queen Anne and King Michael of Romania, King Simeone of Bulgaria, myself. Behind me Henri de France. In front of me, Otto of Hessen and then the Duke and Duchess of Mecklemburg.

On a beach—I don't know which one. From left to right: Princess Sofía of Greece; Michel of France; my cousin Maria Cristina of Savoy-Aosta; Tatiana Radziwill. At the back, Duke Louis of Württemberg. Then, again seated, with a headband, Hélène of France; Prince Christian of Hanover; Princess Irene of Greece; and myself.

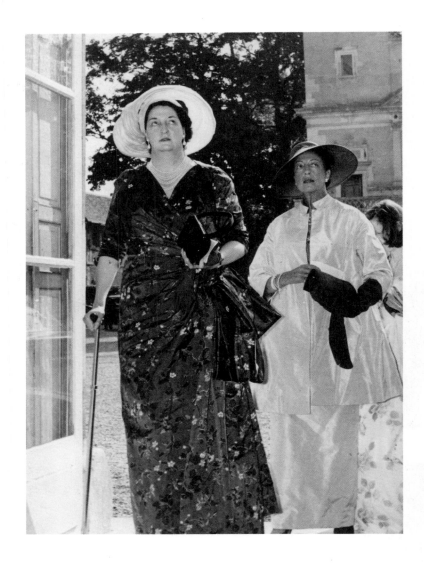

Here we begin the series of family weddings. There were quite a number of them, and they were the great monarchic festivities of the late 1950s and 1960s, which garnered massive media attention. We start in France, at Dreux, on the family's estate, the Orléans' royal chapel, 1957. The marriage of the "Dauphin" Henri of France to Duchess Marie-Thérèse of Württemberg. My mother's two sisters, the Duchess of Aosta and Princess Pierre Murat. All the guests were invited to gather before the wedding at the Château of Anet, which therefore features in this photo in which everyone is meeting up before setting off for Dreux in a procession of cars.

A Bavarian prince from the Spanish branch with Isabelle, Viscountess of Las Antrinas and the widowed Duchess of Montpensier, whom we called Aunt Bellina. A short, plump woman, she could have been the heroine of a novel, and more particularly of a detective story. She married my grandmother's youngest brother, Ferdinand, Duke of Montpensier. Following his mysterious death, there was an equally mysterious fire at their château, and the vast inheritance likewise mysteriously disappeared. Then his widow secretly married her secretary, and so on.

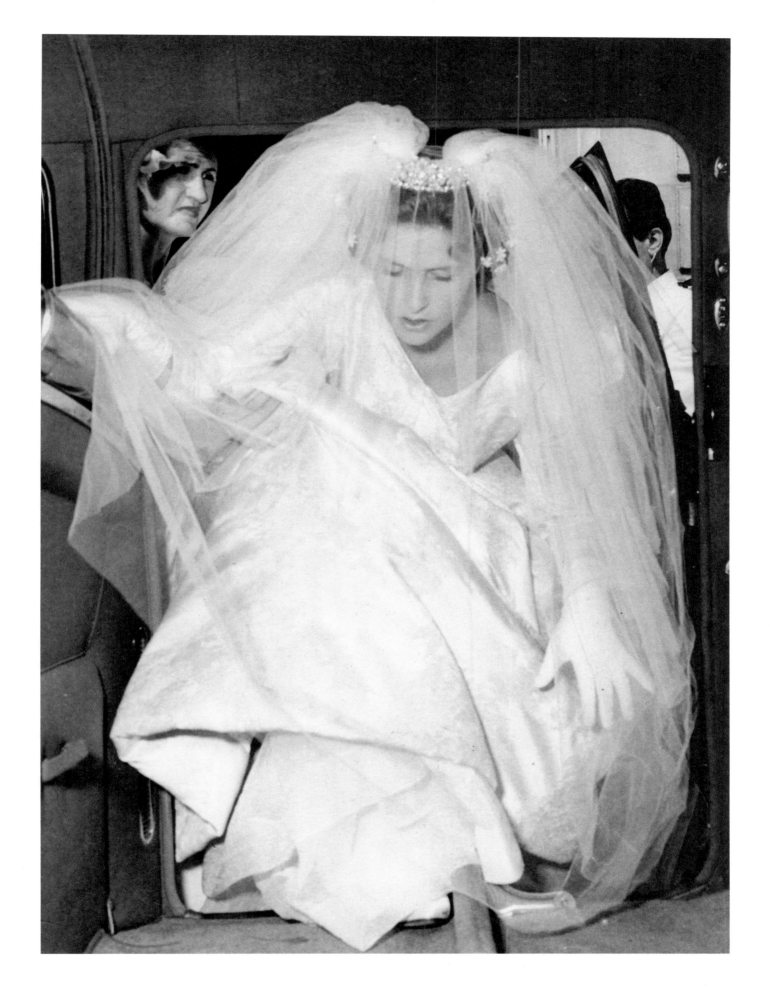

Duchess Marie-Thérèse of Württemberg, getting into the car that will take her to her wedding.

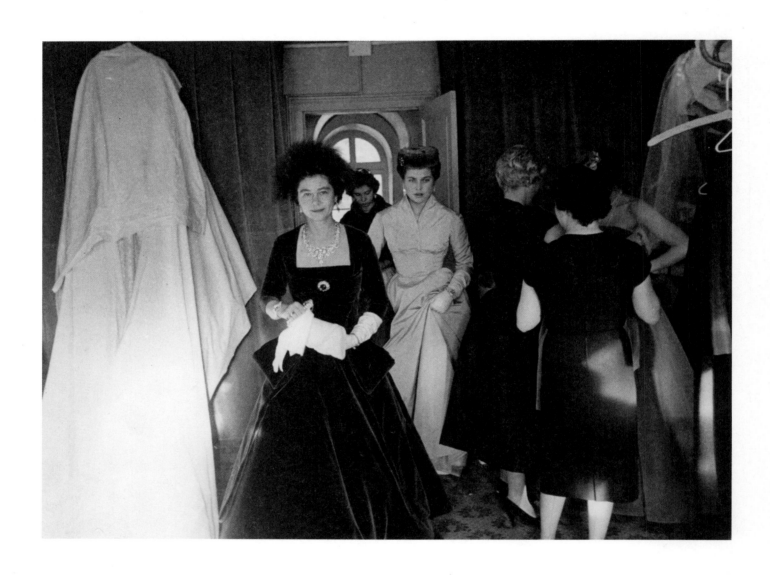

Not long before Henri of France's wedding, the marriage of his sister Hélène of France to Count Evrard of Limburg-Stirum took place in Dreux. Queen Frederica of Greece arrives in the royal dressing room, followed by my cousin Isabelle of France.

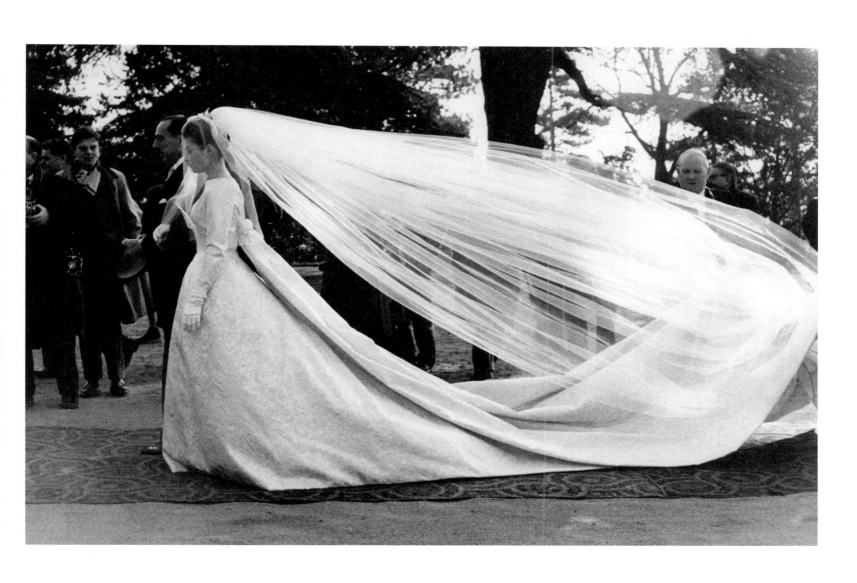

Here, the bride on her father's arm. A gust of wind is making her veil billow behind her as she makes her way to the chapel. It was January and it was quite cold.

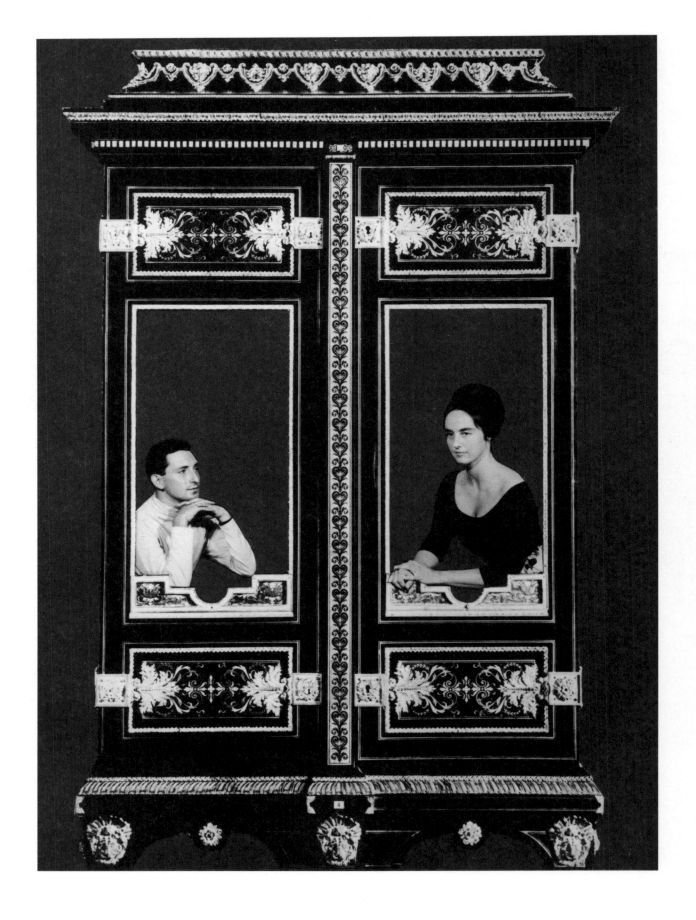

At a very early age I started making collages, poaching from the bound World Tours at my grandmother's. Here, in a Boule cabinet, I've mounted a photo of my favourite cousin Monique d'Harcourt, Countess Boulay de la Meurthe, who is actually like a sister to me, and myself. I was extremely proud of the result.

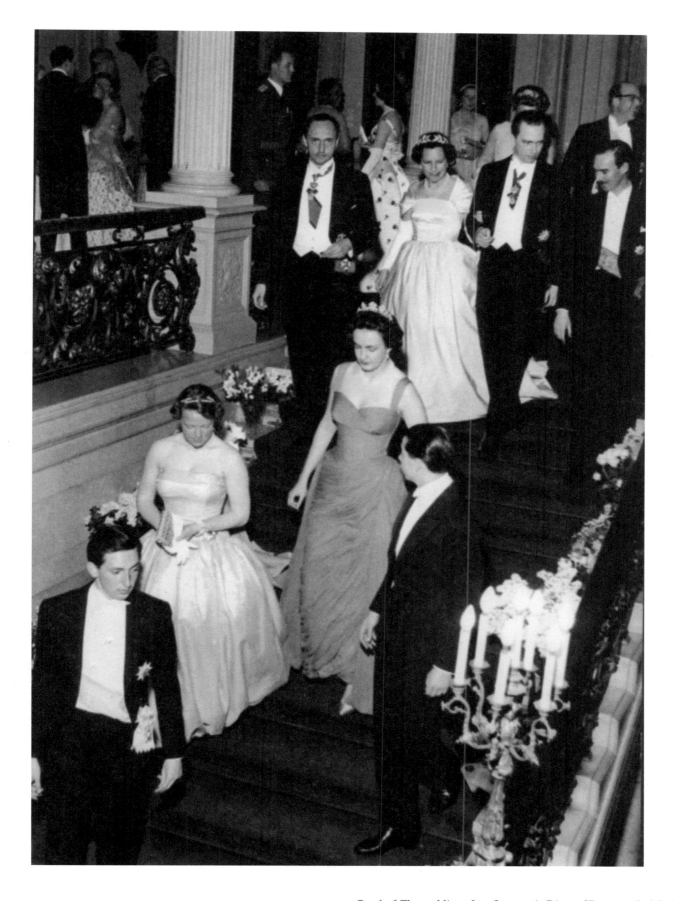

The wedding of Marie Adelaide of Luxembourg. The evening reception at the Grand Ducal Palace. From left to right: me; Princess Irene of the Netherlands; my first cousins Maria Cristina of Savoy-Aosta and François of France. Behind, prominent representatives of the House of Austria: Archduke Robert; one of his brothers with his wife, née Princess of Ligne; and on the right, Grand Duke Jean of Luxembourg.

Overleaf: The wedding of my first cousin Diane of France to Carl, Duke of Württemberg, took place a few years later. It was held in the enormous Altshausen Castle. The dancing happened in the grand salon. The bride whisked her little brother, Thibaut, off into a waltz. Behind them, the King of Bulgaria watches the scene with a tender smile as he dances with Archduchess Alexandra. My uncle, the Count of Paris, also seems touched by it. Behind him, his eldest son Henri dances with Chantal of France, his youngest daughter, and at the back on the left is the smiling Countess of Paris.

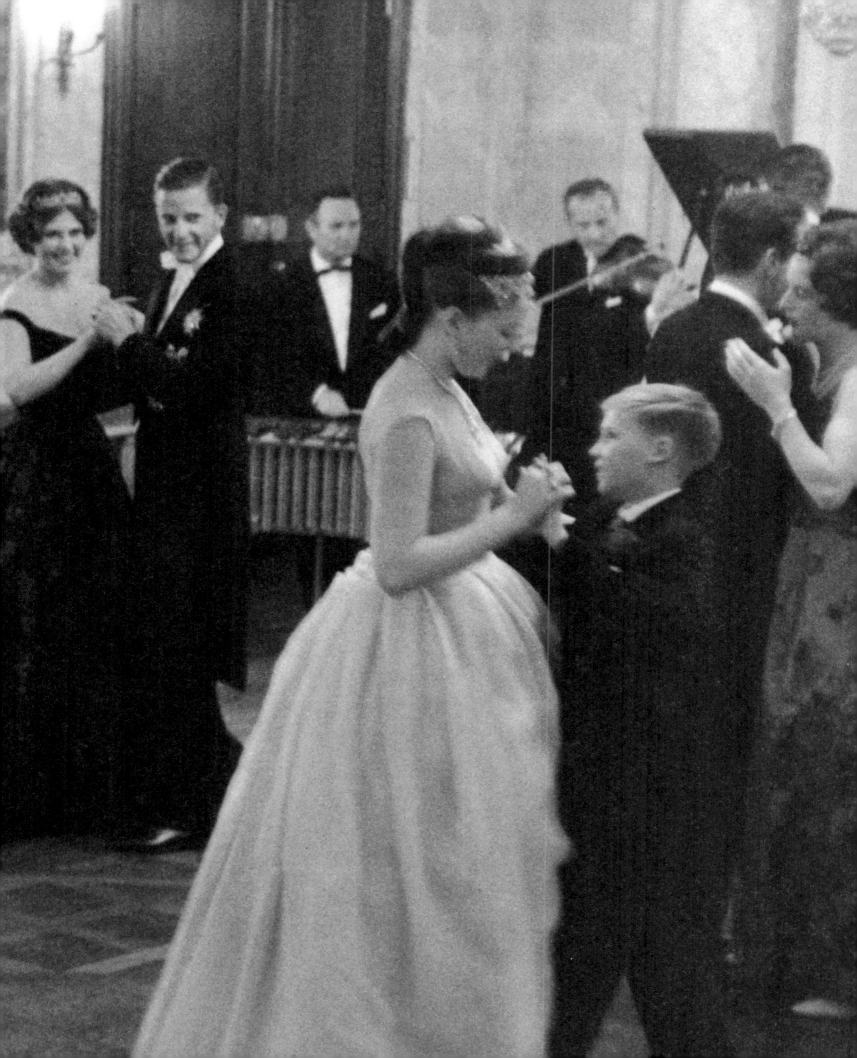

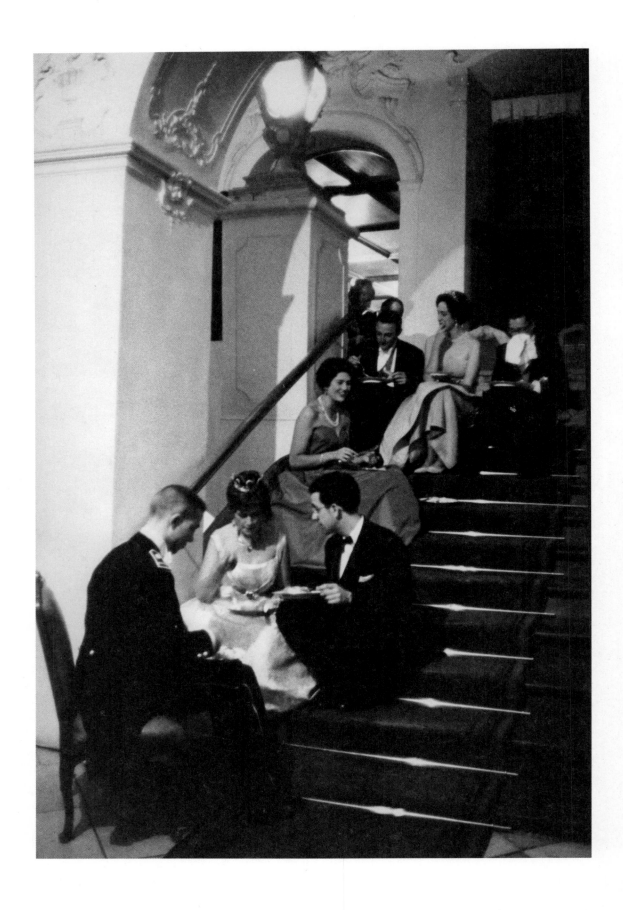

Two moments from Diane's wedding in 1960, or rather from the preceding evening in Altshausen Castle. First, a number of the guests sitting on the grand staircase with plate in hand. In the foreground, Henri of France and his wife Marie-Thérèse of Württemberg eat their supper and chat to a great friend, Michel Missoffe. Further back, Franz, Duke of Bavaria with Maria Cristina of Savoy-Aosta.

Me in Greek suit and embellishments with the beautiful and exciting Countess Marguerite of Limburg-Stirum, known as "Gogo." These family weddings were occasions of much laughter and great entertainment that all the younger ones, including myself, enjoyed and that left us with unforgettable memories.

My grandfather George I arrived to reign in Greece in 1863. The centenary of our dynasty was therefore celebrated in style in 1963. There were countless displays, celebrations, shows, gala events, and sadly also countless infinitely boring speeches. Here, King Paul of Greece has gone to greet our cousin King Frederick of Denmark, since our family belongs to the House of Denmark.

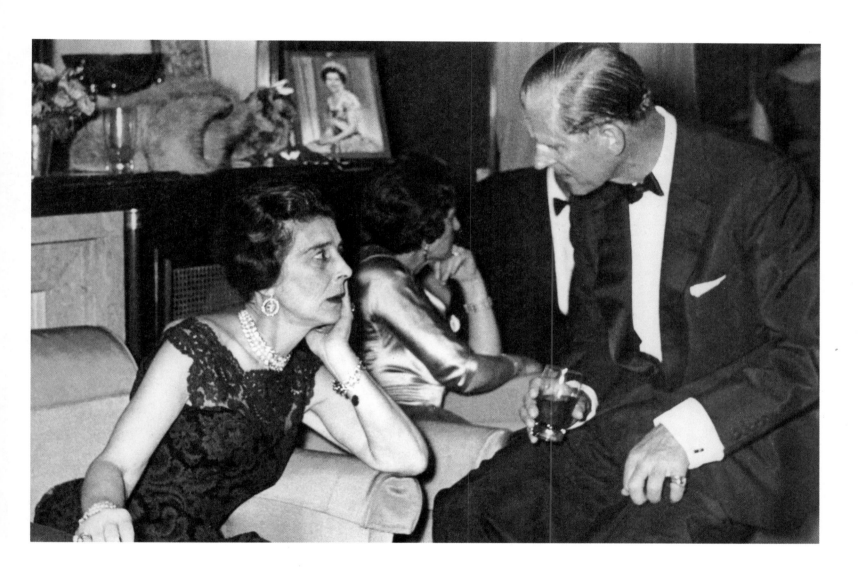

Two first cousins at a private supper in Athens: Marina, Duchess of Kent, and Prince Philip, Duke of Edinburgh, chatting.

Overleaf: The silver wedding anniversary of Queen Juliana of the Netherlands and Prince Bernhard of Lippe, her husband, was celebrated in grand style. Heavyweight royals came flocking, as did a myriad of young princes and princesses for marrying. I had the joy of taking part, and frankly I had great fun. Here, during the grand ball, in the front row are Prince Philip, Grand Duchess Charlotte of Luxembourg, Britain's Queen Elizabeth, the Shah of Iran, Queen Juliana and Prince Bernhard, Prince Bernhard's mother, the Grand Duke of Luxembourg, Empress Farah of Iran, the Grand Duke of Luxembourg and the Duchess of Kent Marina of Greece. In the second row, Grand Duchess Joséphine-Charlotte of Luxembourg behind her mother-in-law, then Princess Margriet of the Netherlands, a Swedish prince, and the crown princess of the Netherlands behind her mother. Between Prince Bernhard and his mother is the King of Norway. At the end of that row are Princess Irene of the Netherlands and Prince Louis Ferdinand of Prussia with his wife, Grand Duchess Kira of Russia. I'm in the third row, behind Juliana, and behind me is the beautiful Alexandra of Kent.

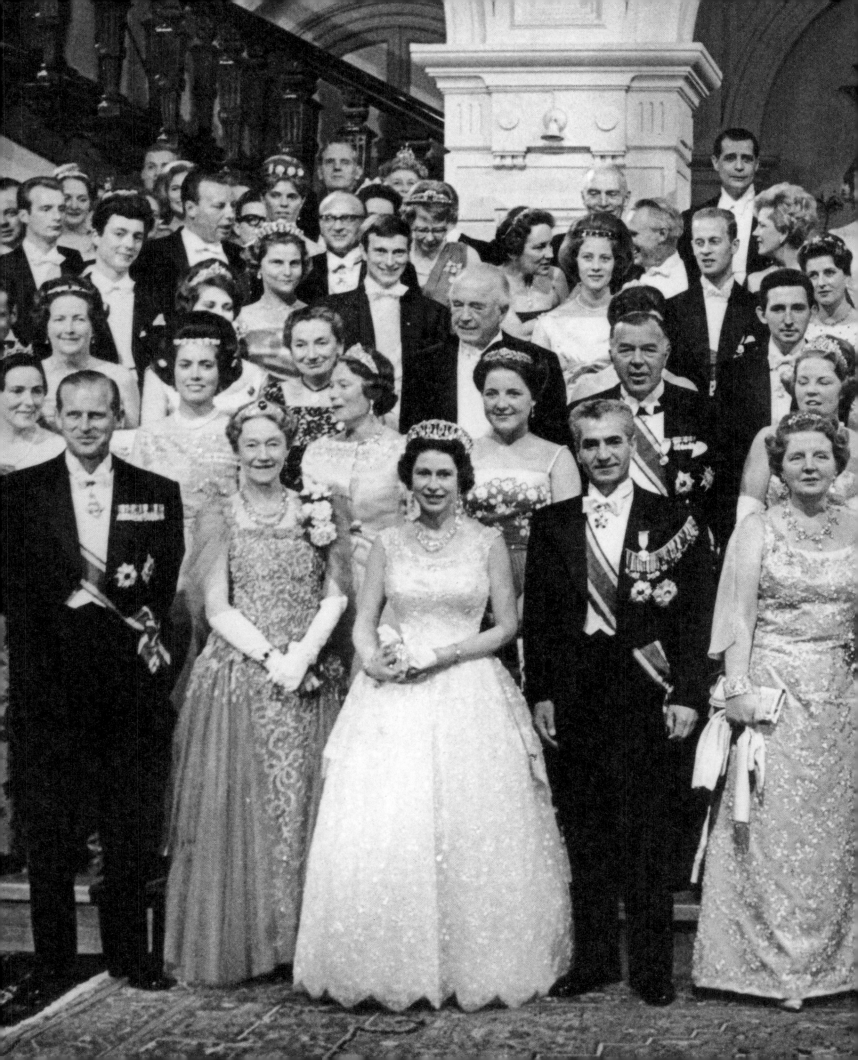

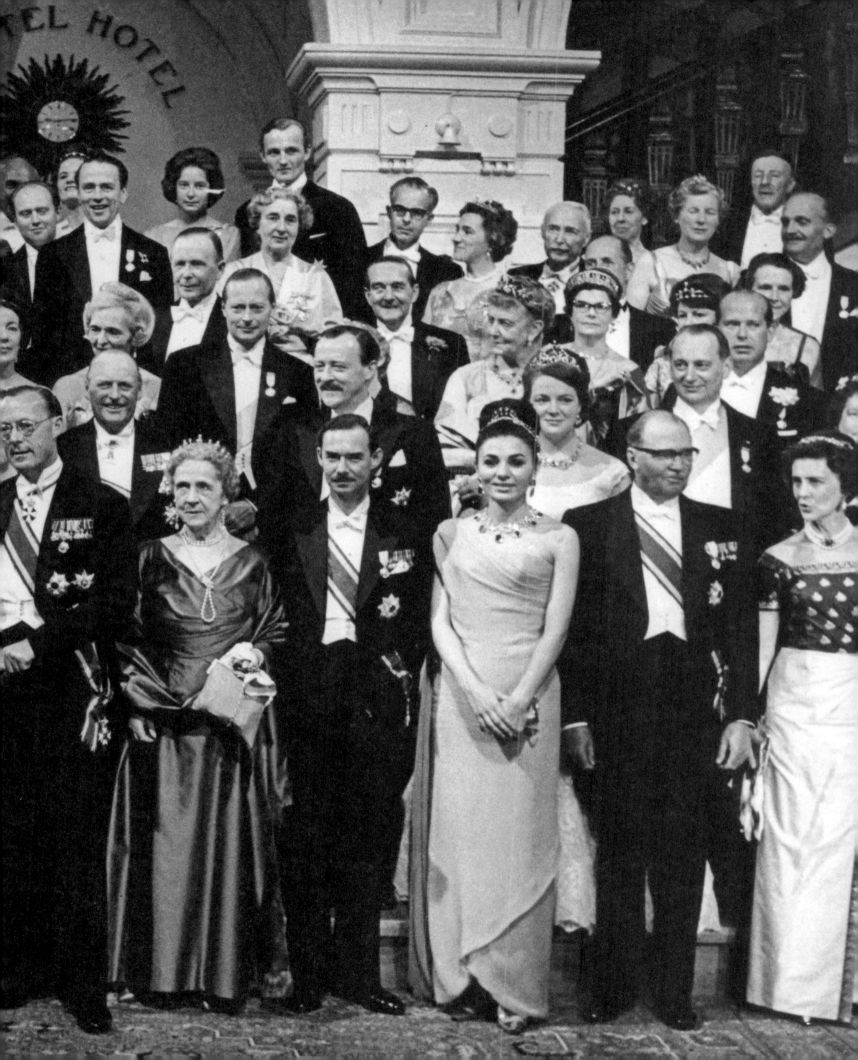

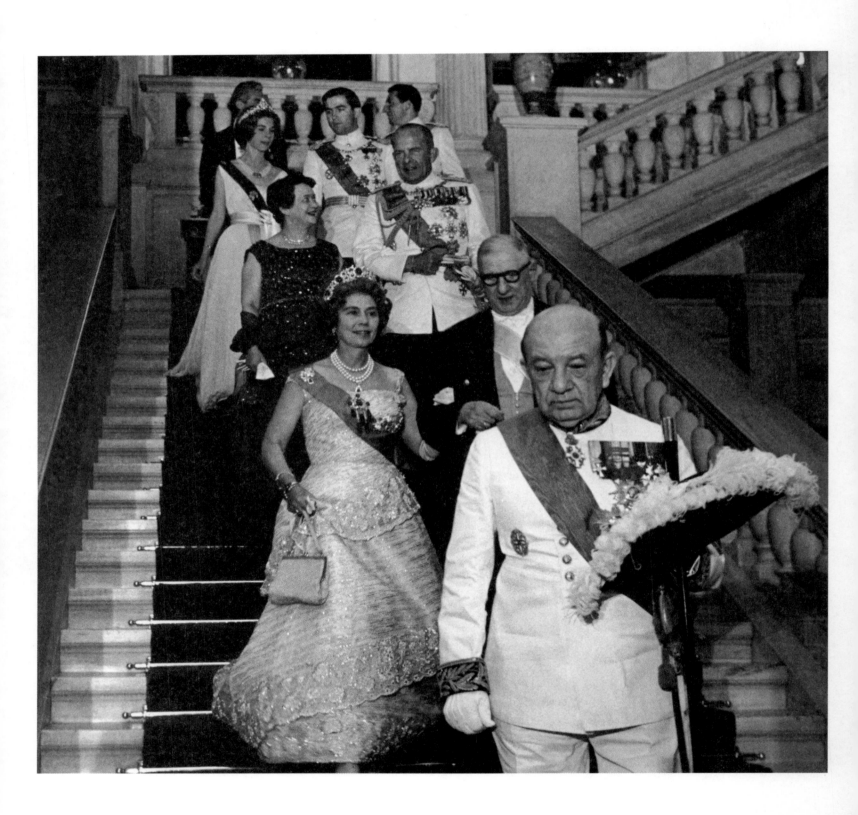

I had the chance to encounter another historical giant, General de Gaulle, who came on an official visit to Athens in 1962. Here coming down the stairs of the royal palace, the Grand Marechal of the court Dimitri Levidis, behind Queen Frederica with the General. Then Madame de Gaulle with Prince Paul. Then Princess Irene and Prince Constantine and then myself.

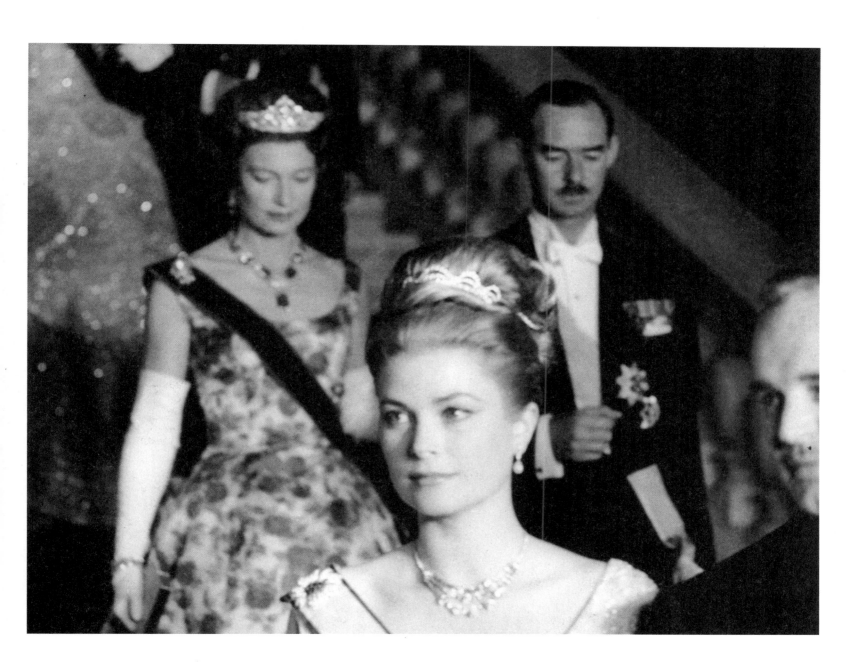

Wedding in Athens of Princess Sofía and Don Juan Carlos, future King of Spain. Again they are coming down the staircase in the Royal Palace for the grand ball before the ceremony. Behind are Grand Duke Jean and Grand Duchess Charlotte of Luxembourg; in the foreground are Prince Rainier and Princess Grace of Monaco. This was the moment when Princess Grace made her entrance into the world of royalty. Everyone was keen to meet her and suss her out. All the men were instantly entranced by her, and the women—even the most severe ones and the ageing aunts—found her impeccably well brought up and noble-looking, as well as extremely courteous. An all-round success.

Still Sofía and Juan Carlos's wedding. Cayetana, Duchess of Alba, was the only child of the Duke of Alba and inherited his vast fortune, fabulous collections and countless palaces. Throughout her life she did exactly as she wanted, including getting married for a third time, at the age of 85, to a man far younger than herself. The Spanish people idolised her, and during her third wedding she had no hesitation in going down into the street to dance Sevillanas in front of the enthusiastic crowd.

The groom's grandmother Queen Victoria Eugenie of Spain with her grandson Alfonso of Bourbon. She was the profoundly respected matriarch of the Spanish dynasty.

At the wedding in Athens, brother, and sister: Lord Mountbatten and Princess Andrew of Greece, Prince Philip's mother. Lord Mountbatten—"Dicky" to those closest to him—liked to cover himself in decorations. He said himself that he was the vainest prince of all. But he was a thoroughly nice man, very approachable and always ready to lend a hand.

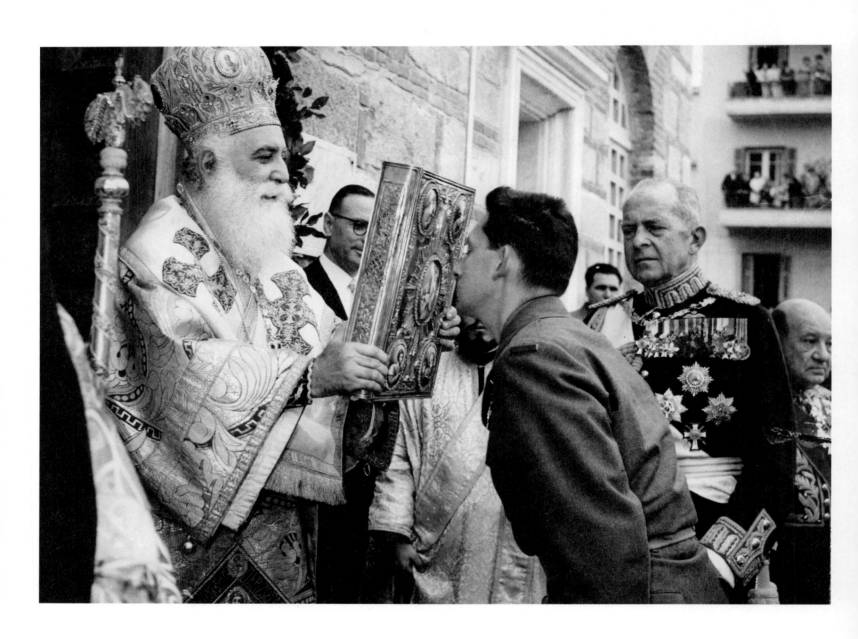

In 1960, having completed my studies, I set off to live in Greece as had been agreed long before. King Paul and Queen Frederica welcomed me warmly and generously on the family estate at Tatoi. They involved me in court life, but at the same time I was starting my military service. I'm shown kissing the Gospels, which is being held out to me by the Archbishop of Thessaloniki, with King Paul next to me, during the annual Te Deum on 28 October—the day that marks the city's liberation from Ottoman domination by my uncle King Constantine as leader of the Greek Army.

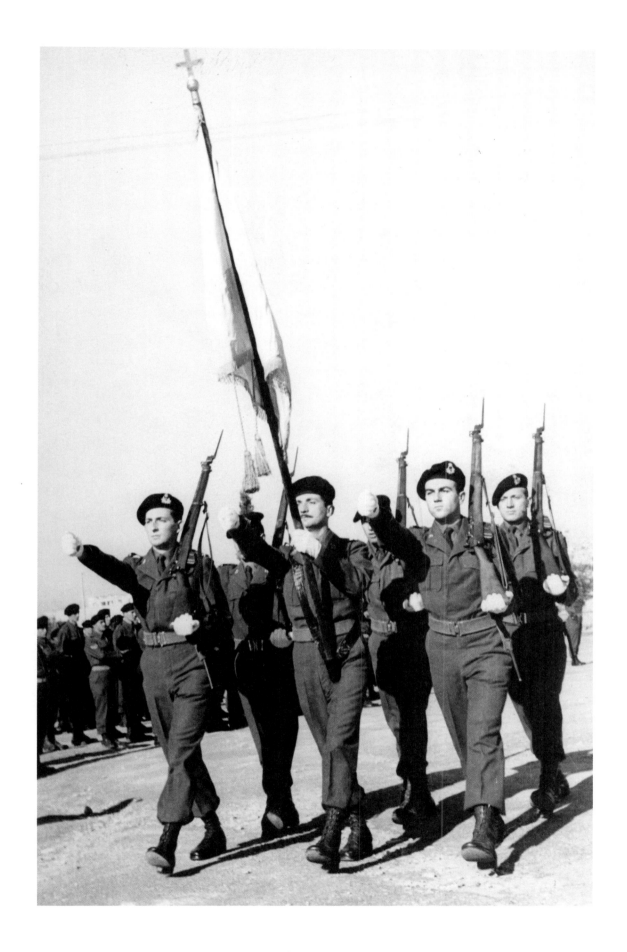

Me as part of the platoon of honour carrying the flag during a military parade. The one carrying the flag is Lieutenant Kolyonis, who became a great friend of mine, as did the soldier in the front row on the right.

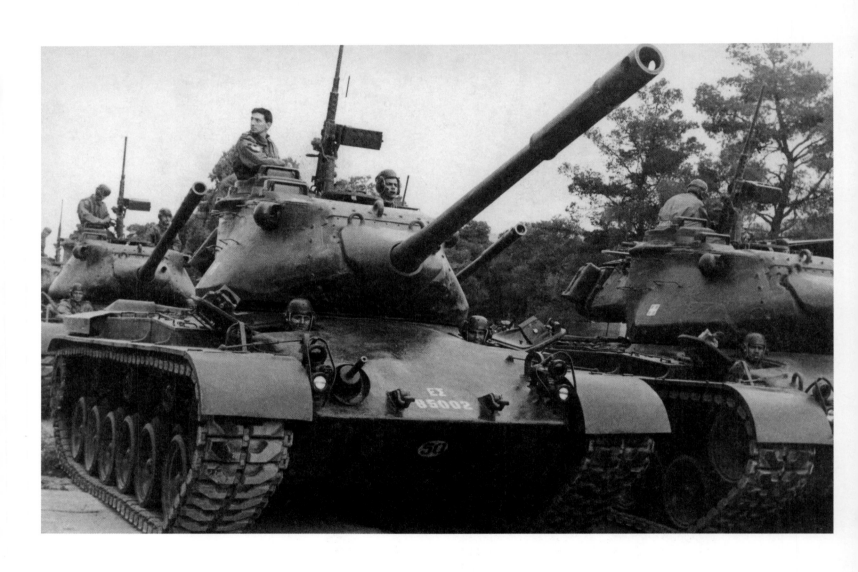

A few pictures of my life in the army. On top of my tank, I am getting
ready to go on parade in Athens on 25 March, Greek Independence Day.

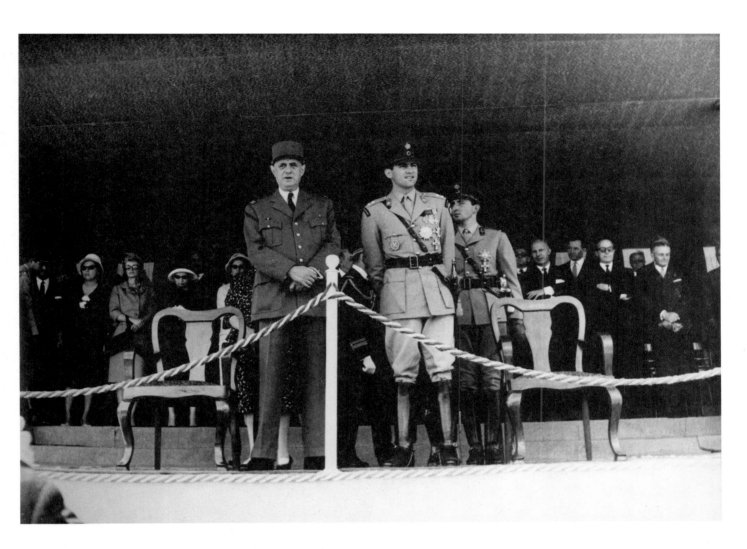

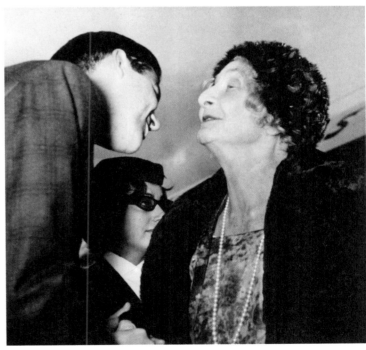

During General de Gaulle's visit to Athens, King Paul had had an emergency operation for appendicitis during the night, so it was Constantine and I who were tasked with accompanying the General in Thessaloniki for a grand military review. The three of us were also in the official stand.

The diadoch Konstantin received at the Athens airport our aunt Marie Bonaparte, who had married my father's brother, Prince George of Greece. She was a wonderful personality. One of the founders of psychoanalysis, an intimate of Freud, she was profoundly original and benevolent. The anecdotes about her were innumerable. I liked her because as a teenager she considered me an adult and treated me as such.

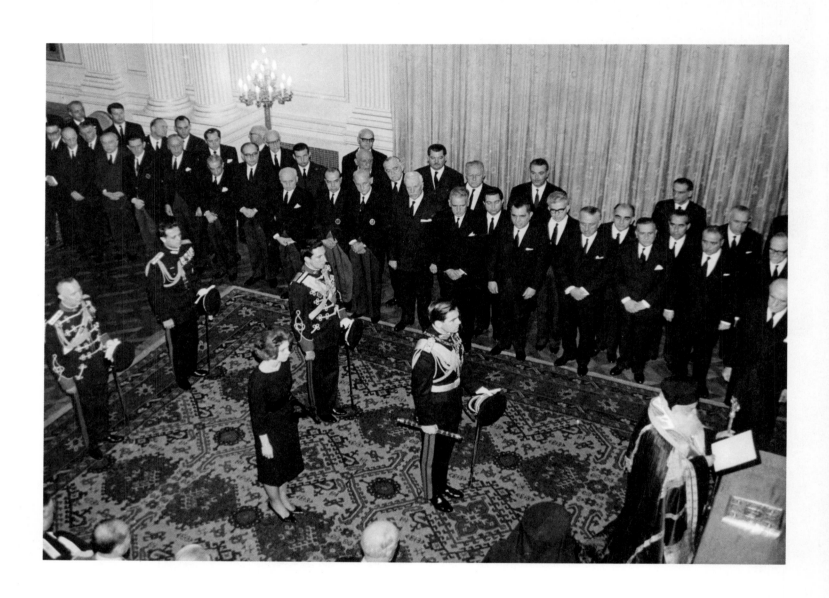

King Paul died following a short illness in March 1964. The very same evening, or rather the very same night, at midnight, the new King Constantine took his oath in the Throne Room of the Royal Palace. His sister Irene, who had become Crown Princess, and I were both in attendance. I had a fever, with a temperature of 39°C, and I don't know how I managed to stay standing. The men in black are members of the socialist government. On the right, you can see the Prime Minister, George Papandreou. It was a quick and extremely moving ceremony that began a new chapter in Greek history.

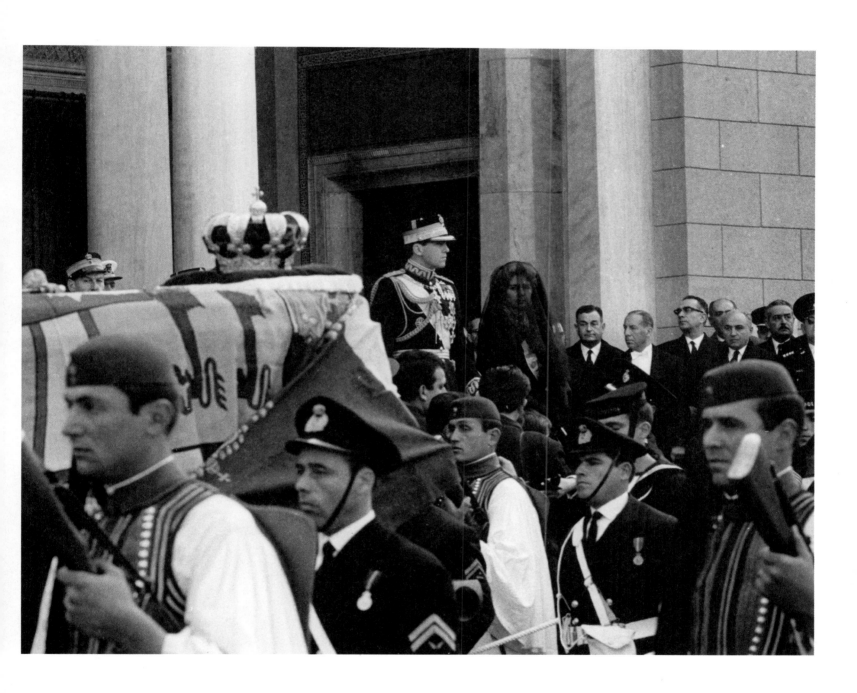

Leaving Athens Cathedral for King Paul's burial. His coffin is surmounted by a large golden crown that King Othon had had made and which was never intended to be worn (it's too big for that) but just to be placed on a cushion. In front of the cathedral, the new King Constantine with the widowed Queen Frederica.

Overleaf: Dare I say it, the Orthodox Church offers a whole other kind of amazing spectacle than the Catholic Church. The prelates' vestments alone ensure that. Here, a mass of Greek Orthodox bishops present at King Constantine's wedding. They are all wearing diamond-set crowns and vestments in pink, pale yellow, pale blue, and pale green brocade embroidered with gold, and have encolpions—pendants encrusted with precious stones—hanging from their necks.

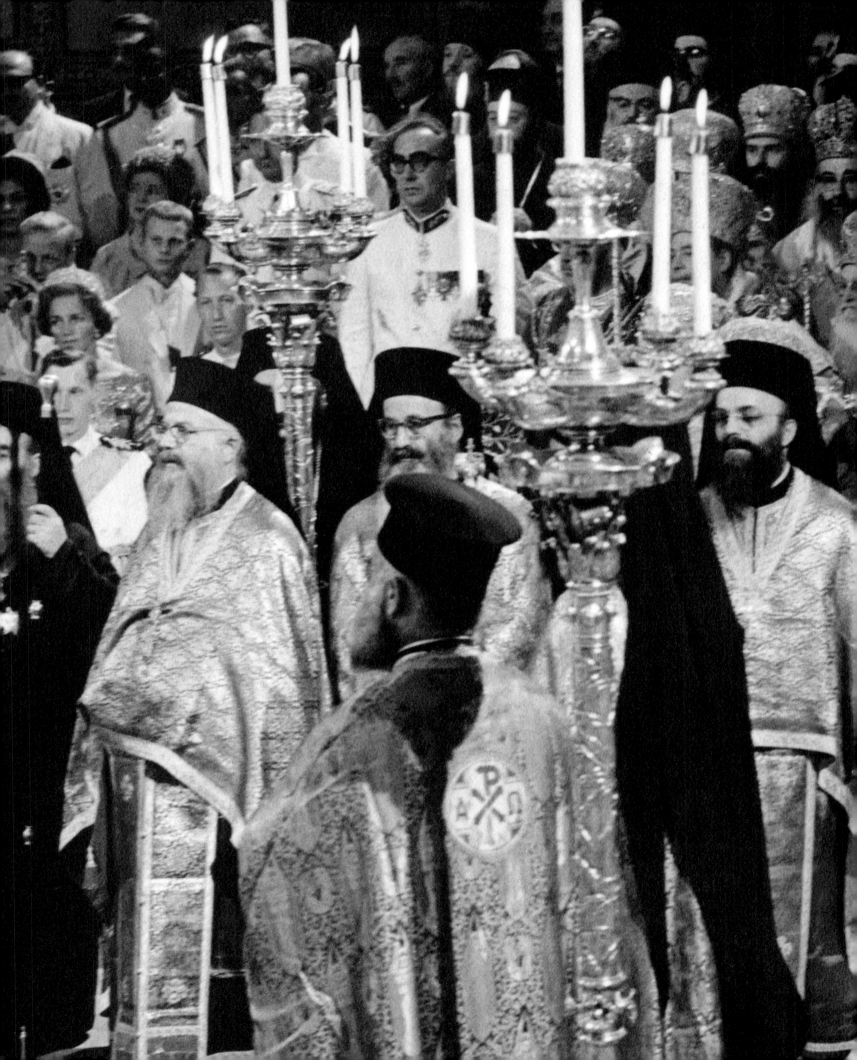

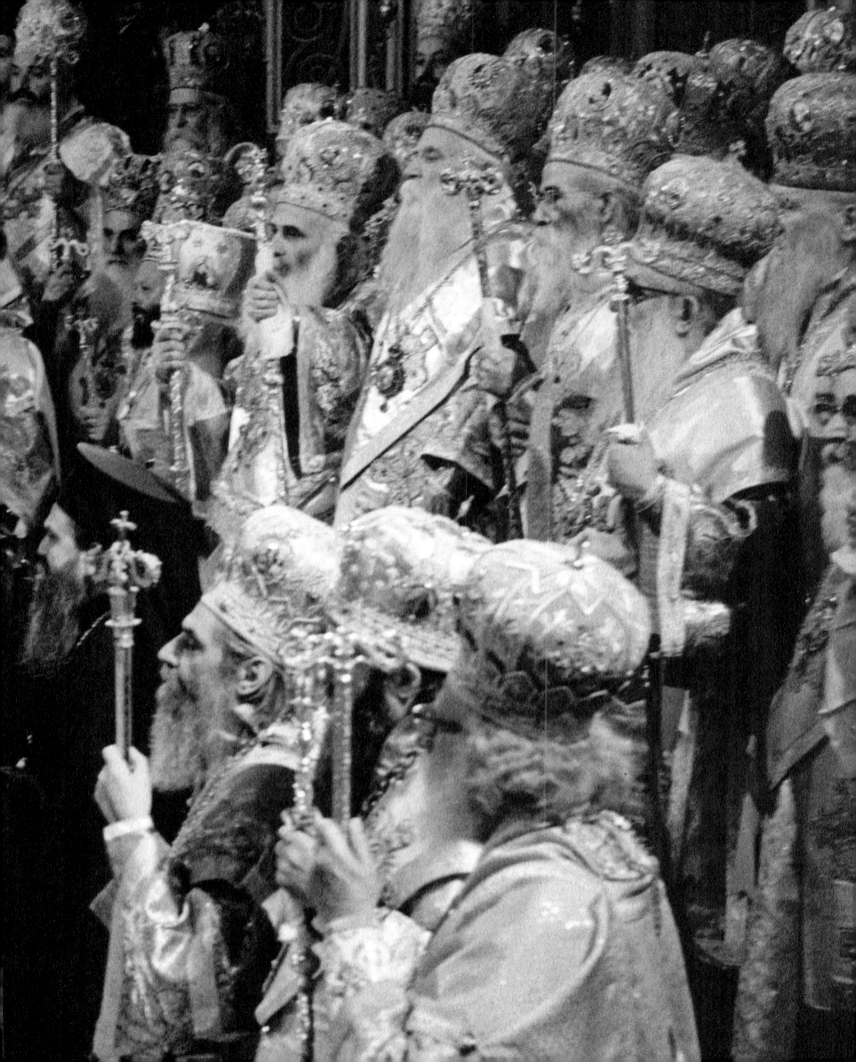

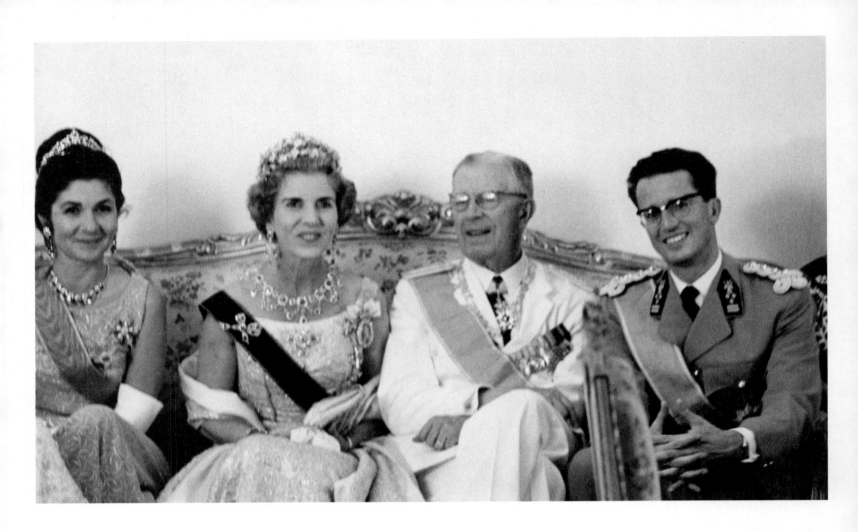

Before King Constantine's wedding there was a magical ball in the gardens of the Royal Palace with all the queens in diamonds and the kings heavily decorated too. Everyone was happy, everyone was enjoying the moment. Sitting on the same sofa: Queen Farida of Egypt, who had generously hosted the Greek royal family during the war; next to her, Queen Ingrid of Denmark; then her father, King Gustav VI Adolf of Sweden; and their nephew King Baudouin of Belgium, son of a Swedish princess.

Queen Frederica chatting to King Olav of Norway.

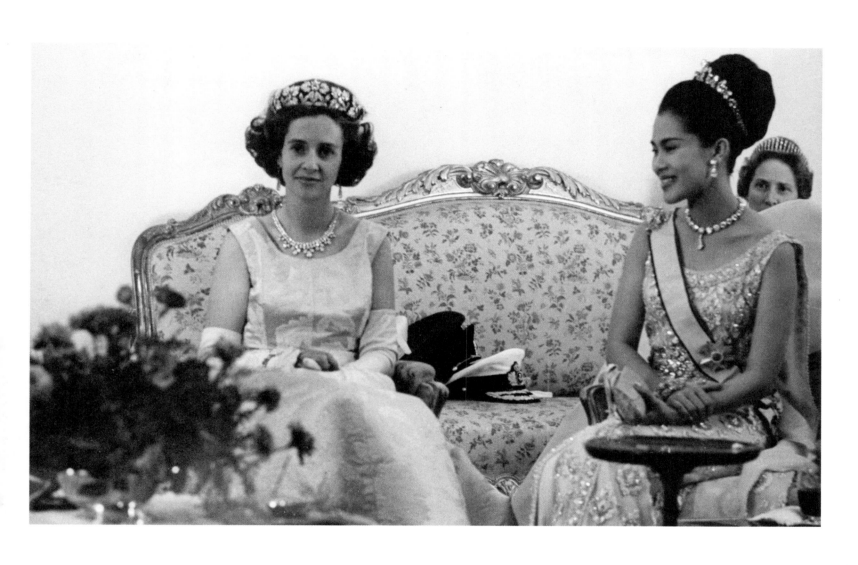

Queen Fabiola of Belgium with the very beautiful Queen Sirikit of Thailand,
who caused a sensation at the wedding because of her grace, beauty and elegance.

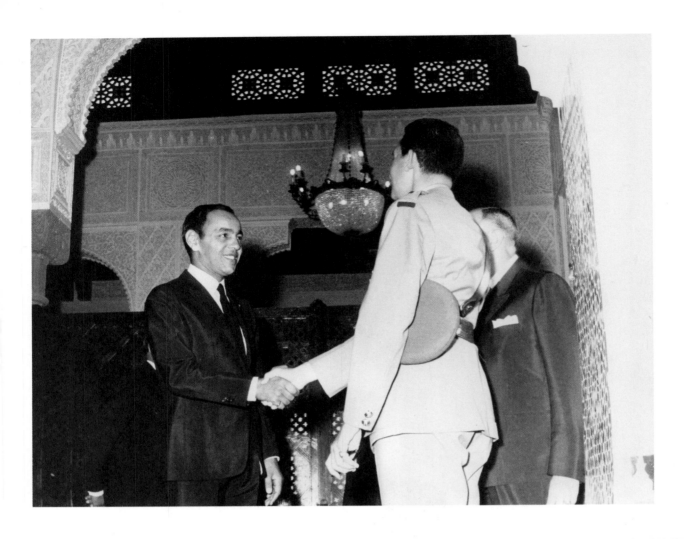

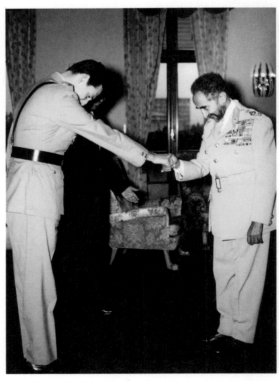

My official trip to invite rulers to King Constantine's wedding. Me greeting King Hassan of Morocco, whom I'd known when he was 18 years old and returning from exile in Madagascar having been called back by the French with his father, King Mohammed V.

Me respectfully greeting the Emperor of Ethiopia, the Negus Haile Selassie, who greeted me the same way. He was an extraordinary man, noble, courteous and infinitely cultivated. He talked to me at length about the Byzantine churches of Thessaloniki, which he knew by heart.

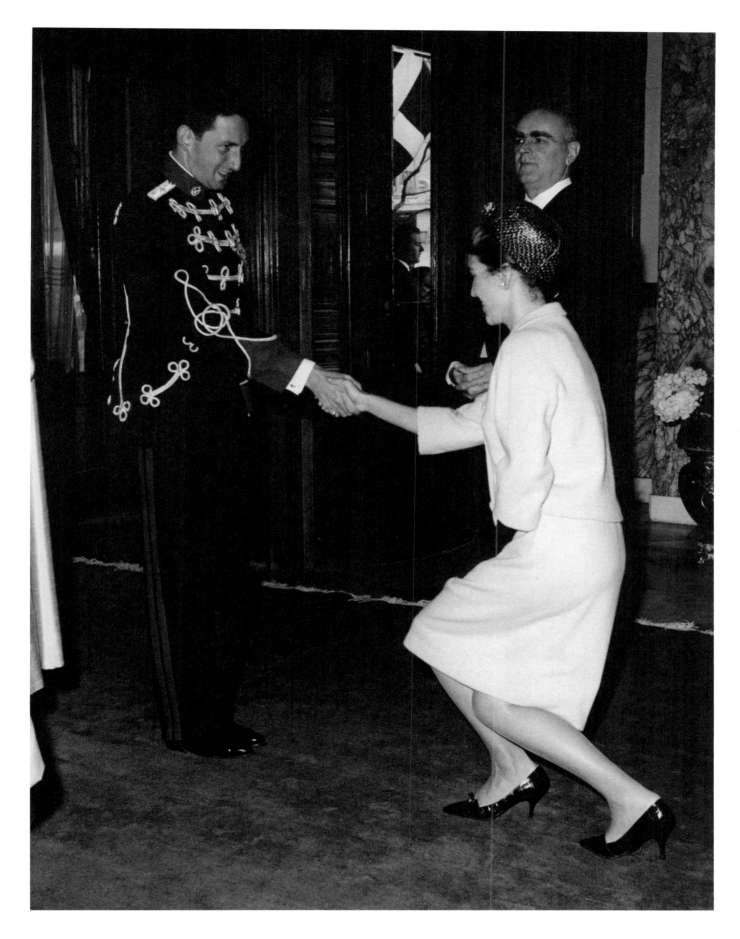

Protocol dictated that the wife of the prime minister Konstantinos Karamanlis, Amalia, would curtsey to me. When I arrived in Greece and at the Court and barely knew anyone, it was Mrs. Karamanlis and Mrs. Makri, wife of the Minister of the Interior, who, out of pure kindness, looked after me in the official ceremonies where I was a bit lost, and introduced me to quite a lot of people in literary and artistic circles, for which I will be forever grateful to them.

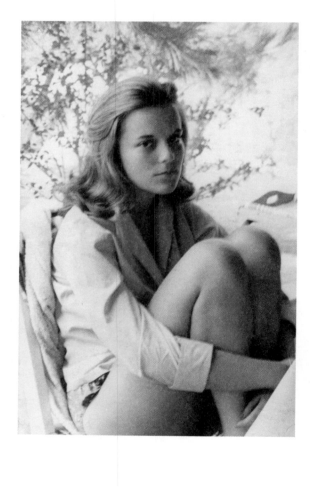

Countess Xenia Cheremetiev, Madame Sfiri. She is the only granddaughter of Prince Yusupov and Princess Yusupov. She is, therefore, a cousin of ours. Incredibly beautiful and charming. She lived with her mother in Athens, where we had many opportunities to see her.

After the official ceremonies, some down time sprinkled with Veuve Cliquot was in order. So, having invited my cousin Gilonne d'Harcourt, here we are off on a champagne picnic on some beaches that only I knew about, on the Attic Peninsula, which had very little in the way of built development at the time.

Marina Karella, whom I knew socially, invited me one day on a cruise with mutual friends. There was a stopover in Hydra. That evening there was a ball at the Koudorioti Palace. Here is the beautiful girl dancing the saraband with Evy Lykiardopoulou and Prince Alexander Romanov. I was also at this ball, and it was that evening, seeing Marina and talking with her, that I decided to marry her.

A young man and young woman relaxing. He is about to have an afternoon nap.
She is being teased by her friends. Someone must have thrown something edible
that landed on her shoulder. She is Marina, and he is me—at the time when I
was starting to be seriously interested in her.

Overleaf: He asked for her hand. She agreed to marry him. They are happy. Everything is fine.

CHAPTER THREE

MARRIAGE AND ATHENS 1965–1974

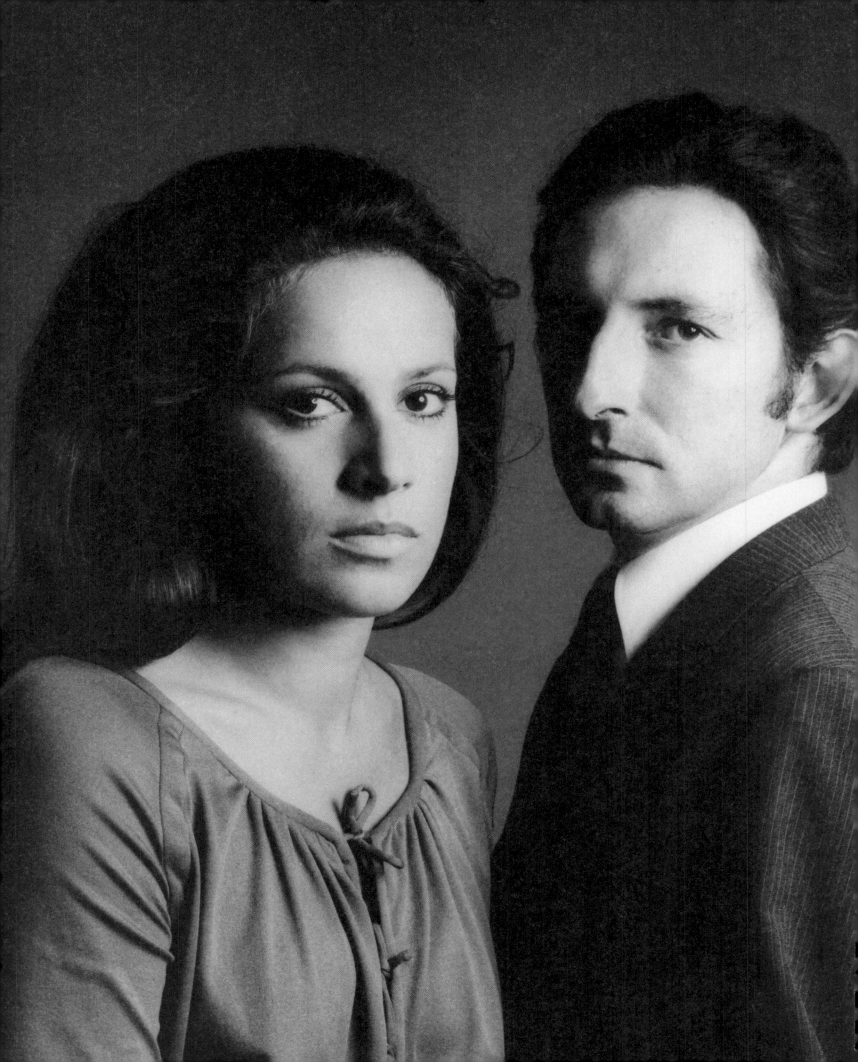

As a naturally independent person who loved meeting people, I made a group of Greek friends who I met at parties—members of high society, all of whom were very interesting. I established closed relationships with them all. I noticed a young girl named Marina who was part of this intimate group. A daughter of industrial scions, she had studied at the Beaux-Arts school in Paris. She began a career as a painter when she was very young. A renowned Greek actor commissioned costumes and décor for different shows from her. Little by little, she came to have a growing importance in my life, until the day when I truly fell in love with her and decided to propose to her. She accepted. However, numerous difficulties awaited us. During that time, morganatic marriages were neither common nor popular among royalty. We had to wait and negotiate for nearly two years. We finally won the case. We were married on February 7, 1965, at the Royal Palace in Athens.

Following our marriage we lived with my in-laws, Elly and Tedy Karella. They belonged to an eminently respectable, dignified, and discreet family and were also very generous. We then moved to a villa in Maroussi, in the middle of a pine forest. We continued to spend time with people in my social circle, that of the kings. I attended the 2,500th anniversary of the Persian Empire with legendary celebrations in Persepolis. We met diverse characters here and there.

We traveled together often during those years. We became aficionados of music festivals in Salzburg. We took two trips that lasted several months: one in Asia, the other in South America. We went on frequent trips to my beloved Middle East.

We also worked to a great degree. Marina successfully pursued her career as a painter and I set about mine as a writer.

Above all, this period was marked by the births of our two daughters, Alexandra, in 1968, and Olga, in 1972. They became the treasures of our existence.

Our official engagement photo.

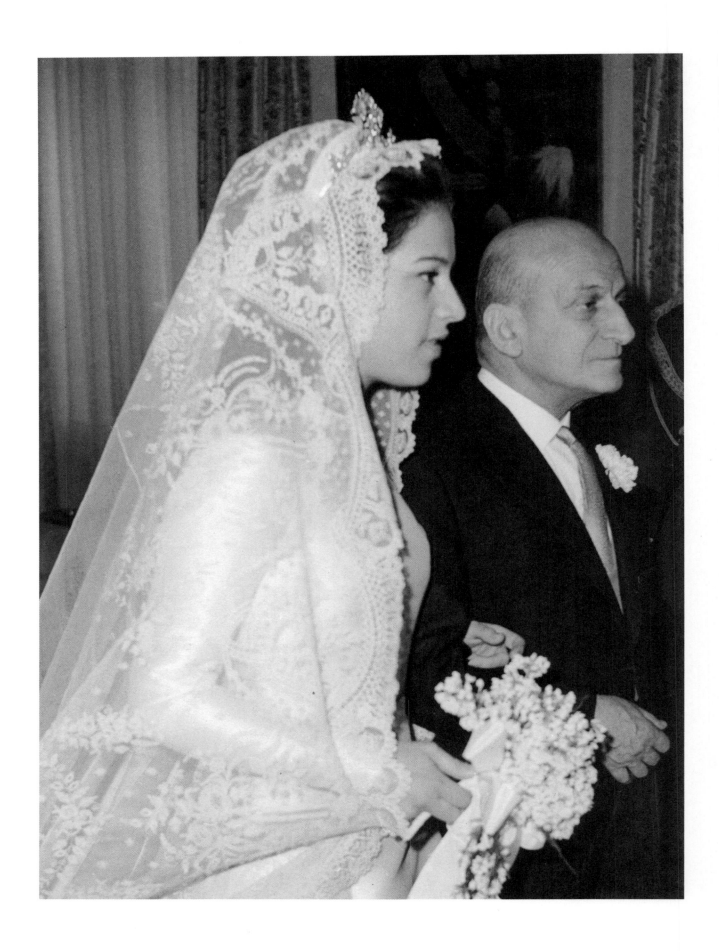

Marina arriving on her father, Tedy Karella's arm, with him looking very emotional.

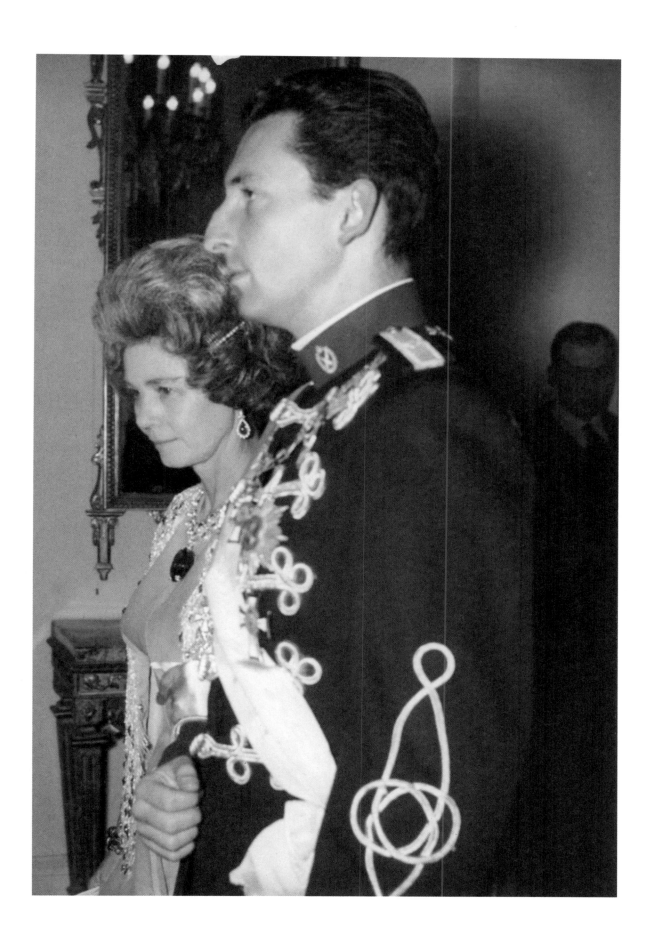

I made my entrance on the arm of Frederica the Queen Mother, who was wearing a pearl necklace and, hanging from it, one of the world's biggest sapphires, which had belonged to Queen Marie of Romania.

Overleaf: Our witness, King Constantine, holds the crowns above our heads while the Court Chaplain—Monsignor Ieronymos, later Archbishop of Athens—marries us.

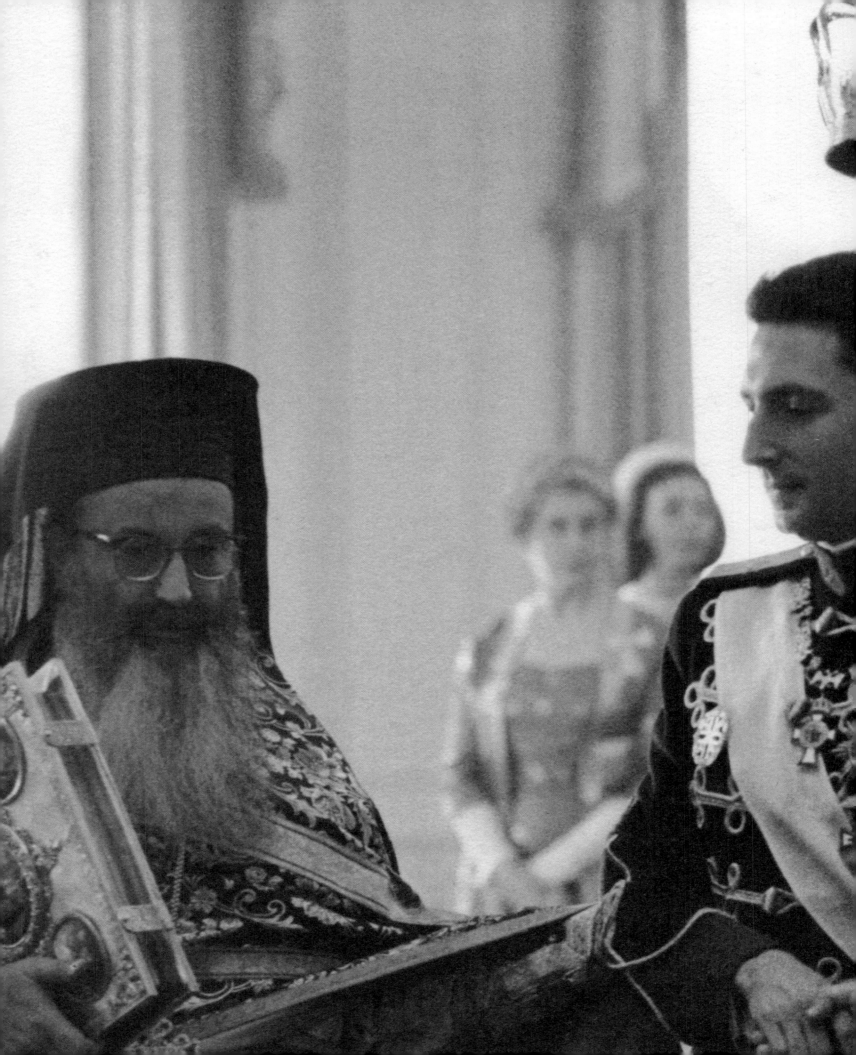

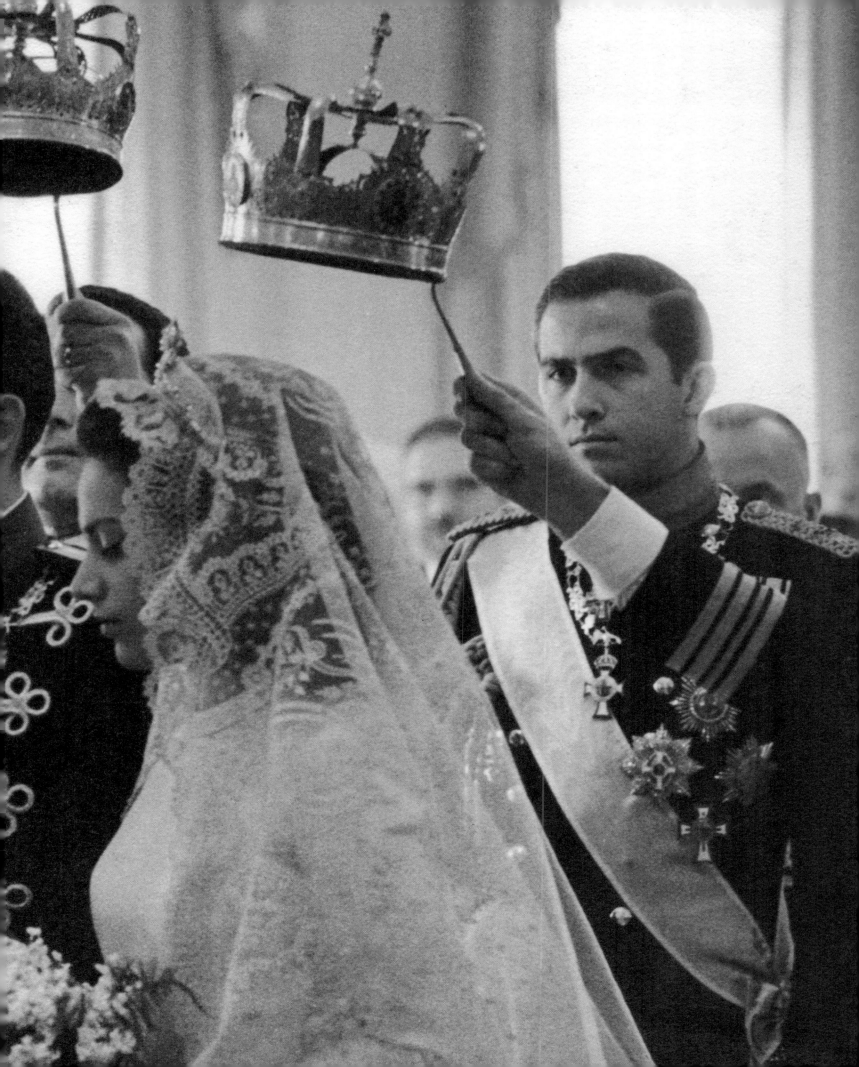

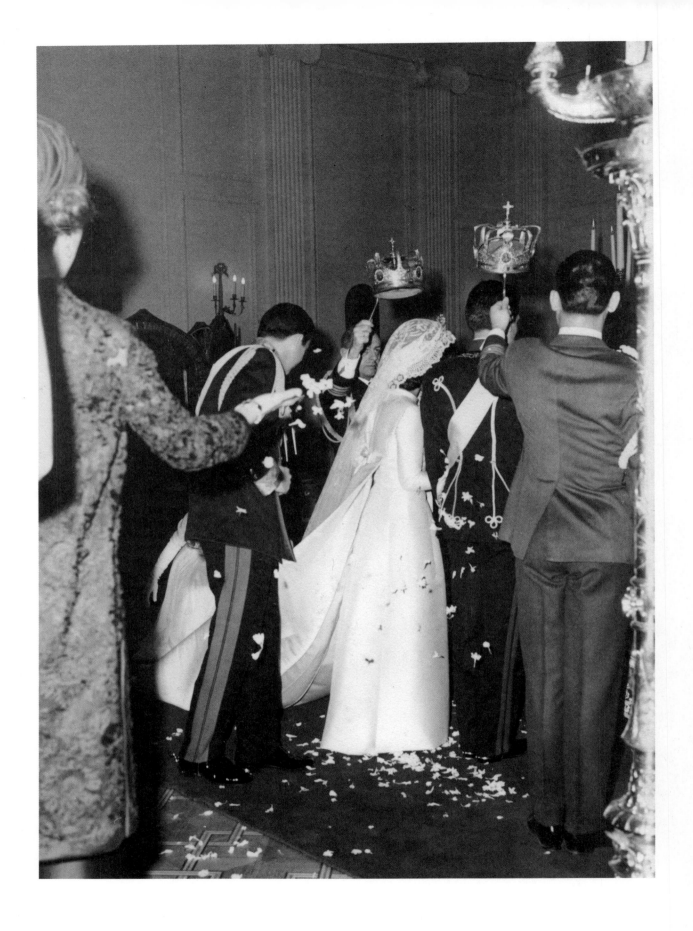

In the Orthodox marriage ritual, there is what we call the Dance of
Isaiah. The newlyweds walk three times around the altar, crowned by
the witnesses, and receive a shower of good-luck petals and rice that are
thrown by the guests. That is what's happening here.

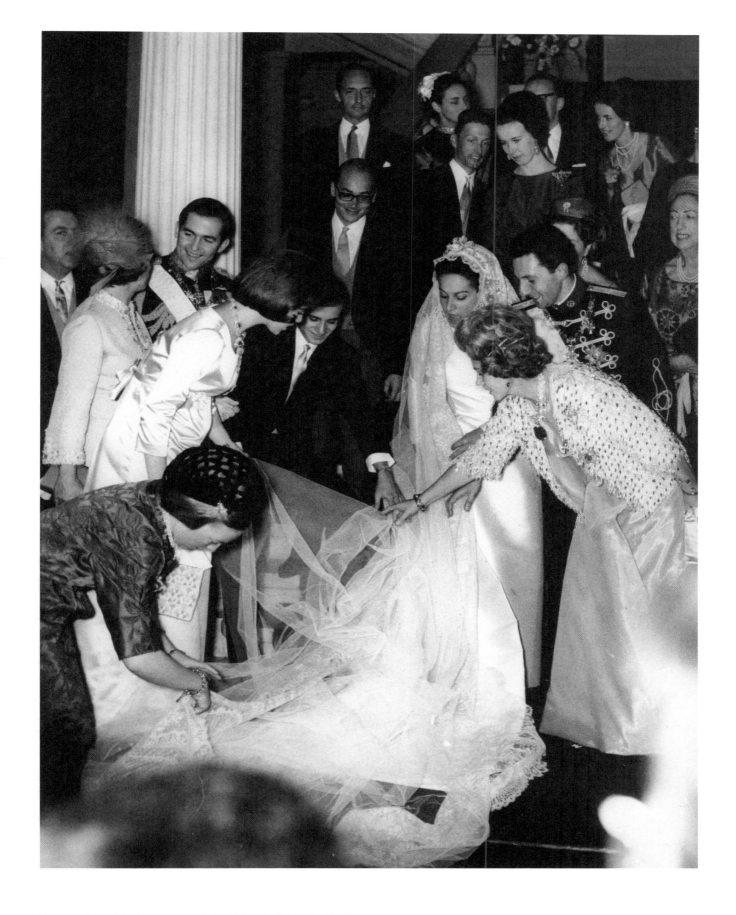

Everyone is mucking in to arrange the bride's train for the family photo on the Royal Palace's staircase. From left to right: my mother-in-law, Elly Karella, talking to King Constantine; in front of them, Queen Anne-Marie with my young brother-in-law Niko Karella; the Duchess of Württemberg; my cousin Diane of France; and Queen Frederica bending down to arrange the folds of the fabric. Behind us, the newlyweds, I see Marina's half-brother Alexandre Lantiez, then my Aunt Ita, Princess Pierre Murat.

We decided not to go on honeymoon straight away. It's a detestable and tiresome convention. So on the evening of the wedding, we took all the relatives who'd come from abroad, plus the friends I'd made in the army, to a tavern run by some friends in Paiania, a village near Athens. The two biggest bouzouki stars of the time came to perform and demonstrate their talent: Vicki Moscholiou and Zambeta. We also asked our very dear friend Rory McEwen to sing and play his guitar—the talent that had made him famous—and my friends from the army performed too.

Marina with an unknown individual who was wearing an evzone outfit.

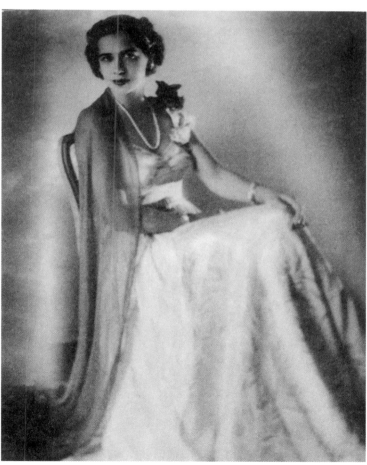

In fact, my marriage served to anchor me to Greece—my anchor's name being Marina—which is what I wanted with all my heart, having fallen in love with my country since arriving there. I started out by getting into the heart of a typically Greek family, my parents-in-law the Karellas, who welcomed me with open arms and with all the generosity and love in the world. This page shows Tedy and Elly Karella. He a discreet, shy, and wonderfully kind businessman.

She an able, intelligent, generous, affectionate, and assertive woman. Both of them treated me like a son.

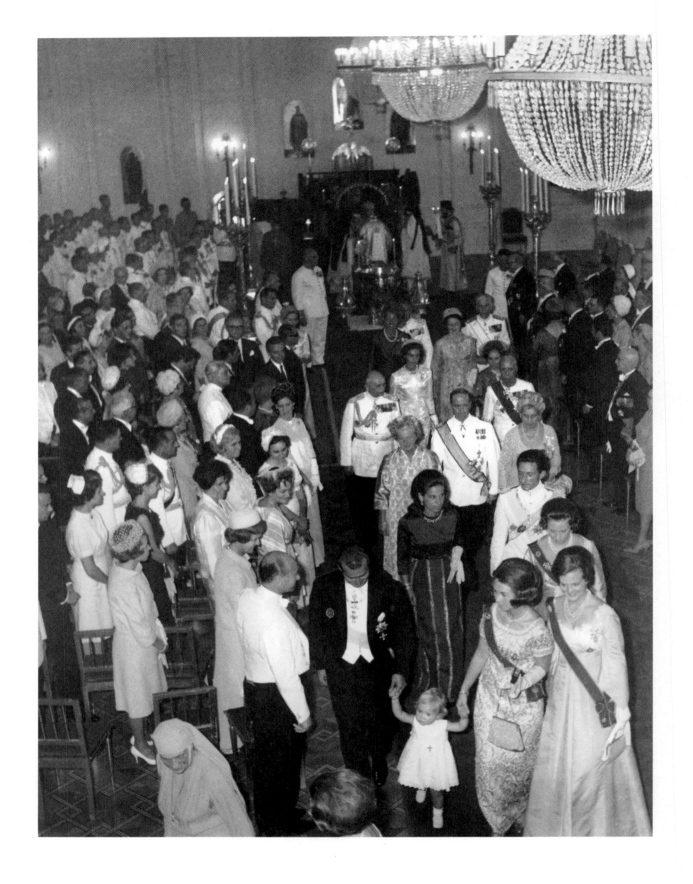

To marry Marina, I gave up my right to the Greek throne—something I was intensely pleased to do. I was therefore no longer a member of the court, and no longer invited to official ceremonies. Marina and I continued to be invited to family celebrations. Thus we attended the baptism of King Constantine and Queen Anne-Marie's first child, Princess Alexia. Here we are emerging from the sanctuary. From left to right: Princess Andrew of Greece, mother of Prince Philip; behind her, the Prince and Princess of Spain, Juan Carlos and Sofía, holding their eldest daughter Elena's hands, with the then Crown Princess and now Queen Margrethe of Denmark; behind them, her sister Princess Benedikte; and lastly, Marina and me, followed by members of court.

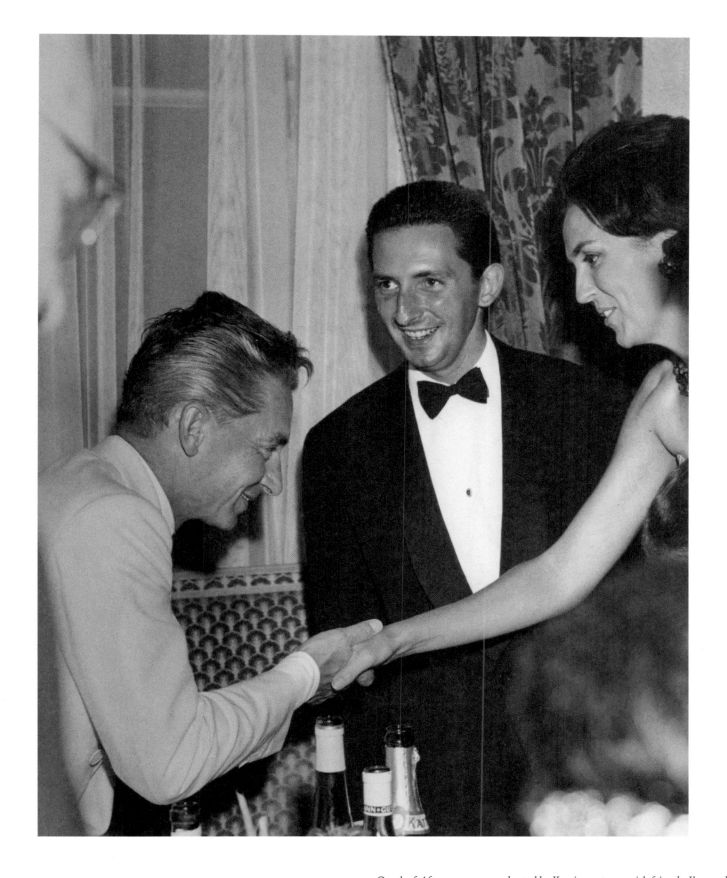

Marina and I had separately started going to the Salzburg Music Festival, and we have continued doing so, from when we were newlyweds right up to today. After a spectacular performance in which Karajan conducted the Berlin Philharmonic, here he is kissing my cousin Maria Cristina of Savoy-Aosta's hand, with my blessing.

Overleaf: After an opera conducted by Karajan, supper with friends. I'm on the left, and next to me is Raffaello de Banfield, director of the Trieste Opera House and a close friend of the Karajans. He is talking to Elyette Karajan, who has remained a friend of ours ever since that time. The two ladies towards the right are the sisters the Princesses of Croÿ, Emmanuella and Catherine—close friends of ours. At the end on the left is Marina. These suppers in Salzburg were most cheerful and interesting. Obviously we would always talk about the concert that we'd just attended. All these people were extremely cultured, so there were interesting discussions, but also gossip, and comments that weren't always very charitable but were certainly entertaining.

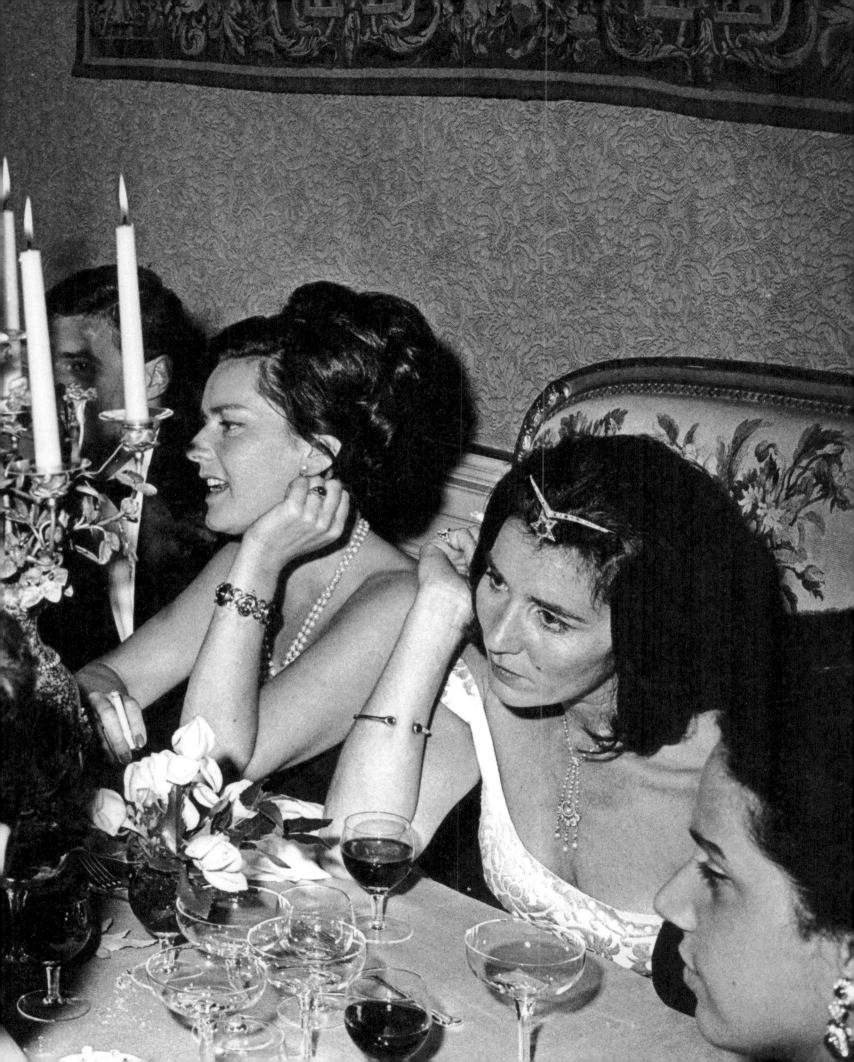

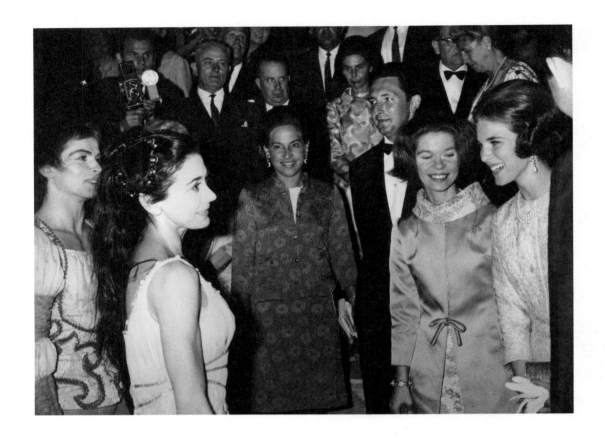

Various artistic performances. At the summer festival in Athens, in the ancient theatre of Herodes Atticus, Queen Anne-Marie and Princess Irene, along with Marina and myself, congratulate the two star dancers: Margot Fonteyn, prima ballerina of the Royal Ballet in London, and especially Rudolf Nureyev. Margot was 48, and obliged to continue dancing to pay for her paralysed husband's care. Rudolf was in his twenties. They danced *Romeo and Juliet*. There was an undeniable electricity between the two of them. They were the most convincing on-stage lovers we've ever seen, and above all the most talented.

A supper meanwhile after an opera in Salzburg. Princess Maria Gabriella of Savoy is sitting between the renowned painter Kokoschka and his wife. He directed a summer school of painting in the Hohensalzburg Fortress, which looms above the city. Marina took classes there, as did Maria Gabriella.

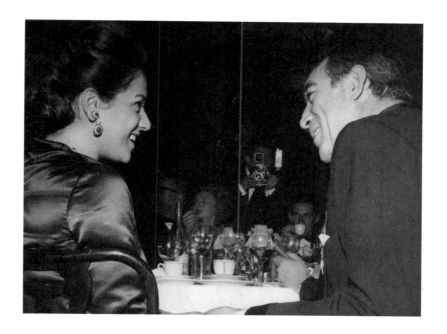

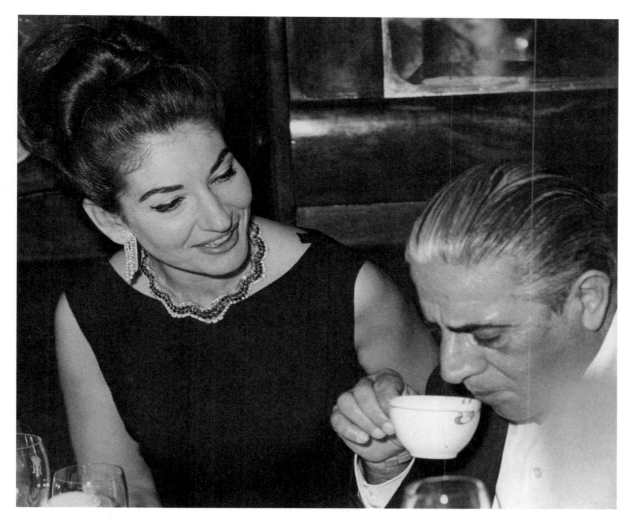

Our post-wedding festivities continued in Paris. One evening at Maxim's, after a gala show, Marina found herself sitting next to the Mexican actor Anthony Quinn, who had just triumphed in *Zorba the Greek*—it had been the film's premiere. She found him very nice, and they met again years later in a foundry near New York where they were working on their sculptures; he'd become an artist after being a great actor.

Also at that gala were the star couple of the time, Maria Callas and Aristotle Onassis. We knew both of them and remained close friends of Maria Callas until her death. She was the greatest female opera singer of the century. A very direct, straightforward woman and a very faithful friend.

Alexandre Lantiez. He was Marina's half-brother, with whom she was very close. He had an immense knowledge of literature and art. He was a friend of all interesting people.

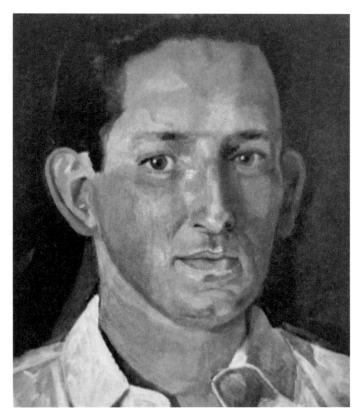

Marina had studied under the greatest Greek painter Yannis Tsarouchis. Here we are watching a theatre rehearsal, and he's the one in the white hat. Before my marriage, I'd met him and he'd asked me if he could do my portrait (reproduced here). I accepted, and he made me pose often and for long periods. I didn't regret it. The great artist would transform himself into Scheherazade, and every time he'd tell me such thrilling tales, in such an interesting way, that I would stay riveted and stock-still for hours. An unforgettable friend and an unforgettable artist.

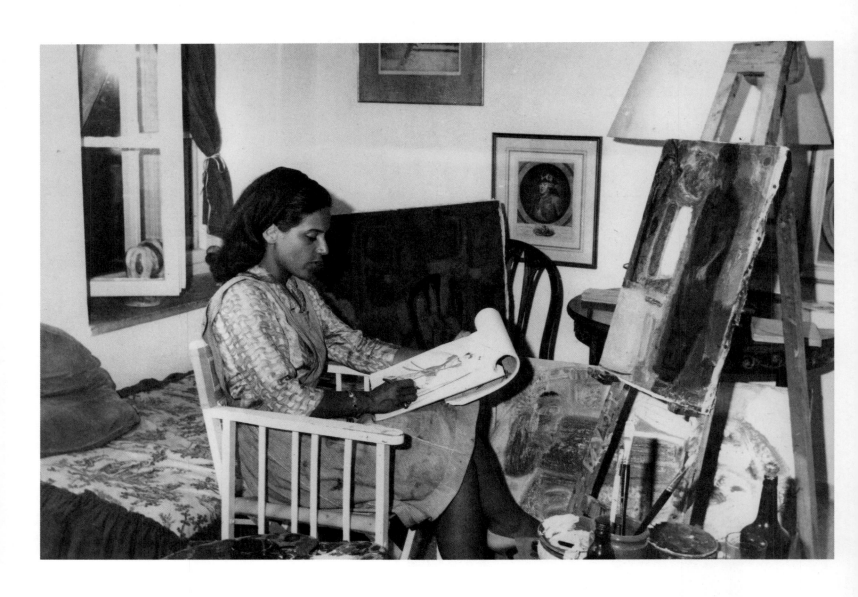

Speaking of artists, Marina continued her career as a painter after our wedding. Here she is in her studio in the villa that our parents-in-law gave us in Maroússi, not far from Athens.

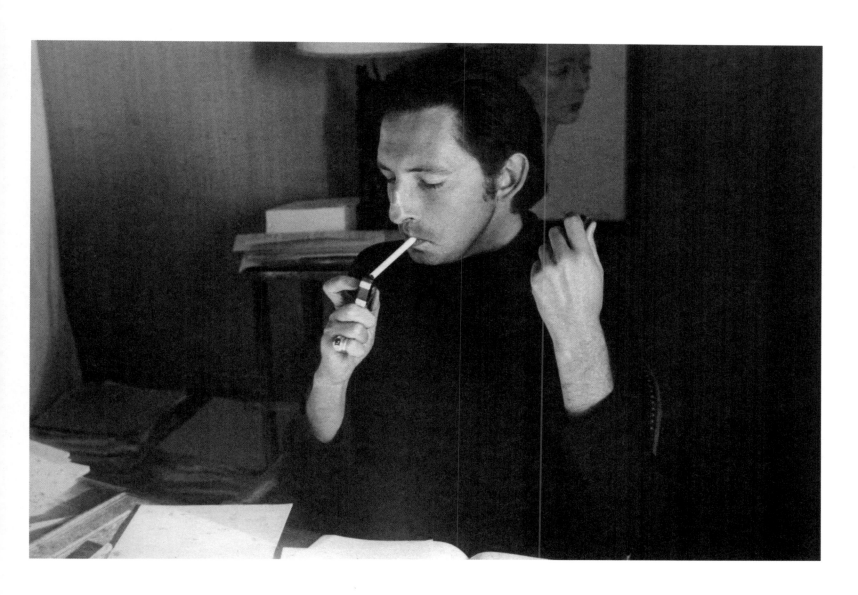

As for me, I set out on my literary career, which in all truth didn't begin brilliantly. I refused to be discouraged, and I loved writing. It's an occupation that gives me fulfilment and that I wouldn't be able to live without.

Overleaf: Besides painting, Marina continued making theatre sets and costumes, such as the ones for Aristophanes's *The Assembly of Women*, which she created for the great Greek actress Anna Synodinou for the inauguration of the Lycabettus Theatre. Here, Marina poses with the troupe, with the star, Anna Synodinou, in the middle.

Marina in the middle of the stage with her scenery.

The great actress greeting us—me and our close friends Christina and Ioannis Kyriakopoulos—while an army friend, Christos Tsironi, kisses her hand.

Details of Marina's work for the play. Her with her accessories.

The premiere of *The Assembly of Women* at the Lycabettus Theatre.

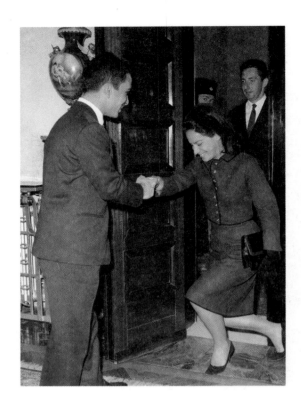

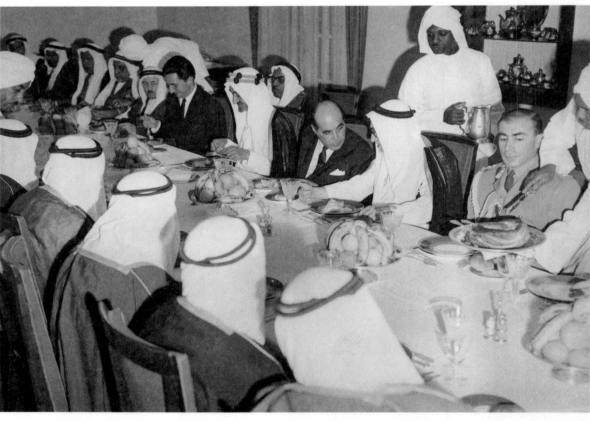

We were also sometimes sent on missions abroad. Marina and I visiting King Hussein in Amman, the capital of Jordan. Marina is curtseying, as protocol demands. He was short with a rather large head, and was very well-built. He was a shy man but was immensely charming, with a deep voice that could seduce anyone without the slightest effort. He had undeniable aura and charisma. He was a very great man, and a very great ruler.

I was sent to Saudi Arabia to try to patch things up with King Faisal, whom Greece had somehow offended—I can't remember what the situation was. He couldn't have been more friendly in his welcome, and he wasn't interested in the pomp of the Arabian court before and after him. He was all about austerity, spirituality, focus, and work. Probably one of the most fascinating men I've ever met. He thought only of his country's advancement, and was full of pride, enthusiasm, and warmth when he showed me the plans and maquettes that had been brought to him. A remarkable, truly inspired man. He would be assassinated by a member of his own family.

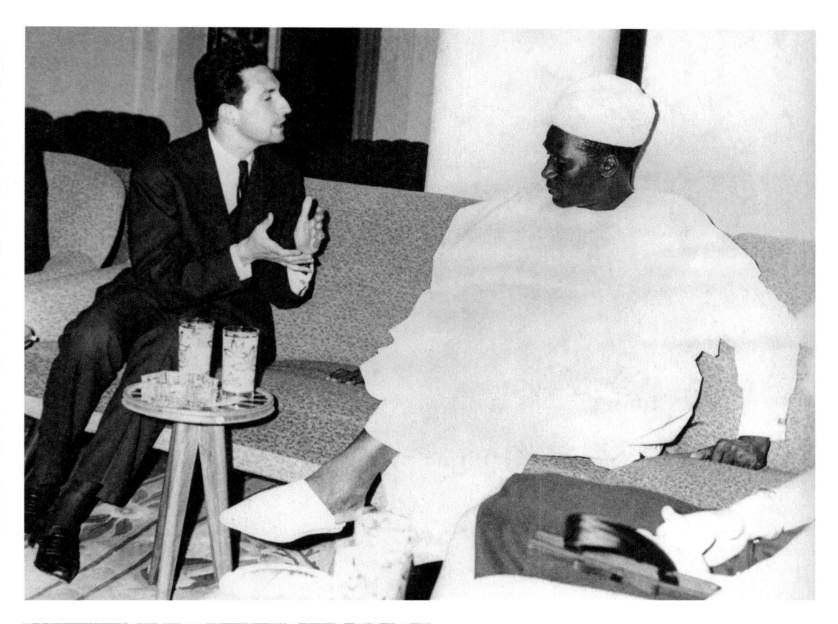

The Prime Minister George Papandreou sent us on a public relations tour of several African countries. During that trip we stopped off in Guinea, where the communist leader Sékou Touré, despised by De Gaulle, was then in power. We were treated to a folk-dance performance, and I had several enthralling conversations with this man, who had an almost hypnotic power when he was talking.

Overleaf: There were also vacations. Here we are with a few friends on a beach that looks out toward the island of Euboea. It was Holy Week in 1967, barely a few weeks after the dictatorship had taken over in Greece. Marina and I are standing, while sitting or lying down are the beautiful Eleni Elianou and Theodore and Penny Velissaropoulos, our great friends. It was a chance to relax after the terrible tension of the preceding weeks.

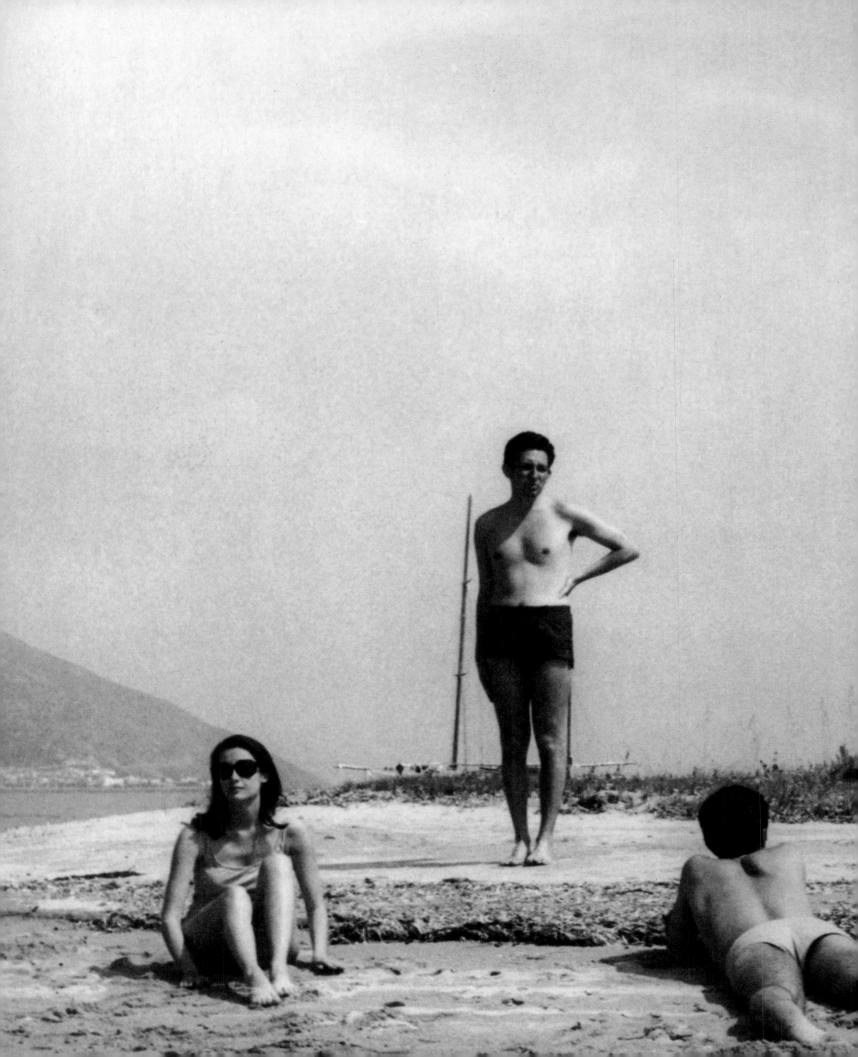

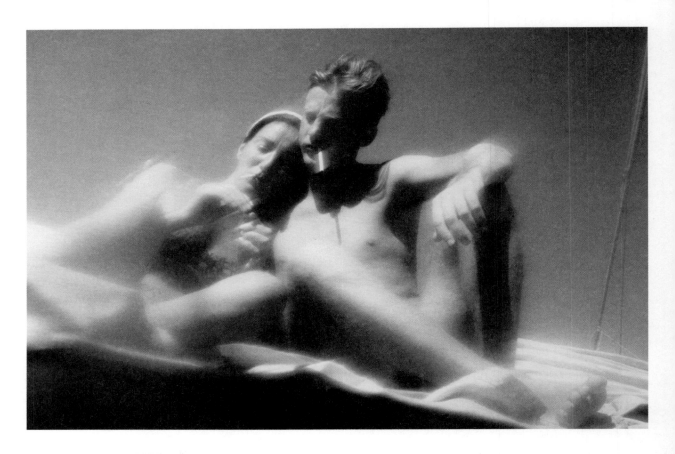

I loved those short cruises. I'd always loved the ocean, and those Greek panoramas of sea, islands, and rocks drew me into a state of calm and reflection. We invited friends to join us on the boat. Here, Princess Catherine of Croÿ with Manley Hudson, an American lawyer, who was very taken with the beautiful princess.

My parents-in-law had a magnificent sailing yacht, the *Thendara*, on which we enjoyed countless mini-cruises.

The sailor Nicolo, faithful of faithfuls, taking us to the beautiful boat that, for me, was evocative of a racehorse.

Portugal in the late 1960s. The Count and Countess of Paris on a beach not far from Lisbon. Wearing the same outfit, my aunt would later be chucked unceremoniously into the swimming pool at the House of France's Quinta do Anjinho residence.

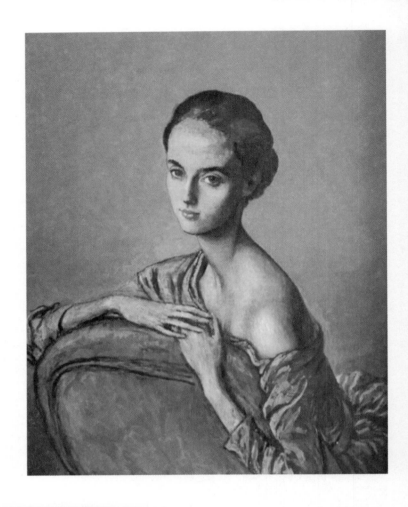

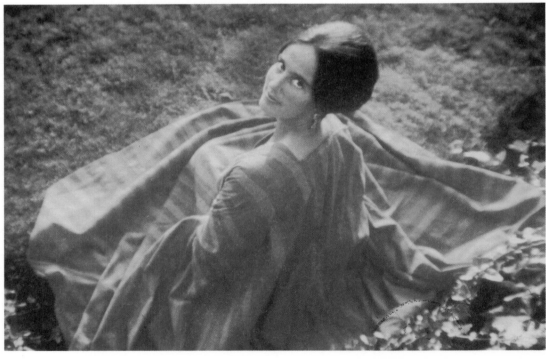

My first cousin Monique d'Harcourt, Countess Boulay de la Meurthe. In the summer when my mother died, I was sent to my grandmother's in Morocco. Not knowing quite what to do with me, my grandmother called her granddaughter, Monique, who had a farm thirty miles away, to ask her to look after me—which she and her husband Count Alfred Boulay de la Meurthe ("Micky and Fred") did, offering me all their kindness and sympathy. An unshakeable friendship was born there and then, and has endured ever since. Micky became the sister I never had. We've been telling each other everything for more than sixty years. All those travels, partners in crime. So much laughter and emotion. Here, she is posing in our garden at Maroússi.

Monique captured by the painter Jean-Claude Fournot in a portrait that still today hangs in my bedroom.

We regularly visited Swinging London thanks to my childhood friends, the enchanting Scottish McEwen family. The star couple: Rory McEwen, who had sung and played guitar on the evening of our wedding, and his wife Romana von Hofmannsthal, granddaughter of the famous writer. Their house in Tregunter Road was filled with beautiful things and always full of friends and celebrities: actors, artists, duchesses. Rory was one of my best friends. Not just a musician, but later a very talented painter.

Lady McEwen, who had five sons and one daughter. She dominated this turbulent world with her natural authority, charm, kindness, and undeniable humour.

Rory's brother David, who was the rascal of the family. A drinker and womaniser, he was very funny, sarcastic, mischievous, and irresistible with his inamorata of the time, the famous Jean Shrimpton.

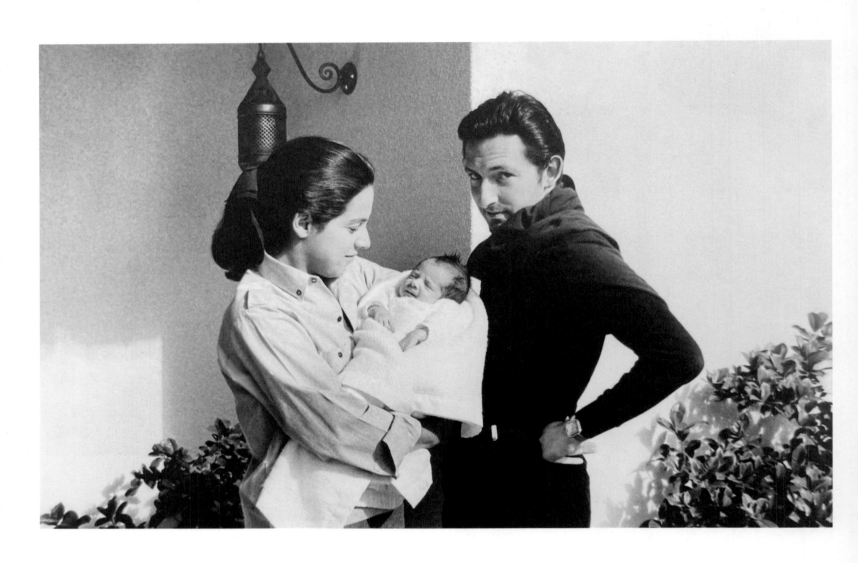

In 1968, on 15 October, our first child was born: our daughter Alexandra. The moment I saw her in the clinic, I felt my life shift completely. A whole new existence opened up ahead of us. An enchanting one. That little girl and her sister Olga are the greatest blessings of our lives and have filled us with joy ever since.

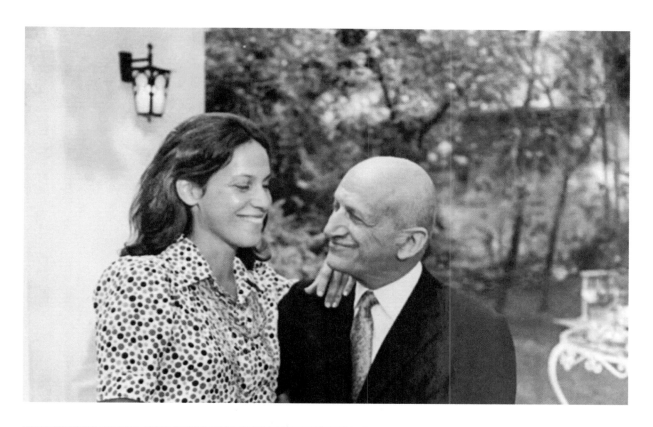

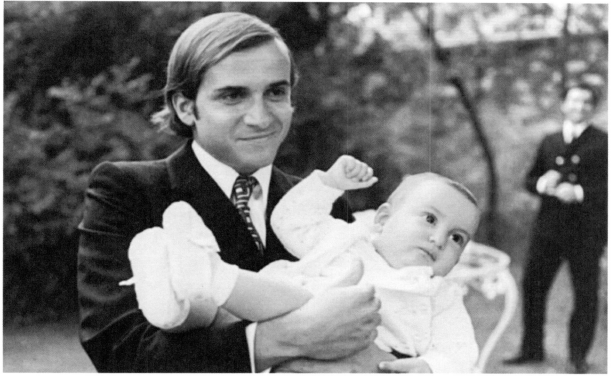

The baptism of our second daughter, Olga, at the Karellas' property in Kifisia. Marina with her father, and the godfather, Marina's brother Nikos Karella, holding the newborn baby. She already had the lively, incisive look that would characterise her and be part of what makes her so charming.

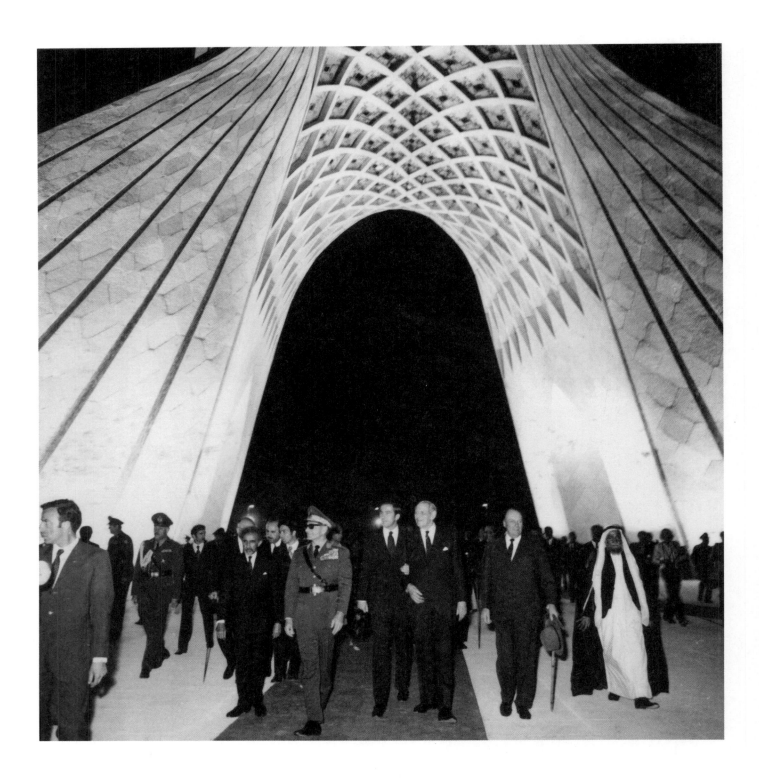

Marina was expecting our second daughter when we were invited in October 1972 to the festivities
in the ancient city of Persepolis, celebrating the 2,500th anniversary of the Persian Empire.
Consequently Marina couldn't come with us. I went on my own. It was an unmatched display
because the whole world was there. Kings and presidents of the West, but also of Asia and Africa,
as well as all the leaders of the communist world. Everyone behaved as if we were all friends. There
were numerous very productive private discussions that helped to further the cause of global peace.
In Tehran, the Shah and his guests inaugurating the huge triumphal arch built over the tomb of his
father, the great Reza Shah, who founded the dynasty. The Shah is walking with the Negus, Emperor
of Ethiopia, and the Kings of Greece, Denmark, and Norway.

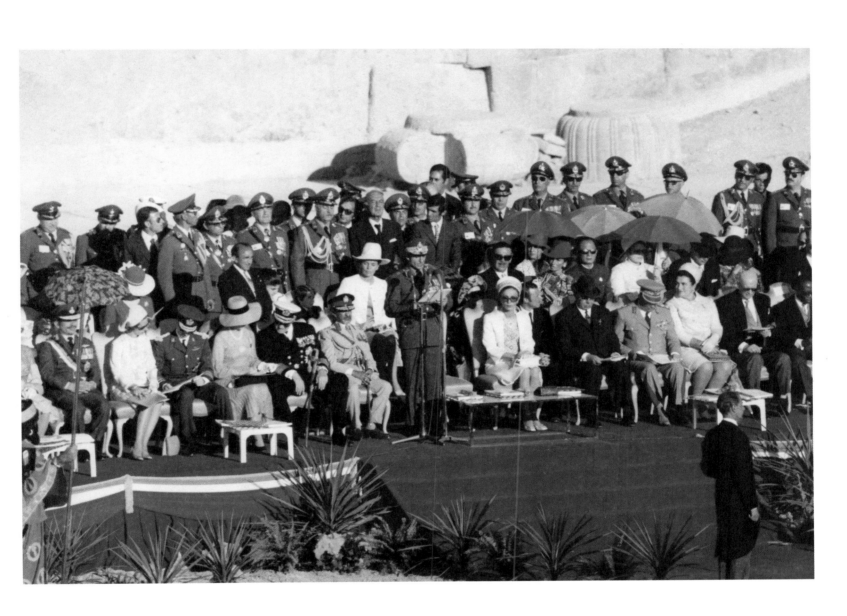

The fabulous military review in the ruins of Persepolis, where soldiers dressed in uniforms from all periods of Persian history processed alongside modern soldiers. They weren't mere costumes. They were all so convincing that you felt as though you were being taken back centuries into the past. Here, the Shah is giving his speech, again with the Negus next to him; on his other side is Empress Farah; then the Russian President Podgorny in a black suit and hat; then Marshal Tito, President of Yugoslavia, and Mrs. Tito. Next to the Ethiopian Emperor are, I believe, King Frederick IX of Denmark with Queen Ingrid.

Alongside our children's births and our careers, we also had an intense social life. Here I am attending a gala in Monaco as Prince Rainier's guest. He is seated with my cousin Hélène of France between myself and him. He was a generous, open-minded, extremely entertaining man, who sometimes used unrefined language in a way that made me laugh a lot. A *grand seigneur*, too.

During a supper at the home of Robert de Balkany, who had married my cousin Maria Gabriella of Savoy, I found myself next to Imelda Marcos, wife of the Philippine President. This woman, who came across as a monster and an ogre, would transform into a little girl when she started to sing, with an extremely attractive and youthful voice, and for the time that the song lasted she'd become a great artist. On my right, the Duchess of Cadaval, and then Jimmy Goldsmith, who was to become one of our best friends.

Our friend the Bolivian billionaire Antenor Patiño built a sumptuous resort on the west coast of Mexico named "Las Hadas," which means "The Fairies" in Spanish. He invited us to its opening. Marina deep in conversation with André Oliver. Of all the men I've ever met, he was the one with the most taste. I shamelessly copied him for countless interior decoration details. On top of that, he was spiritual, lively, and charm incarnate.

Notable figures in attendance at the inauguration of "Las Hadas" included the interior designer François Catroux, nephew of the famous French army general, shown here to the right of Marina, and also, in her blue evening dress, the Countess of Ribes, one of the biggest stars of Paris society and a talented fashion designer. A remarkably intelligent woman whose conversation I always enjoyed.

Overleaf: Not having had a honeymoon, Marina and I decided, before having our first child, to take a three-month trip to South Asia, from December 1966 to March 1967. Since the monarchy still officially existed in Greece, we were given a privileged reception everywhere. The President of Pakistan, General Ayub Khan, gave us an audience. "I'm Greek," he said, which rather surprised us. "In fact, I'm a descendant of one of Alexander the Great's soldiers." And with that, reminded us that our illustrious ancient compatriot had come as far as India. Thanks to him, we enjoyed a privileged welcome in Lahore. Here we are in a horse-drawn carriage in the garden of the province's Governor General.

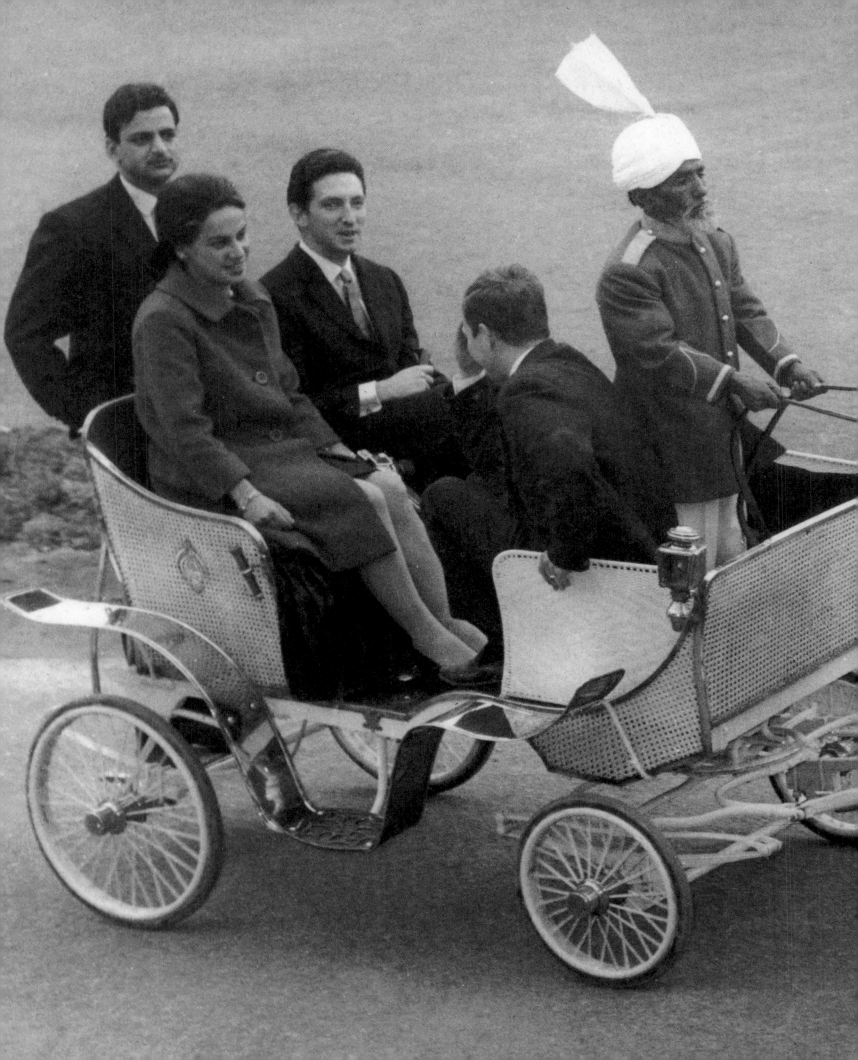

After Pakistan, it was India. Rajasthan, with its various Maharajas—colourful, romantic, exasperating characters who were the subjects of gossip across the country. On the way we came across this procession of camels ridden by young turbaned men.

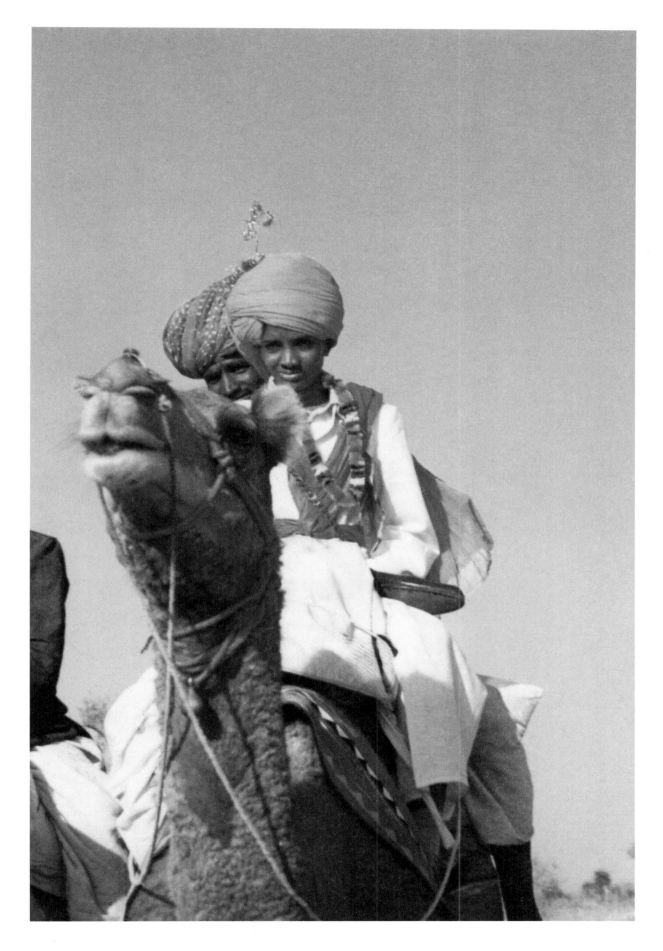

Since then, India has become one of my favourite countries. As I always say, India is the mother of everything. The Indians invented everything and at the same time they are so entertaining, full of humour, kind, welcoming. I feel at home with them. This vast country, which is in fact a continent, is boundless.

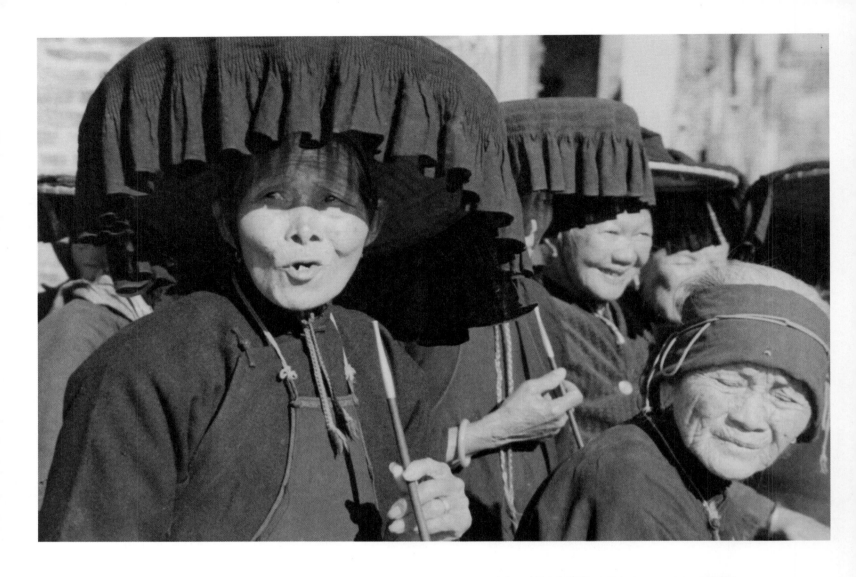

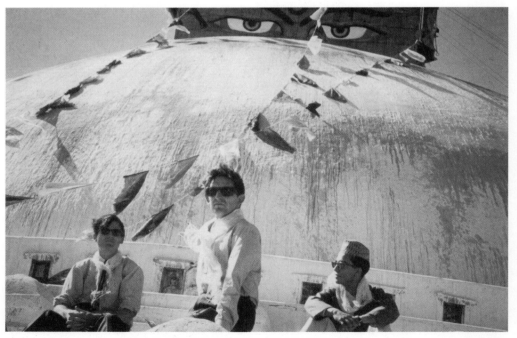

Still our trip to Asia. In a village near Hong Kong, Chinese people in traditional costume, cheerfully smoking.

Then, Nepal. Me posing in glasses with our Nepalese guide and our friend the American lawyer Manley Hudson, who had come with us, in front of a stupa not far from Kathmandu.

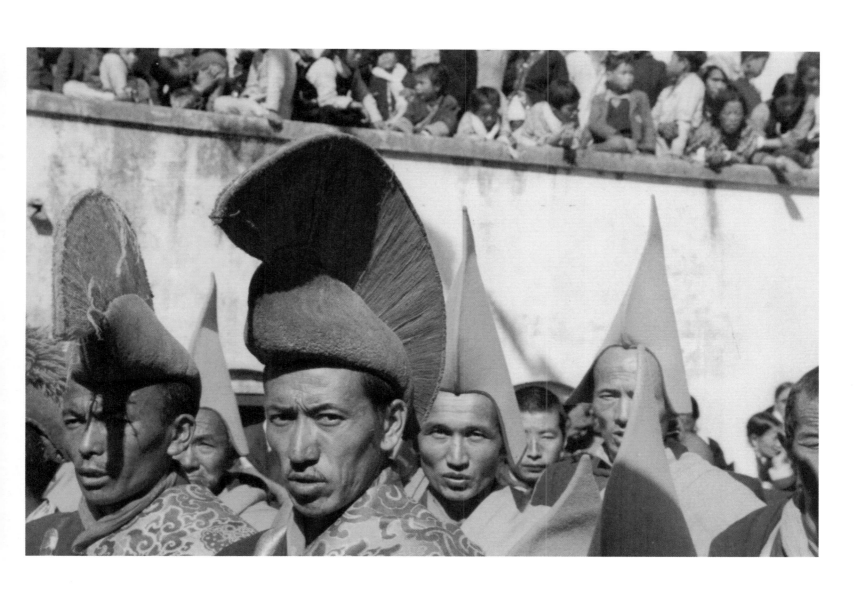

Tibetan priests, who had taken refuge there because of the Chinese communist invasion of their country.

I've travelled many times before our wedding and since, right up to the present, to some of my favourite regions of the world: Western Asia, Northern Africa, and the Arabian Peninsula. The extravagant Montaza Palace in Alexandria. It was built by King Fuad of Egypt. It was converted by the Egyptian Republic into a casino, but even before that, King Farouk would play cards there night after night. One evening when the poker round had got intense, the King announced a quad of kings. One of his guests, whom I met, very boldly asked to see. The King produced one king, a second, a third... "And the fourth?" prompted the guest. "The fourth is me." And without hesitation, the King took the pot.

A street in Cairo with carts ferrying people about, just like in the Middle Ages. You can see this spectacle in all the engravings. Nothing had changed in Old Cairo. Swarming and stuffed with magnificent, almost unknown monuments.

The Roman city of Hatra, north of Baghdad, which we visited in the middle of the desert.
I've only ever stayed in Iraq once, and I found the locals hospitable, but also quite brusque.

After Asia, another long trip, to South America and in particular Peru. The most intense, exciting, mysterious country of all. Marina in the famous ruins of Machu Picchu.

Me on a staircase in the sacred city of Sacsayhuamán, the construction of which still remains one of history's great mysteries. Peru fascinated me with its well-kept secrets, its ancientness, and its intensity.

But I left my heart in Mexico, which still today is by far my favourite country in Central America. In the south of Mexico we visited the park of La Venta, with its strange and enormous Olmec heads. Marina poses with one of our closest friends, Silvia, the beautiful Argentine woman who became Countess Jean d'Harcourt.

While staying in Acapulco, we were invited by the famous actress Merle Oberon to her splendid villa. She was Anglo-Indian and had inherited the beauty of both races, which made her an extraordinary character. Here she is surrounded by her adopted children.

Also while in Acapulco, we were guests of María Escandón, the wife of an extremely powerful Mexican and the queen of Acapulco. Marina and I are posing with Silvia d'Harcourt and her friend Josefina Bemberg. There had been quite a commotion in the Escandón villa the week before we arrived: some bandits had come and fired machine guns in the house's corridors at María Escandón's butler, who belonged to another group of bandits.

A few amazing creatures that we met by chance during our travels. When we visited Salvador Dalí in Cadaqués, we met his favourites of the moment: a pair of extraordinarily beautiful Anglo–Indian male twins. One was devilish, the other a saint. We never knew which was which.

The famous model Deborah Dixon, who would marry the poet Anthony Robert and is still a friend of ours today. She is sitting in a priest's chair in the ravishing little ancient theatre at Amphiprion, not far from Athens.

Marina got a number of our young friends—and not-so-young ones—to pose for her work. Among her favourite models were this iconic couple: François Wimille and his wife, the producer Catherine Breillat. Both were young, good-looking, and talented.

Our friend Gilles Dufour, who went on to become a very important figure in fashion and assistant to Karl Lagerfeld.

The whole family: Marina, me, our two daughters Alexandra and Olga, and the dog Paquito, in the wooded garden of our house in Maroússi. At that time, it was a suburb of Athens. When we moved there, our Greek friends said: "What? You're going to the countryside?"—something the Greeks view with horror. Countryside or not, it was a house where we were very happy, with a magnificent view over Athens, an adjacent pine forest, and a family I adored.

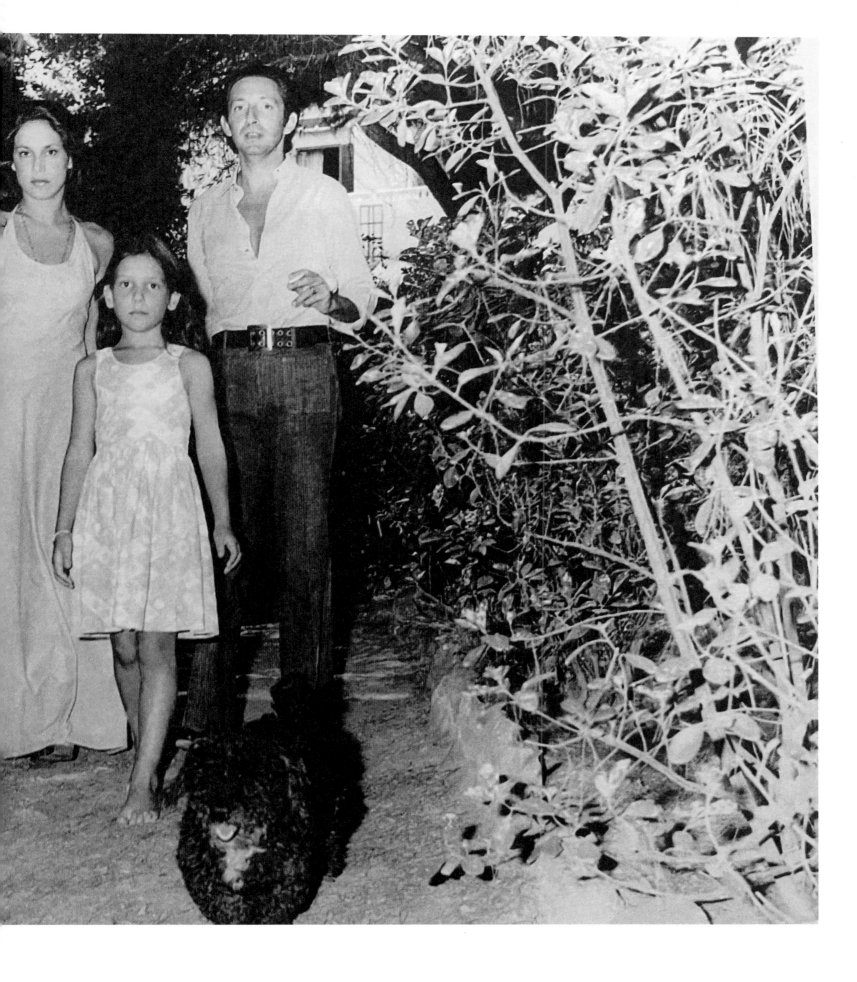

CHAPTER FOUR
PARIS 1975–1980

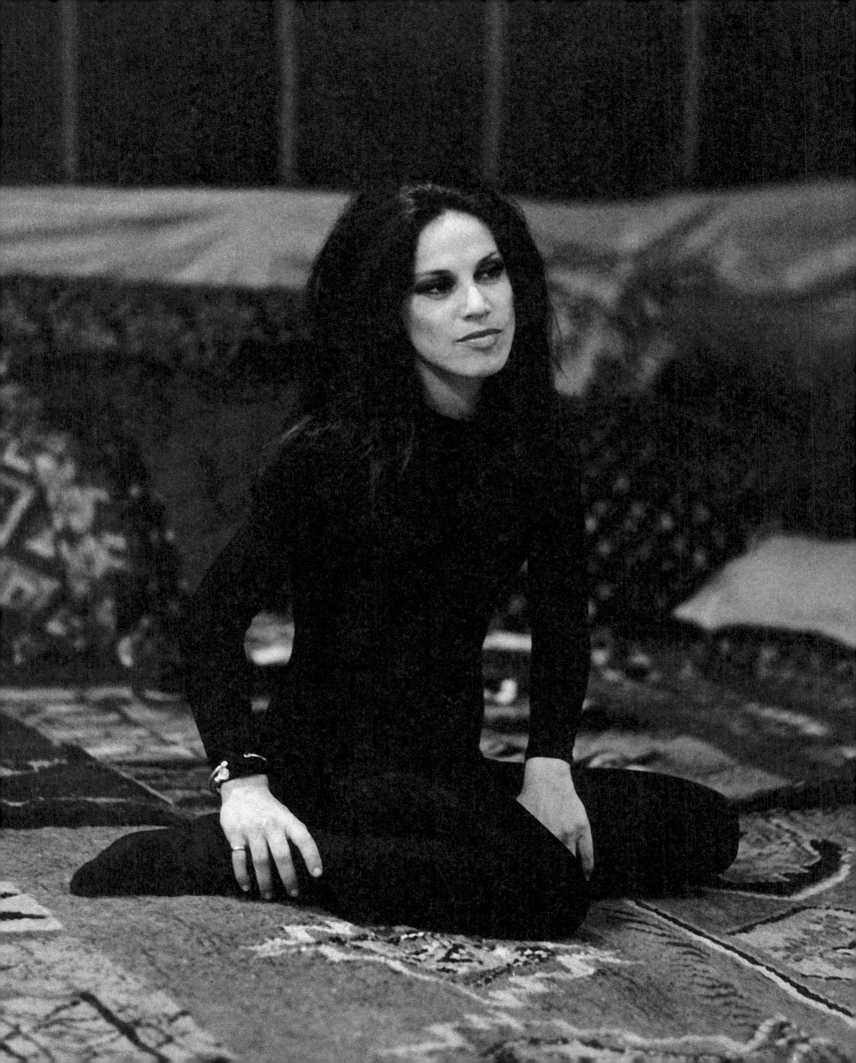

At the end of 1974, we moved to Paris. The intention was mainly professional. The idea was to get closer, for Marina, to the world of art and galleries; and for me, to the world of literature and publishers. We found a beautiful apartment in the 7th arrondissement in the old part of the capital. Our windows overlooked the rue de Verneuil, at that time lined with artisans and delightful old stores. Marina's career took off again while I was enjoying great success with my first historical novel, *La nuit du Sérail*. We met many interesting characters from different backgrounds—in particular, one of the most famous artist–couples, Niki de Saint Phalle and Jean Tinguely, who remain a unique example of collaboration. Thanks to them our horizons were broadened. We established a deep friendship with them but also a kind of partnership. We participated in extraordinary experiences with them. This stay of a few years was therefore extremely enriching, while our daughters grew up and expanded their knowledge alongside us.

Marina during the shooting of Niki de Saint-Phalle's
Un jour plus long que la nuit, for which she designed the costumes.

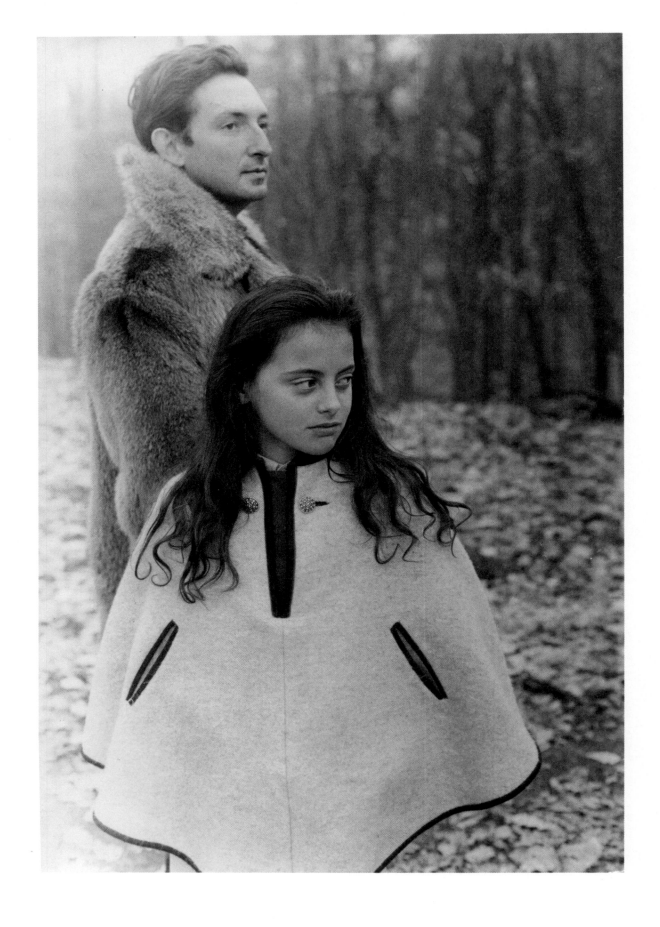

At the "Moulin des Dames," the country residence of the Marquis and
Marquise de La Fressange. The photographer Patrice Calmettes immortalised
me with little Inès de La Fressange, who went on to become a famous model.

We became close friends of Frédéric Mitterrand, whose knowledge, intelligence, kindness, imagination, and loyalty made us very fond of him. Here, he is having a relaxed dance at a party with another great friend of ours, Countess Silvia d'Harcourt.

The last King of Italy, Umberto II, at the marriage of his daughter, Princess Maria Gabriella of Savoy, to Robert de Balkany. Umberto II was the most courteous, cultivated, considerate person I ever met. He was also an innocent victim of history.

Marina and me at home in Paris. We had found an apartment in the old town, behind the Musée d'Orsay. At the time, that part of the city was still full of craft workers. It was a quiet, pleasant neighbourhood. Until the Musée d'Orsay opened and it became a hubbub of tourists and pointless shops.

We met Niki de Saint Phalle in New York but went our separate ways. Later
we saw her again, in Paris, and we became very close friends, right up until she
went to heaven. Marina loved collaborating with her and asking for her advice.
At the time Marina was making the costumes for Niki's movie, *Un jour plus long
que la nuit*. Niki directing the cameraman.

Niki and Marina in the costume that she'd designed.

Marina overseeing the makeup of the "fish-men." One was a great friend of
Niki's, the other was our secretary Stéphane Moreau-Neret. In the film, these
fish-men were the residents of a brothel, where the madam was none other
than the interior designer Andrée Putman.

In the film, I played the king. I was dressed in an antique oriental robe, and
we found this crown in a costume rental shop. Here I am with the film's star,
Niki's daughter Laura Condaminas.

The sculptor Luginbühl, a great friend of Jean Tinguely's, who featured in an unforgettable night scene in Tinguely and Saint Phalle's enormous sculpture *La tête*, which stands in the Forest of Fontainebleau.

Jean Tinguely, meanwhile, had designed his own and his assistants' costumes.
They were all Swiss giants who looked like ogres, but in fact were kindness itself.
Here, in their rather explicit outfits, they go into the women's brothel. Photos by
Laurent Condominas.

Marina's career took off and she had quite a lot of people pose for her work. Me with Olivier Orban. I'd met him as the husband-to-be of the actress Christine Palle, who was quite well-known at the time and was the sister of Umbert Fusco, my best friend from university. Later he became my publisher and we remained lasting friends. I appreciated his intelligence, his talent, and the breadth of his thought.

Niki de Saint Phalle posing for Marina in our living room.

One of Marina's models, Oliver Hoare. He was an English dealer of Islamic art. An immensely alluring Londoner, who was well aware of his charms and exploited them boundlessly, but he was also a true gentleman and proved it.

Another of Marina's models, Stavros Xarhakos. At the time he was the youngest and most brilliant Greek composer. We became friends and we would often go to concerts together. He is still composing now, with the talent that he is known for. Another immensely seductive one.

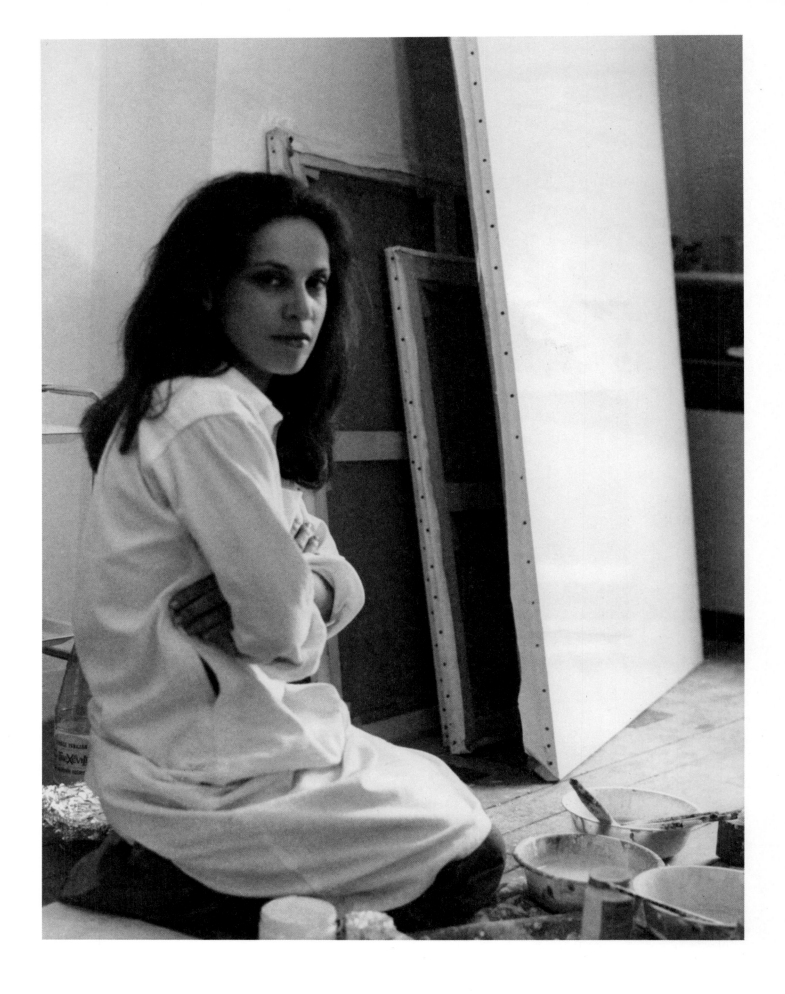

Marina in her studio with one of her works. Looking at her, you can see how she got her models to pose.

Marina Karella, *Flower body*, 1978, 200 × 130 cm, oil on canvas. Private collection, Paris.

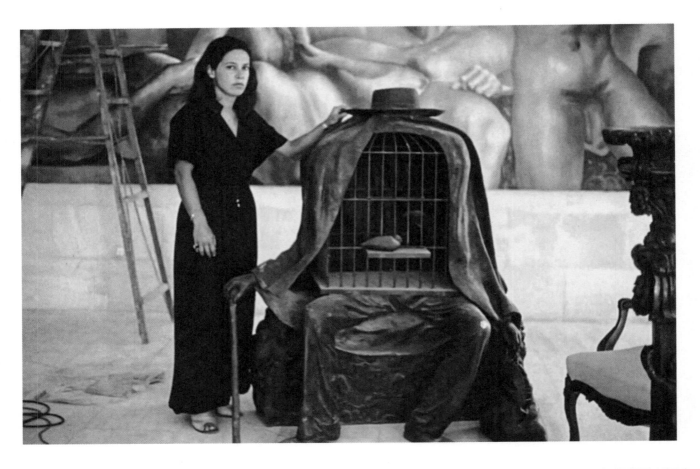

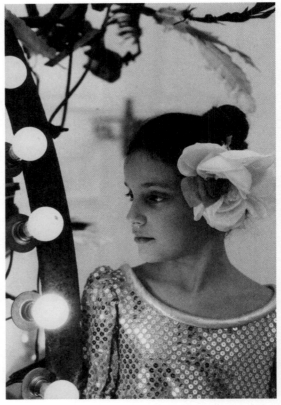

Marina posing next to a sculpture by Magritte. Behind is a painting by
Harold Stevenson, which makes me think that this photo must have been
taken in the Athens villa of Marina's gallerist, the famous Alexander Iolas.

Jean Tinguely and the sculptor César. Jean had invited Marina and me to the Monaco
Grand Prix. It was the first and last car race I ever attended. It was exhilarating. We got
together at the Colombe d'Or for supper. Niki de Saint Phalle, Tinguely, César, and
us. César had us dying with laughter with his very bold stories.

Our two daughters, Alexandra and Olga, posing for Marina
in specially chosen outfits that they particularly liked.

Olga posing for Marina with a sculpture by Eva Aeppli. She was Tinguely's first wife, a Swiss sculptress who made giant dolls. When Marina brought one of these sculptures home, sitting next to her in our car, she caused quite a stir in the Paris traffic jams when the occupants of nearby cars saw the mannequin beside her.

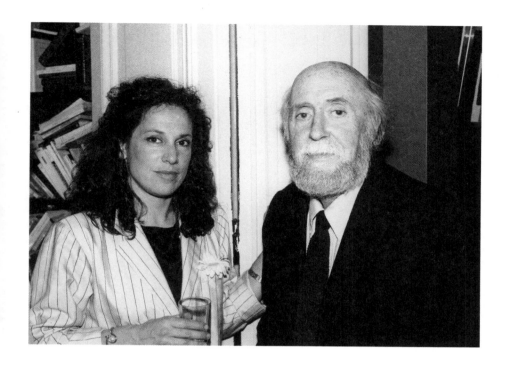

Marina with our friend Yannis Tsarouchis, the greatest Greek painter.

Marina with Teeny Duchamps. She was the painter Matisse's daughter and the artist Marcel Duchamp's wife. A *grande dame* of the arts.

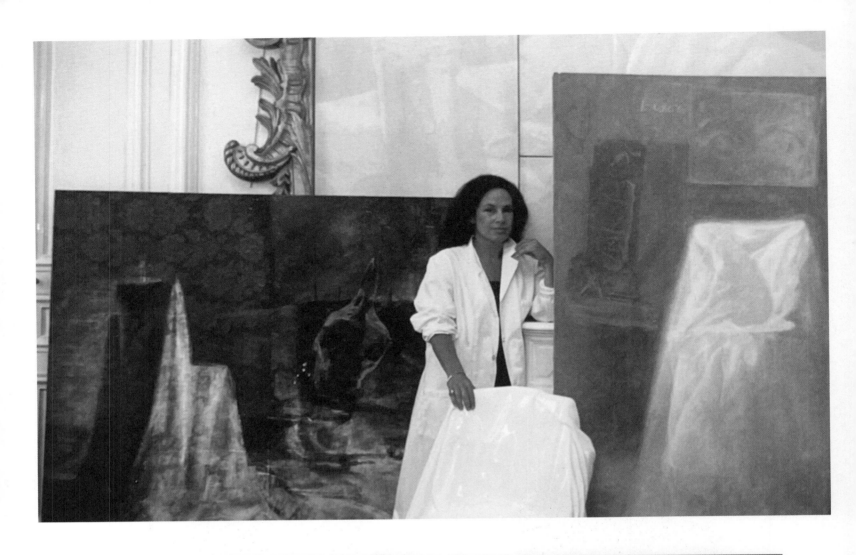

Marina surrounded by several of her works in our living room in the Rue de Poitiers, Paris.

Marina created scenery and costumes for the Monteverdi opera *L'incoronazione di Poppea*, produced in the Athens Opera the Liriki Skini. It was one of her biggest successes. A masterpiece of poetry, grace, and inventiveness, unanimously praised.

Marina's gallerist, who was the start of her major career: Alexander Iolas. He came from Alexandria and had been a dancer in the Marquis de Cuevas's company. During the Second World War he became an art dealer. He bought works by artists who had sought refuge in the United States for nothing, and practically made their careers. Visiting the MoMA with him was fascinating. He would stop in front of numerous masterpieces that were worth millions of dollars and say, "I bought that one for 150 dollars," or, "that Magritte, I bought it for 90 dollars," and so on. He was extravagant and outrageous, very entertaining, and had an infallible eye for art.

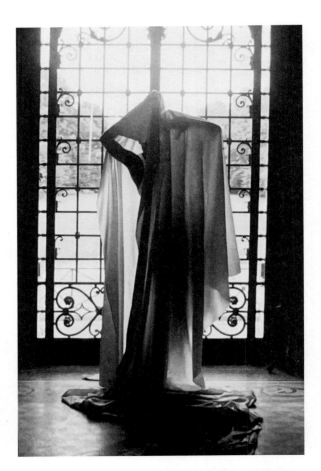

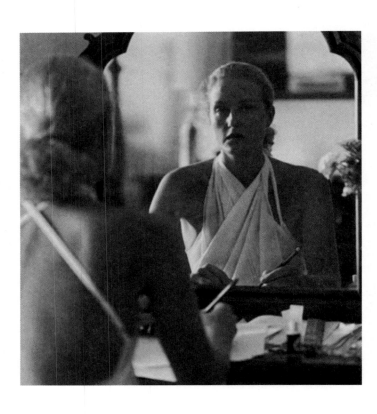

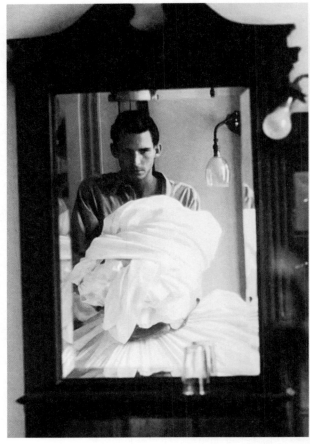

Alexandra Condon, a young woman who worked at the Marlborough Gallery in London. She was half English and half Austrian, and her mother was a member of one of the aristocracy's most prominent families. She came to our place as our daughters' au pair and never left us. She and James Brown, who had also arrived in Paris, met each other through us. They fell in love and married. They remained our closest friends until a brutal car accident took them off to heaven.

James Brown posing for Marina. This Californian painter living in Paris came into our lives at that point. He was good-looking, charming, very talented, and somewhat mysterious.

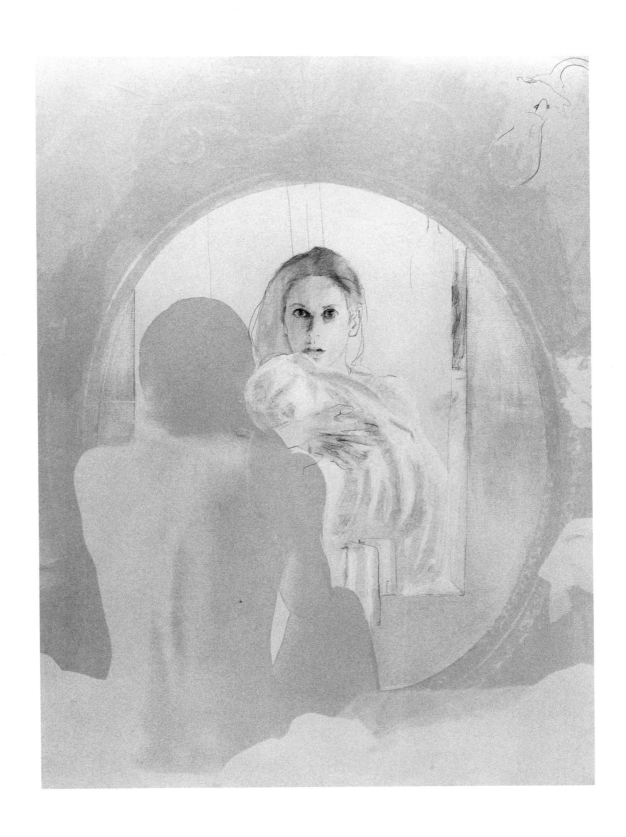

Marina Karella, *Through the Looking Glass*, 1984, 120 × 95 cm, charcoal and oil on canvas. Private collection, Paris.

Marina posing gloriously and me whimsically. We loved Paris. We had our apartment.
We found our children endlessly delightful. But soon we'd be moving again.

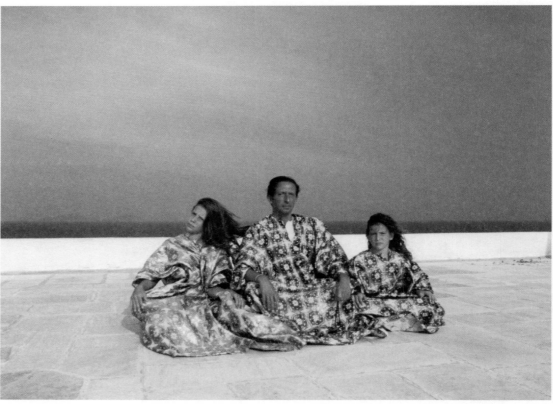

Our daughter Olga, by Christophe de Menil.

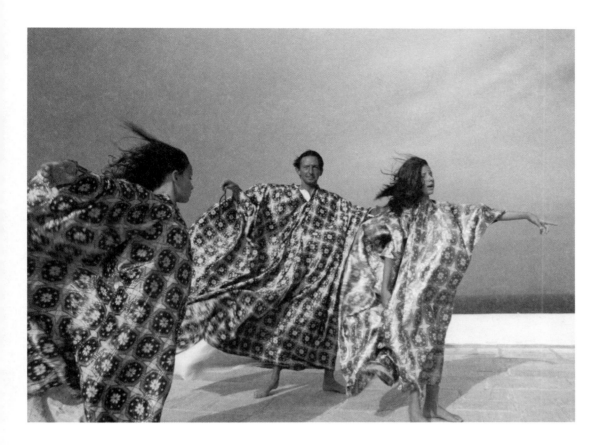

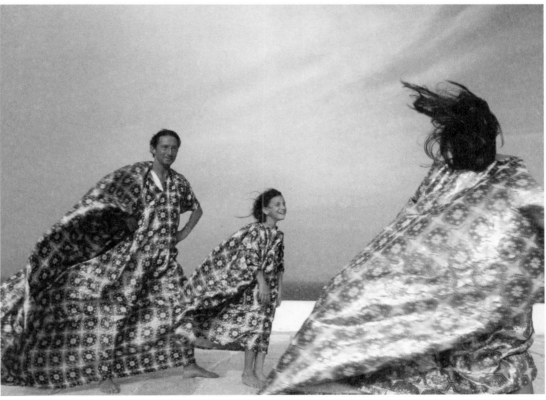

Me with our two daughters on the terrace of the villa that we rented in Spetses one summer. I'd found these brocade fabrics in the souk in Aleppo, where my friend Georges Antaki had taken me. He was appalled at my purchase. Indeed, these fabrics were intended for household staff, who were crazy about them. Except that I'd gone crazy for them too, and so did everyone who saw them.

CHAPTER FIVE
NEW YORK 1980–1992

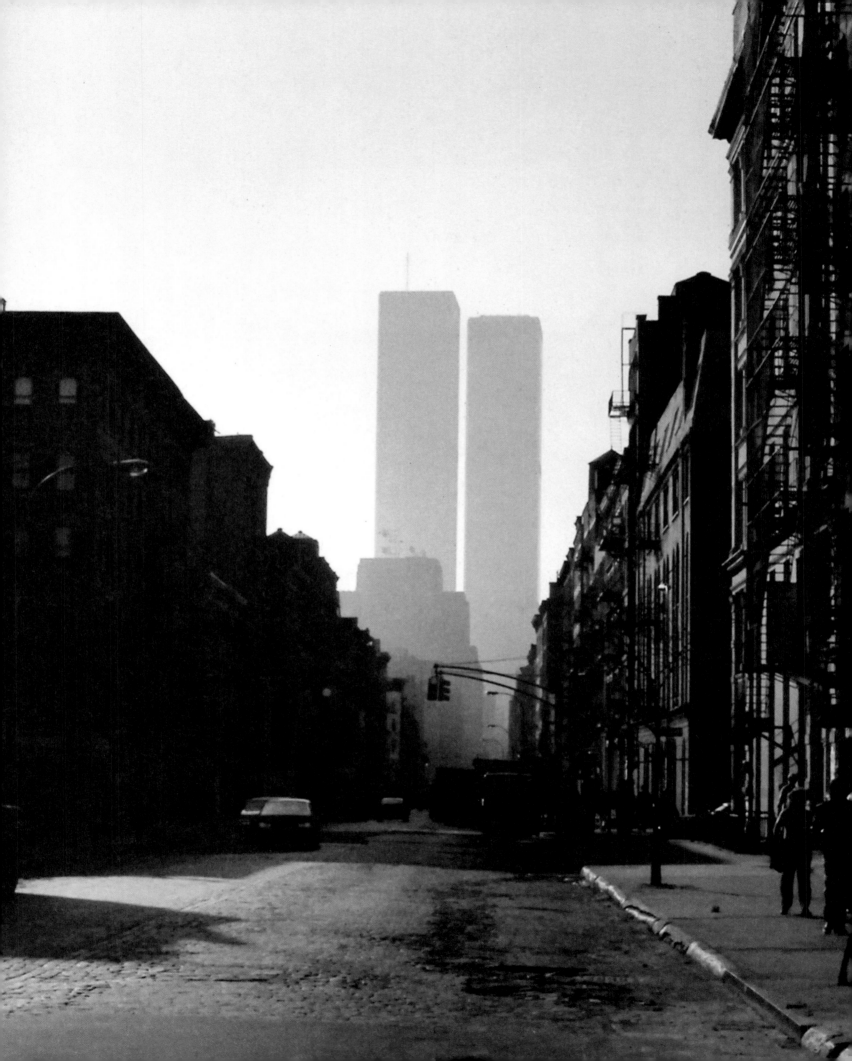

One day, we decided to go live in New York. Marina had lived in the United States as a child and she had a cherished memory of it. As for myself, I was curious to discover this mysterious empire that dominated the world. We lived in a beautiful apartment on the Upper East Side. Marina rented a spacious studio in SoHo, which wasn't trendy yet. It was one of the most exhilarating periods of our lives. We met all the renowned American artists of the time, all the famous personalities, and all the great figures of New York society. We happily brought these groups together at the many dinner parties we organized, because we so loved entertaining.

We were tireless in hosting anyone who counted for us—none of which prevented us from going on our habitual far-off trips, a lot of which were for research related to my work. We were extremely happy in New York. The four of us had never been so close and so delighted to live together. I am infinitely thankful to the United States for what it offered me: freedom, endless opportunity, and effortless contact with whomever we hoped to meet. But also for the energy and the talent that Americans possess to be generous and present in the moment.

Freshly settled in New York, we walked everywhere at all hours of the day and night. This is how Marina came to photograph the Twin Towers very early one morning, which in this deserted street appear like the ghosts of buildings. It is a photo that could almost be premonitory.

Having been interviewed for Andy Warhol's famous *Interview* magazine, Marina was photographed by Robert Mapplethorpe. He was an extremely kind, likeable man. We were at his last birthday party when he was already terminally ill with AIDS. He displayed unimaginable courage and dignity at that party.

Marina's work and personality meant that we were instantly immersed in the highest echelons of the New York art world. We became very close friends of a wonderful couple. He was the painter Francesco Clemente, who would later paint my portrait. She was his wife, Alba. Two very different characters, explosive and incredibly friendly, warm and so wonderfully Italian.

But Americans also know how to be welcoming and friendly, such as Brice Marden, the famous artist, posing here for Marina.

Helen Marden is a huge personality. She is pursuing her career as a known artist. At the same time, she is a very kind friend. I don't know what she is doing in this photo, but she is certainly having a lot of fun with Fran Lebowitz, the author and satirist, a well-known character in the art world.

A gathering of the worlds of high society and the arts, as only New York knows how to put on. Marina, on the left; then James and Alexandra Brown; Count Cornelius de Bousie, smiling; and the illustrious painter Francesco Clemente with, at the front, his wife Alba. On the far right, the artist Keith Sonnier and his wife Nessia Pope. In the foreground is Silvia Martins, the beautiful Brazilian artist who was to marry Konstantin Niarchos.

At the home of Earl McGrath and his wife Camilla Pecci-Blunt, who threw New York's most successful, entertaining, and artistic dinner parties. From left to right: Brice Marden, Francesco Clemente, and Ricky Clifton, a key figure in New York society.

On our Park Avenue staircase, from left to right: Vincent Fremont, one of Andy Warhol's main assistants, who at the time was in charge of his videos and later played a crucial role in his foundation (he and his wife Shelly became close friends of ours); then James Brown; and the painter Alex Katz with our friend Clarice Rivers. She was a phenomenon. Born in Wales, she had come to New York to work as an au pair for the daughters of the great painter Larry Rivers. She ended up marrying him. In her Upper West Side apartment, she threw the most successful dinner parties with huge quantities of excellent food that she cooked herself. She would host the world's top artists mingled with people from high society. Everyone had a better time there than anywhere, endlessly lively, that being Clarice's great gift. It was rumoured that she'd had quite a lot of affairs, including with many of her guests. She was a central figure in New York at the time.

The painter Julian Schnabel in his studio. He couldn't have been more welcoming, kind, open, and genuinely warm.

A gathering of high society and people from the art world. On the left, Bill Rayner, a very wealthy man who was very popular in the artistic milieu. A young couple I don't recognise, then the famous Clarice Rivers, me, and Jerome Robbins, tsar of American ballet. In front of him, Marina. In front of her, the lady from downstairs, if I dare put it that way—she lived in the apartment beneath ours on Park Avenue. Her name was Lily Auchincloss and she was a *grande dame* from one of the city's most distinguished families, who introduced me to the most unexpected aspects of New York. Further along is Laetitia Boncompagni, Princess Boncompagni, née Pecci-Blunt, sister of Camilla McGrath.

A British theatre troupe brought the famous play *Nicholas Nickleby*, based on the Dickens novel, to New York after its triumph in London. The star actor was called Roger Rees. He and several others came to our place for supper afterwards and we became friends. I felt deep affection for Roger. He was kind, open, funny, and completely natural. I went to see him in *Hamlet* in Stratford-upon-Avon, the iconic town of Shakespeare. He asked me what I thought of the play. I wrote him several pages on Hamlet, whom I found an unsympathetic and stupid character. Egocentric to his core.

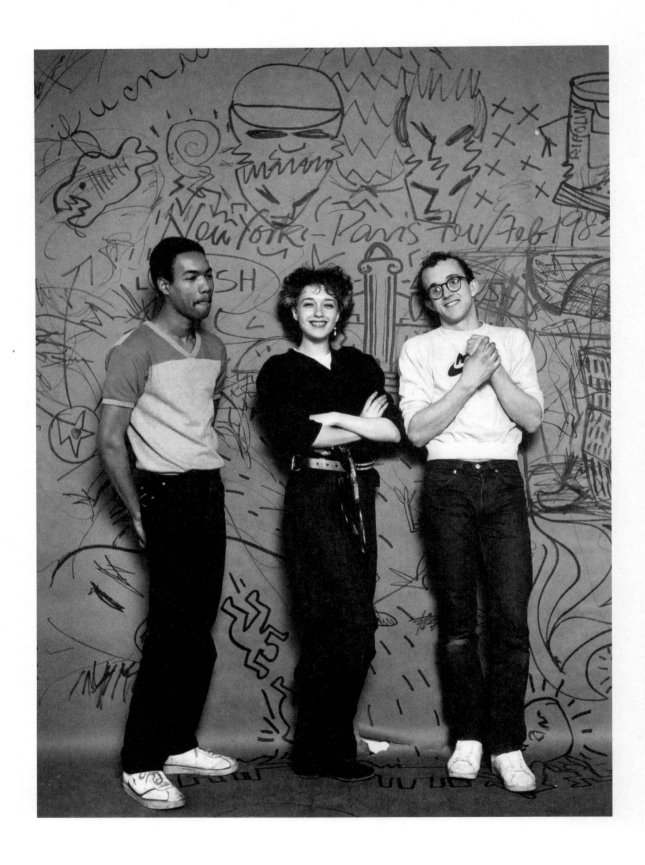

New York, the glorious 1980s. Samantha McEwen, from that famous Scottish tribe I have known since I was a teenager, is here with her great friend with whom she was living at the time, Keith Haring, and his partner, Juan Dubose. They are photographed by Tseng Kwon Chi. New York was then the center of the art world and a city where one could see the purest bohemia and the richest society rubbing shoulders.

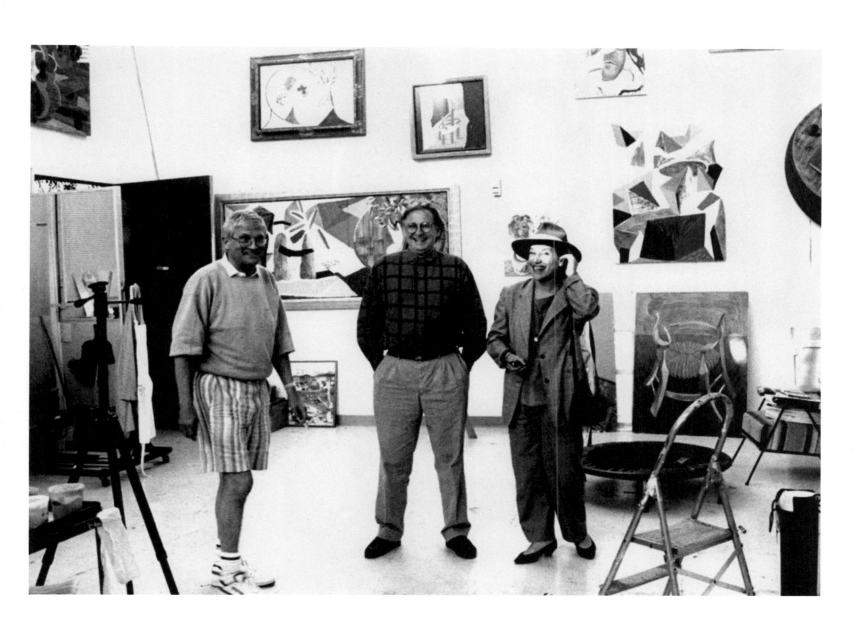

Marina visits her gallerist Earl McGrath in Los Angeles. He took her to David Hockney's studio. Later I
was to meet him, and I liked him immensely. He wore a gold toothpick around his neck on a long chain.

A private viewing of one of Marina's exhibitions. Probably New York's greatest and most famous gallerist, Leo Castelli, a genuine legend of the art world.

Another visitor at Marina's opening: Dominique de Ménil, née Schlumberger, from that illustrious and ultra-rich family. She had married the Baron of Ménil, who massively increased the family fortune and was among the most relentless of collectors. He passed on this passion to his wife, who continued to pursue it as a widow, founding, in Houston, one of the United States' most famous museums to house this collection, which is unique in terms of both its quality and originality.

I can't remember who brought the actor Michael Douglas to Marina's exhibition opening. His wife at the time, Diandra, whom we knew, was beautiful, alluring, and charming. He was likewise a delight at that inauguration.

After New York, Athens. Attending one of her exhibition openings, the actor Takis Horn, who had given Marina her big opportunity by commissioning her to create costumes and sets when she was only 18. He was our close friend and one of the most entertaining people I've ever known. Here he is chatting with Melina Mercouri and her husband Jules Dassin. Melina was an explosive and very amusing character but in fact a wonderful friend, a person of absolute honesty and integrity. Dignity and elegance itself. A truly great lady.

The young man is the son of Peggy Zoumboulakis, Marina's gallerist. On the left is Marianna Vardinogiannis, one of the most remarkable women I know, involved night and day with her charities. At the end on the right, her daughter Christiane. Beyond her—the woman who is almost entirely outside the frame of the picture—is Peggy Zoumboulakis, our friend and the gallery's director.

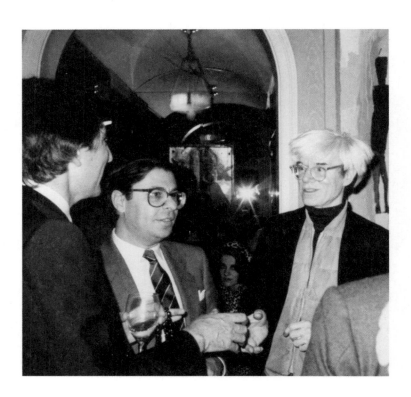

A few guests at our uptown dinner parties. Our friend Vincent Fremont, Andy Warhol's assistant, looking at me as I chat with Mick Jagger. He pretended to be an uncultivated man of the people, but was actually quite the opposite. He came from a good middle-class family and was very knowledgeable. A dazzlingly intelligent man.

The celebrated painter Brice Marden in my library with the photographer Robert Mapplethorpe, who was kindness itself.

New York's biggest star, Andy Warhol, as our guest. He was absolutely charming but never committed himself at all. He would never say anything spiteful or express even remotely strong opinions. He agreed with everything and didn't speak much, expressing himself mostly monosyllabically. But his presence electrified the whole gathering. Between him and me is the ultra-famous journalist Bob Colacello.

Chatting to my daughter Alexandra is Mick Jagger's wife at the time, Jerry Hall. Mick could never resist women. And women couldn't resist him either. He had already married and then got divorced from our friend Bianca Jagger, and eventually Jerry divorced him. She later married the billionaire Rupert Murdoch, owner of *The Sun* newspaper.

Kynaston McShine, one of the curators of New York's Museum of Modern Art, with James Brown.

Alexandra in her apartment in New York with, behind her, her friend from university Ahmad Sardar, who came from a prominent Iranian family. Next to her, the actress Uma Thurman, whom Alexandra had met thanks to a charity in which both were involved: Room to Grow.

Two great painters of the time: Robert Rauschenberg, an amusing, charming, youthful, and delightful character, with Larry Rivers, who was going to make a very large painting showing me surrounded by my favourite ancestors.

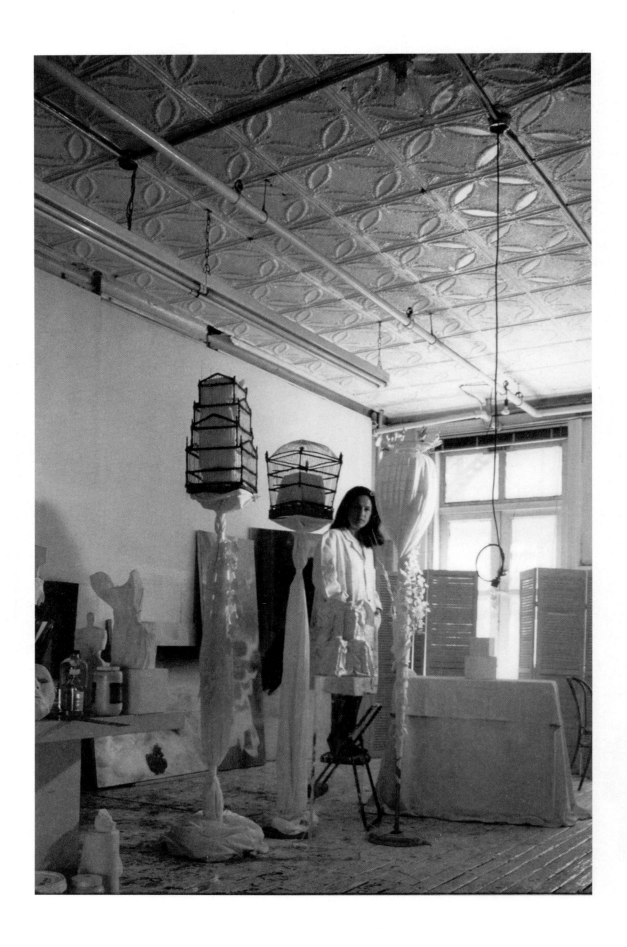

Marina in her downtown studio surrounded by her works. She would leave our apartment very early each morning and come home late in the evening, constantly creating with dedication and talent.

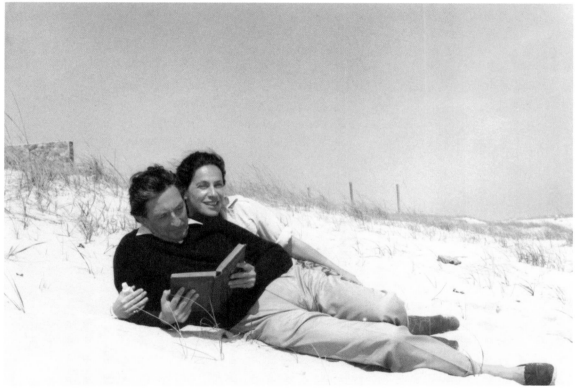

Me on a beach, I suppose in Long Island. I'm reading and a silhouette is approaching. It's Marina.
She comes to join me, as always full of love. So am I, but that doesn't stop me from continuing to read.

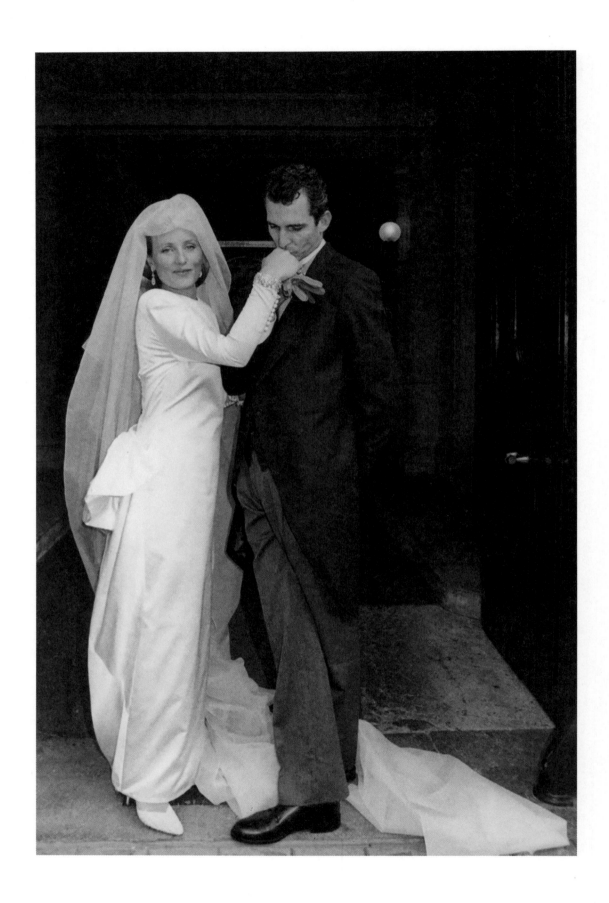

Alexandra and James Brown's wedding, which we organised, at the church of Saint-Germain l'Auxerrois in Paris. That very morning, in Eu, we had celebrated our ancestor Hugues Capet's millennium. Olga and I quickly came back to attend this ceremony with a grumpy, leftist priest who shunned music and flowers. We went on with them regardless.

The bride, Alexandra, arriving at church.

For the wedding, there was a party at our place and then a supper with dancing that went on until very late. In our entrance hall, one of the guests put his top hat on my bust by Igor Mitoraj. Behind is a portrait of my mother.

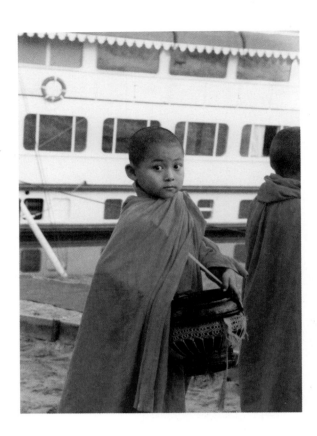

The fact that New York and our occupations were so absorbing didn't prevent us from travelling a lot. I think we needed to escape often from New York in order to survive. So we made an unforgettable trip to Burma (now Myanmar). We saw these very young Buddhist monks there. I loved Burma—its calm, serene atmosphere inspired by Buddhism, its wonderful monuments, and its inspiring landscapes.

That's not to forget my beloved India. I returned there to do some research on the Indian Rebellion of 1857, particularly in Bithoor where Marina and I are photographed here, and where I was trying to uncover traces of Nana Saheb, the most important leader of the Rebellion, who had stayed here for a long time.

During a trip to Burma, on the sacred river that we were travelling along in a boat named *Orient Express*, I met up with my childhood friend Elena Propper. We had got to know each other during the Second World War in Tangier, where her mother and her aunt Liliane de Rothschild had come with her to take refuge. On the left in the photo, her daughter the famous actress Helena Bonham Carter.

An expedition where I took my family to central Turkey. In a little café, I see my two daughters Alexandra and Olga. Facing the camera is my godson Adam McEwen, son of Romana and Rory. I saw him come into the world, grow up and become an artist of great renown. Then, on the right, Ömer Koç, one of our best friends and a fascinating Turkish gentleman.

In Jakarta we visited a Buddhist temple where the atmosphere, with all the lighted candles, was extraordinarily inspiring.

I was in a charming hotel in Provence. I had come there for a literary project. One day
a gentleman approached me and asked if I would pose for him. This gentleman was
Slim Aarons, the famous photographer. And so I found myself in the middle of the olive
trees, in this beautiful countryside, pretending to be absorbed in my manuscript.

I've been interested in yoga since I was very young. I'd found a wonderful teacher in France. I still practise it but much more lazily. Here I am standing on my head, when I was still young enough to do it. My two friends are paying no attention at all: Josefina Bemberg on the right, and Patrick de Bourgues on the left. We were at Monte Argentario.

CHAPTER SIX

BACK IN EUROPE 1993–2000

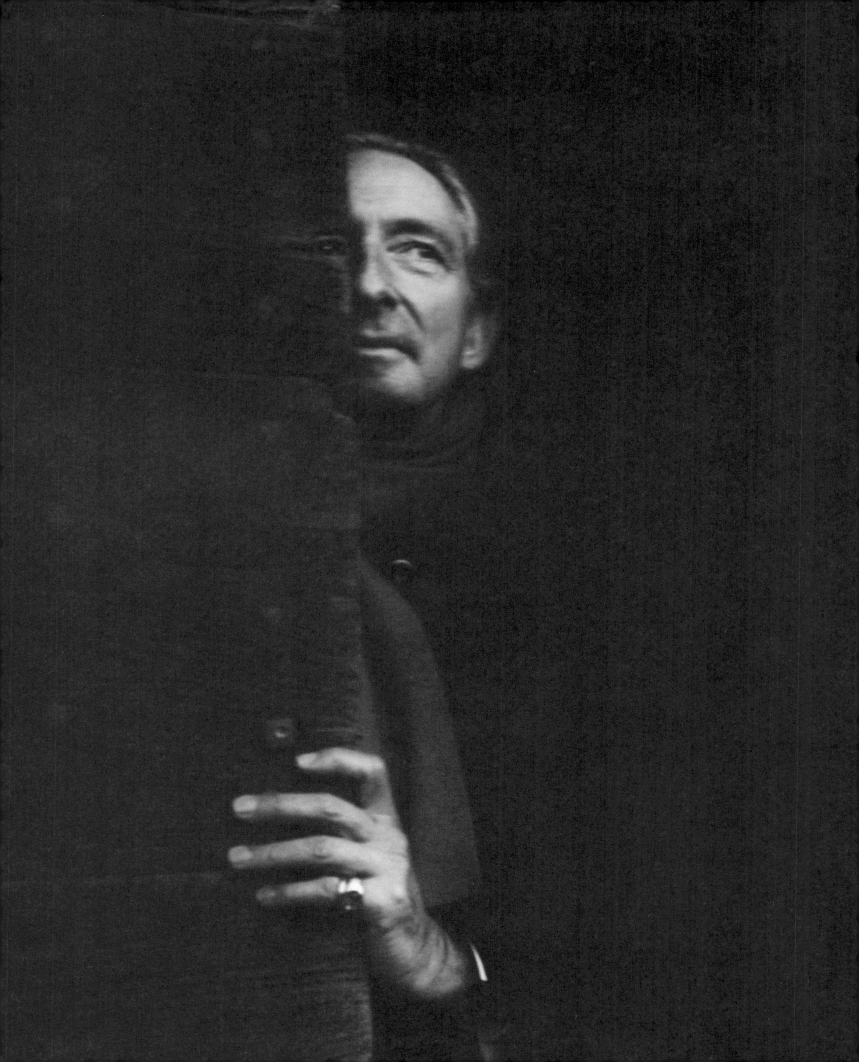

One day, for various reasons, we had to decide between staying in the United States or returning to Europe. We chose our roots and agreed to move back to Paris. Our daughters had grown up and were blossoming. We pursued our careers, our projects. We attended royal weddings. We continued to meet eminent individuals of all stripes. As usual, we continued our travels abroad, but concentrated on Europe: Ireland, Scotland, Spain, Russia... A lot of these trips were dedicated to ghost hunting, one of my favourite pursuits.

However, there was also Mexico, where the Brown family—James, Alexandra, and their children—enticed us once every year. They had, and still have, an important role in our lives.

Finally, the end of this era was marked by our eldest daughter Alexandra's marriage to Nicolas Mirzayantz, a French businessman of Armenian heritage, in Venice. They gave us our first two grandchildren: Tigran and Darius.

Here I am posing in front of the entrance to the Palazzo Soragna, near Parma, which belonged to the prince of that name and where the ghost of one of his famous ancestors—Cassandra, who was murdered by her husband—reigned supreme. This photo was taken by my friend the photographer Justin Creedy Smith, who came with us on all these expeditions.

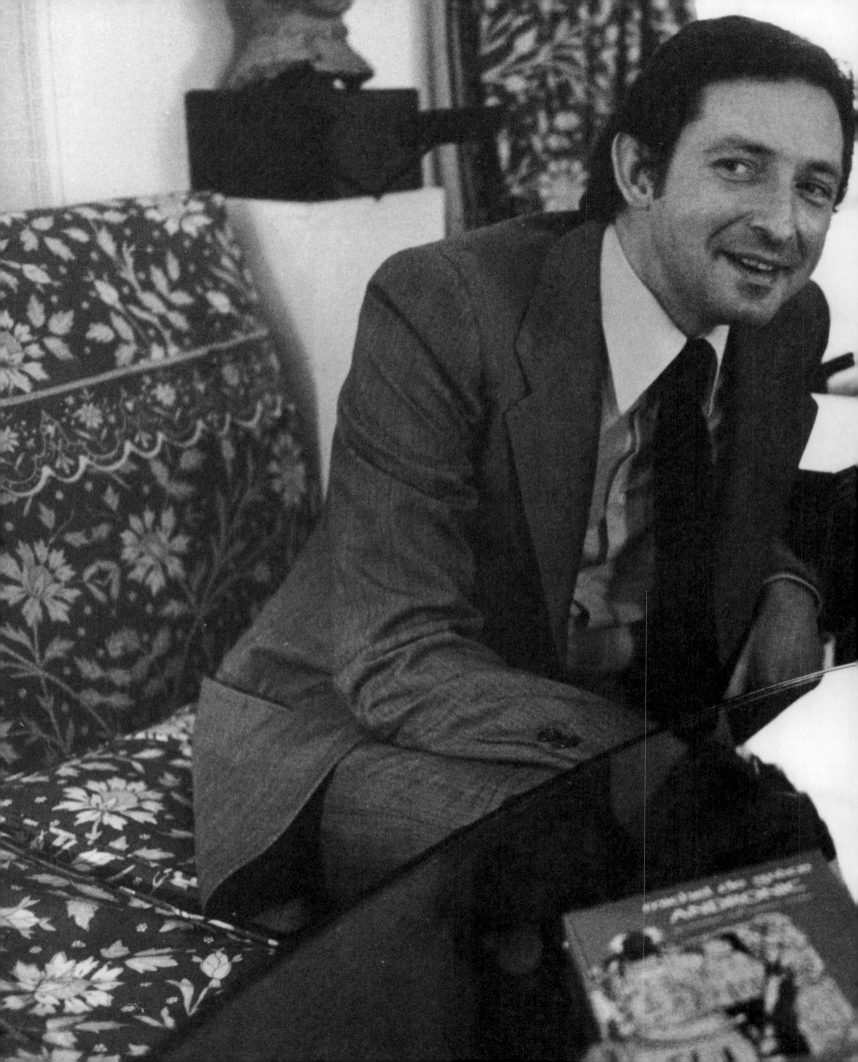

Previous pages: I met André Malraux at the residence of the former Prime Minister of Greece, Konstantinos Karamanlis, who was in exile in Paris. We took to each other straight away, and thereafter I visited him several times in Verrières near Paris, at the château of Louise de Vilmorin, where he lived. His life fascinated me, his personality fascinated me, his work was fascinating. What I found extraordinary was that I was young and not at all interesting, and yet not only was he the most brilliant of speakers, but he also listened to me. He asked me questions, he asked my opinion. We would have amazing conversations thanks to him.

Me with Patrick de Bourges in Argentina. I got to know Patrick when he was the publishing house's publicity director, and he became one of my best friends. He married the famous psychic Yaguel Didier, and together they form the loveliest and most stimulating of couples.

Julia Condon, sister of James Brown's wife Alexandra and renowned portraitist. She is deeply involved in spirituality and esotericism. She is also the most loyal friend, always ready to help.

Me with Olivier Orban and his wife, Christine, the writer. Both have been among our closest friends for decades.

Back in Europe, we travelled quite a lot. Here in Sanlúcar de Barrameda with the Duchess
of Medina Sidonia. She was Spain's top duchess in terms of rank, and in terms of scandal,
too. Named "the Red Duchess" because of her opposition to Franco, he sent her to prison.
Here we are in her archive room, among the richest in Europe, discussing history.

My favourite reading room is my bath. At least I'm left in peace there, so I can immerse myself in my books without interruption.

During celebrations at Württemburg: me entering with the lady of the
house, my cousin Diane of France, Duchess of Württemberg. She is wearing
a fabulous sapphire-and-diamond parure which, as is obviously always the
case where extraordinary pieces of jewellery are concerned, came from one of
her husband's Russian ancestors.

Princess Grace of Monaco photographed by Marina during a weekend at some friends' place not far from Paris. She was an immensely kind, entertaining, interesting, engaged and very unpretentious woman with a huge personality.

Count Cornelius de Bousie, from a great aristocratic family in the Netherlands. He was an interior designer in New York and became one of our closest friends. He had me laughing myself to death a hundred times. We'd go to scour sale-rooms together. He was a warm and wonderful being.

I mentioned earlier that I'd been a close friend of the Scottish McEwen family since my teenage years. This is one of the McEwen daughters, Christabel, who married Lord Durham. Next to her is her elder sister Flora. Behind, her famous mother-in-law, Lady Lambton—"Bindy" to those closest to her. Her life was like a novel. Her husband, a British government minister, had had to resign over his liaisons with prostitutes. He had gone into exile in a sumptuous villa near Siena. As for Lady Lambton, she remained in England and continued to lead a hectic and apparently very pleasant life.

I got into journalism in fits and starts. I did interviews with famous people mainly for *Le Figaro Magazine*, but also for an American magazine. Here, I was received at the White House to interview Nancy Reagan, wife of the then President of the United States. Very elegant, very composed, very controlled, she seemed fragile. In fact, she was rock-solid and had absolute authority over her entourage.

The producer Frank Doelger appointed me historical advisor for an American series vaguely inspired by my book *Sultana—La Nuit du Sérail*. I watched the filming, which took place in Andalusia and was an unforgettable spectacle for me, entertaining in the extreme. That was how I got to encounter the sublime Ava Gardner and the extremely elegant Sarah Miles. Ava Gardner's late arrival on the set, where 200 people were waiting, was that of an empress worshipped by the crowds.

Marianne, Princess of Sayn-Wittgenstein-Sayn—"Manni" to those close to her.
One of that period's most famous *grandes dames*. She was a photographer and
immortalised everyone who attended the grand parties, weekend gatherings and
hunts of the time. She was endlessly amusing and was outspoken in the nicest
possible way. Here she is dressed up for a Venetian ball, posing next to a gondolier.

The *Figaro Madame* had sent me to visit haunted castles to talk about them. One of the most inhabited places I visited is Gleichenberg in Carinthia. So much so that its owners prefer to live in a farmhouse at the bottom of the hill. However, Countess von Stubenberg was happy to pose in the castle's gallery with her little boy and a portrait of their ancestor Count von Trauttmansdorff, Governor of Carinthia in the seventeenth century, who condemned twenty witches to be thrown into a well. Those witches have haunted the castle ever since.

More ghost stories. Me posing in front of Čachtice Castle in Slovakia. That one was the most haunted of all. Even the surroundings and the hill leading up to it were very haunted. It had belonged to the famous Countess Elizabeth Báthory, accused of being a vampire and of having killed three hundred girls to bathe in their blood, believing it would keep her young. Denounced, accused, and condemned, a lady of such high rank could not be touched in order to be executed. So she was bricked up alive inside one of the castle's rooms. This photograph is by Patrick Landmann.

The tipi erected by the American actress Lauren Hutton in New Mexico. We went to Taos because our friends Bill Katz and Francesco and Alba Clemente had villas around there. It's a magnificent country that still has a very strong presence of Native American people. Hence an interesting but sometimes unnerving energy.

With Edvard Munch's *Le cri*, the Pecci-Blunt sisters, Laetitia Boncompagni and Camilla McGrath. They were the daughters of the famous Mimi Pecci-Blunt, niece of Pope Leo XIII, who ruled over Rome's intellectual and society worlds. Mussolini, whom she detested, had a very dim view of her, and she never hesitated to state her opinions.

Marina in a foundry somewhere near New York, putting the finishing touches to one of these very large sculptures inspired by drapery.

I'd invited the painter Francesco Clemente to accompany me to Syria. I think he enjoyed it. In any case, I appreciated him as a delightful and unexpected travelling companion. Here he is posing in front of a famous bas-relief in Palmyra.

Marina with Anouk Aimée. Nothing could describe her better than Fellini's famous phrase upon seeing her after a gap of several decades: "I see that time has been a gentleman to you." Meaning that she remained eternally beautiful and youthful.

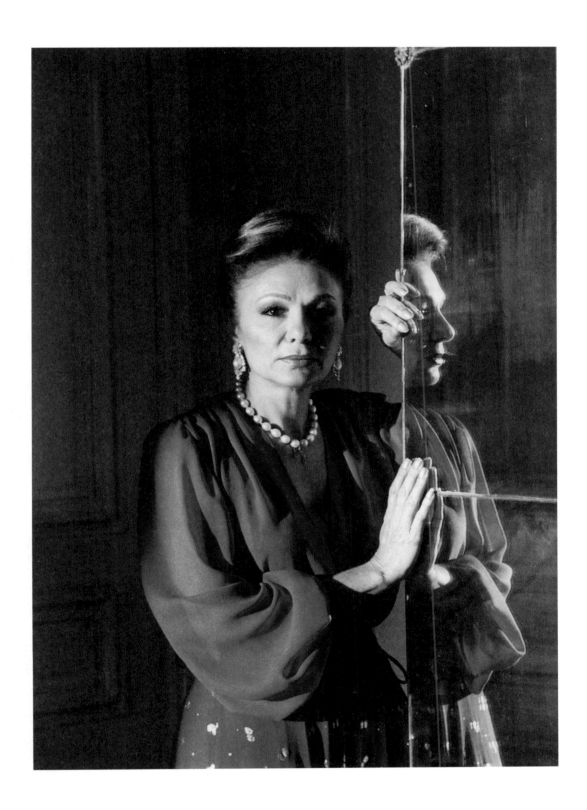

Empress Farah of Iran. Ever since I first met her, in Amsterdam, when I was 18 and she must have been 20, we had remained in contact. When she arrived in exile in New York, driven out by the Revolution, we became very close friends. I have great respect for this woman who has gone through all sorts of misfortunes but never complains or displays any bitterness. When she cries, it isn't for herself but for Iran – she never stops thinking about it. It would be impossible to imagine a more welcoming, kind, courteous lady, and at the same time she is a great and thoroughly human character.

Previous pages: Olga posing for a magazine in an antique Korean robe that I'd bought at auction.

Two personalities from the art world. Jean-Gabriel Mitterrand, nephew of France's former President and a great Paris gallerist who has exhibited Marina's work several times. Such an entertaining and encouraging friend.

Rob Wynne, the renowned American painter and sculptor, with whom Marina has endless enriching professional conversations.

Another very dear friend, Rémy Le Fur, the brilliant auctioneer. It was with him that I saw the Château de Randan in Auvergne. It had belonged to my maternal family from the time of Madame Adélaïde, Louis-Philippe's sister. Its most recent previous owner, Bellina, Duchess of Montpensier, had sealed its fate. Her nephews inherited it. Rémy and I met them: Iberians who brought everything over from Spain, especially cases of Rioja wine, as they found French wine undrinkable…

Marina and me in a moment of emotion at a birthday party that must have involved a lot of drinking, judging by the number of champagne bottles.

At the wedding of my nephew Pavlos of Greece and Marie-Chantal Miller, my daughter Alexandra poses next to that much-loved and much-missed cousin Prince Heinrich of Hesse. He was German through his father and Italian through his mother, Princess Mafalda of Savoy. He was very Italian in his style, spirit and drollness, too. An enormously talented painter, a tireless friend, a perfect host. We spent so many wonderful times with him.

Marina with Chantal of Hanover at Pavlos of Greece's wedding. This intelligent and lovely Swiss-born beauty is the former wife of the Prince of Hanover. She always retains her sense of humour, cheery demeanour, and friendly, welcoming side.

Prince and Princess Michael of Kent had decided to organise a masked ball in the grounds of their residence, Kensington Palace. Setting off for the ball: my son-in-law Nicolas and my daughter Alexandra; on the right, my daughter Olga; and me, at the top of the stairs.

My cousin Prince Jean of Orléans-Braganza the younger, son of my uncle Jean of Orléans-Braganza and the Egyptian Princess Fatima Toussoun. A remarkable man, devoted to protecting the Amazon rainforest and who loved dressing up for the famous Rio carnival.

An unforgettable couple: the exquisite Caroline Herrera, the great Venezuelan-born fashion designer, and on the right one of my favourite people, Prince Rupert Loewenstein. He belonged to that prominent German aristocratic family but above all became manager of the Rolling Stones. He was a multifaceted personality, kind and incredibly entertaining. His company and conversation were masterpieces.

The young Dagmar Brown caught in a moment of inspiration.

Harrison Ford, the unforgettable Indiana Jones, who is still one of my heroes, came to visit us with his daughter in a house we'd rented in Tuscany. Here with Alexandra Brown and my godson Cosmas. He was absolutely charming, friendly and open, simplicity itself. We immediately had the feeling that we'd known each other forever.

Marina and me photographed in our home in Rue de Poitiers, Paris, by Tina Barney. Behind me, a painting by the Cusco School that we brought back from our stay in that city.

At a dinner party at our place, in front of one of Marina's pictures, the young interior designer Tino Zervudachi in conversation with the German painter Anselm Kiefer, who had a studio in Paris that was the size of a factory.

Sophia Vari is a childhood friend of Marina's. She married Fernando Botero, becoming his second wife. In the meantime, she herself became a famous artist. Both of them, faithful and welcoming friends, are sitting in our salon in Paris on the bed known as "Madame du Barry."

Our daughter Alexandra got engaged to Nicolas Mirzayantz, a French businessman with illustrious Armenian origins. A man of heart and depth. She had made a perfect choice and Nicolas is a great addition to our family. The day before the ceremony, he had a dinner party at our friend Larry Lovett's, in his Venetian palazzo where we were staying. From left to right, I can recognise: Clarice Rivers; Alba Clemente; then a woman I don't know; in a yellow jacket, Marina Emo di Capodilista, from a huge Venetian family; then Alex Gregory, a great friend from New York; and Khalil Rizk, our close friend from Lebanon.

Alexandra and Nicolas's engagement celebrations. This was at 8 a.m. in our Paris apartment. Alexandra and Nicolas had just returned from a trip to India. Nicolas asked to speak to me, and asked us for my daughter's hand in marriage, which I naturally accorded him. Then we opened the champagne, even if it was very early.

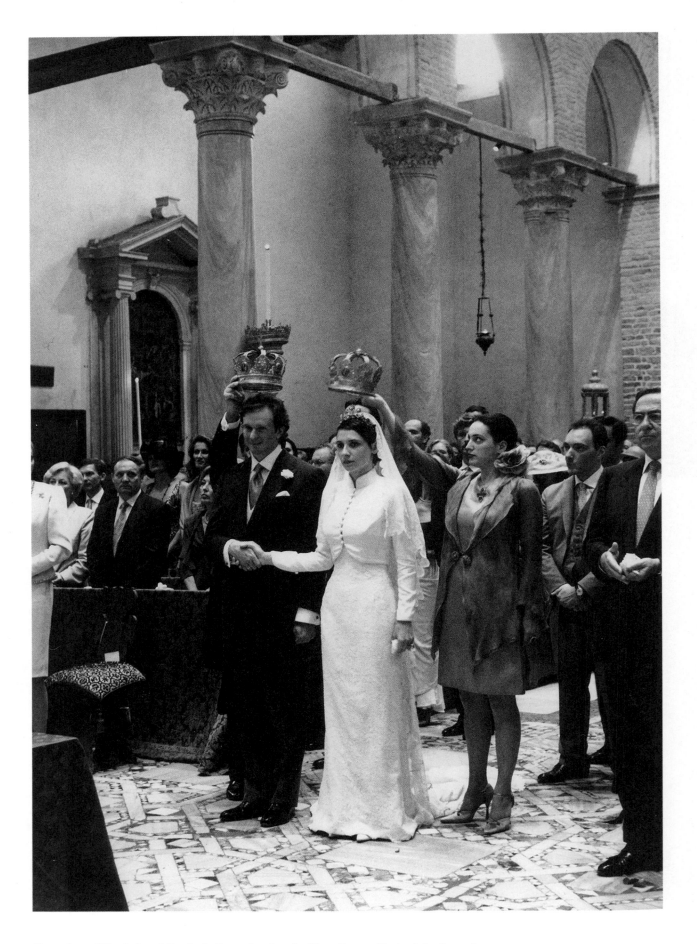

Alexandra and Nicolas's wedding in the Byzantine church of Torcello, near Venice. It is a Byzantine sanctuary on a little island next to Venice, with this huge blue-and-gold mosaic of the Virgin on the wall of the apse. It would be impossible to imagine a more magnificent setting for such a moving ceremony. Olga, the *koumbara*—that is, the witness in an Orthodox wedding—is holding the bride's crown. I can see Menelas Kyriakopoulos, and on the right King Constantine.

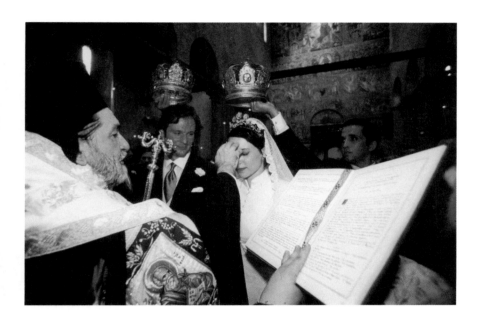

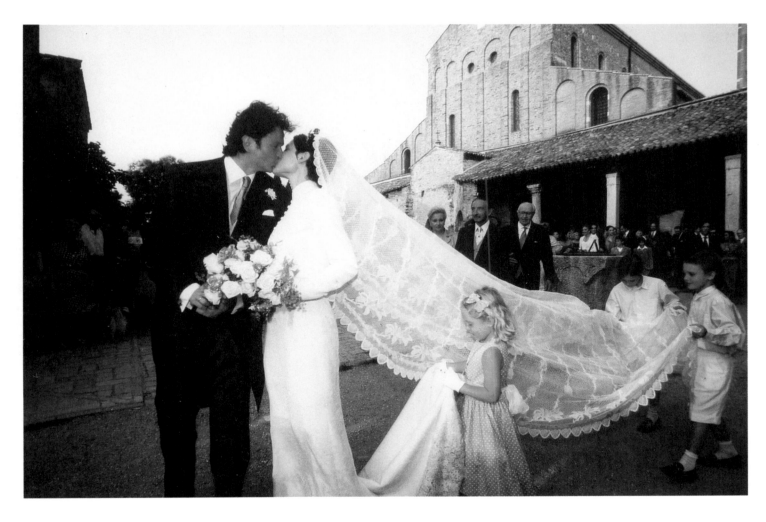

The Orthodox bishop, who came from Florence, blesses the bride and groom, and then, outside the church, they kiss, as the Brown children, without anything being asked of them at all, take hold of the bride's train and tug at it vigorously.

Alexandra and Nicolas's marriage gave us our first two grandchildren. Here, in the countryside on Patmos, I'm having a walk with the eldest, Tigran, already inquisitive about everything. His company was a delight to me then, as it still is now, with him over 20 years old.

My uncle the Count of Paris and I pose for the camera, perhaps a year or two before he died. Our relationship went through various highs and lows because of his very mysterious personality. But at the end we had become very close. This beautiful photo is by Justin Creedy-Smith.

My daughter Olga posing for Helmut Newton, one of the greatest photographers of our time, in an outfit appropriate to his entomological research.

My eldest daughter, Alexandra, posing in front of various works of Marina's.

At the baptism of my godchild Ambrosia Hicks. Her grandmother Pamela was the daughter of Mountbatten and therefore a distant cousin. With her, Hamish Bowles, the press star. He is a cultivated man, interested in everything, truly spiritual, and a friend who gave me the idea for this album.

Marina and me with Jimmy Goldsmith in one of his Mexican properties, close to the Colima volcano. Jimmy was the definition of charm. He always made you feel like he had all the time in the world for you. Although he could be tough on his fellow men, the millionaires, he was considerate even to the humblest of people. He was also entertaining, loving risk and the unexpected. He was a wonderful and luminous being.

The wedding of Markella Karella and Christos Kavatas. Markella is Marina's only niece. An incredibly hard-working and inventive young woman. She has finally found happiness with Christos. They got married in Hydra in a beautiful ceremony. Behind them, my daughter, Alexandra.

Our daughters visiting the monastery of Kostroma with us, in what is known as the Golden Ring of Russian monasteries, north-east of Moscow. I've always felt attracted to Russia. A vast, mysterious, magnificent, unpredictable and fascinating country with extraordinary depth and spirit.

The wedding of Felipe, Prince of Asturias, now King Felipe VI, to Letizia. Olga with Princess Caroline of Monaco. All of Europe's royalty came to this magnificent wedding, which took place amid the fabulous decor of the Royal Palace in Madrid, Europe's richest. Tapestries from the enormous royal collections were hung on all the walls of the vast courtyard. A fabulous spectacle.

Marina's gallerist Peggy Zoumboulakis, a key figure in the Athens art world and society, with the actress Irene Papas, a friend who had commissioned Marina to design several costumes. She was famous for her role in *Zorba the Greek*. A great tragic actress, she could perform in Greek, Italian, English and Spanish, and also had a definite sense of humour.

Jack Pierson, the famous photographer, who became a great friend.

Marina with Pierre Cardin at one of her exhibition openings. He was an extraordinary, very unpretentious man who had made his own way in the world and had something of a mysterious side. He had created a huge empire and right up to the end, even though he was very old, he remained active and busy, taking care of everything.

The young and very talented painter Donald Baechler, just starting out in New York.

Nu-Nu. Nobody really knew her name. She was the Condon sisters' Burmese nanny, who had always remained with them. She came from Northern Burma and would boast of its mountains and marvels. She had a fantastic personality. The whole neighbourhood of London where she lived revered her, because she generously took care of those in need. She also had a recipe for an unforgettable chutney which she always kept secret.

The private viewing of Marina's exhibition in London. Jools Holland, a massive star of contemporary music, with Nicky Haslam, whom we've known for 50 years. A great talent, a great gossip, a great entertainer.

Bianca Jagger, whom we happened to know thanks to Thaddaeus Ropac. We like her. She is extremely friendly and a great activist. Next to her, Joan Juliet Buck, editor-in-chief of French *Vogue*.

In front of the Mayer Gallery in a London street, from left to right: Kisty, Lady Hesketh born McEwen, my great friend from long before my wedding. In the middle, Ashley and Allegra Hicks: he is the son of Lady Pamela Mountbatten and the interior designer David Hicks; she is a very active, creative Italian; and together they are my goddaughter Ambrosia's parents. On the right, Gita Mehta, the Indian writer—talented, intelligent, brilliant, cultivated and very humorous, as so many Indian people are—an extraordinary character.

Another of my remarkable cousins, a more distant one this time. Franz von Wittelsbach, Duke of Bavaria. He heads huge educational and charitable foundations. He is an expert in contemporary art and founded Munich's contemporary art gallery the Pinakothek der Moderne with his collections, which he gifted to the State. Respected by all and an iconic figure, like his grandfather the famous Crown Prince Rudolf.

Marina with Princess Catherine Aga Khan, Sadruddin Aga Khan's widow. A Greek lady from Alexandria, she has an extremely strong personality and is enthralling, amusing, cultivated, interested in everything, and full of life. Age has no hold over her.

Juan Carlos, King of Spain, at the wedding of his eldest daughter, Infanta Elena. We've known each other since we were teenagers. We are cousins. I've always respected him. He had a very difficult start in life and has gone through some thorny situations yet has had a great reign. Re-establishing democracy in Spain, saving his country from a military *coup d'état* and always acting for the good of his country. A very amusing and remarkable man who is hard to sum up.

I can't remember what the occasion was for the four of us to get all dressed up in our finery before setting off for some ball.

Olga showing off her foot, wearing a shoe by Christian Louboutin.

Olga with her great friend, for whom she also worked, Christian Louboutin. I met him during a dinner in Paris a long time ago when we were very young and still unknown. I remember telling Marina afterward: "This man will go very far. He has genius in him, along with an interesting culture."

One day, Yaguel Didier, the famous seer, married my friend Patrick de Bourgues. For the wedding, which happened in the Château de Menou, I took the role of Père noble. I led the bride to the altar. Here we are both in the big living room before the solemn moment.

Queen Sofía of Spain and me at a hotel in Aleppo, Syria. She is my cousin. A remarkable lady and a wonderful asset for the Spanish monarchy. What is extraordinary about her is that she always thinks about everyone. She makes a success of everything because she is so natural. Totally unspoiled and always welcoming. We've shared several cultural trips in Greece and other countries. They have all been exciting experiences, and through the monuments that we visited, I got to know the greatest one of all—a remarkable woman.

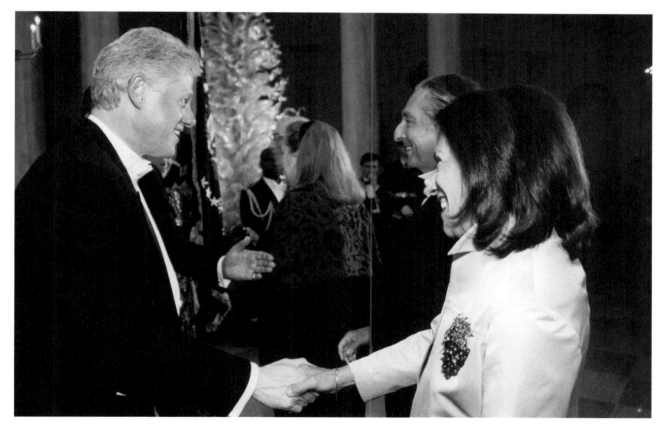

For the baptism of my niece and goddaughter Maria-Olympia of Greece, daughter of Pavlos and Marie-Chantal, in the Greek Orthodox Church in Istanbul, we were received at the Patriarchate. Among others, Marina and King Charles, then Prince of Wales, he being Maria-Olympia's other godfather.

During King Juan Carlos and Queen Sofía's official visit to the United States, they had us invited to the White House. It was a chance to meet President Clinton. At the end of the evening, when most of the guests had left, he came over to chat with us, completely relaxed. To my surprise, I found him to be an extremely cultivated man with a perfect knowledge of Greek culture.

CHAPTER SEVEN
GREECE 2000–2023

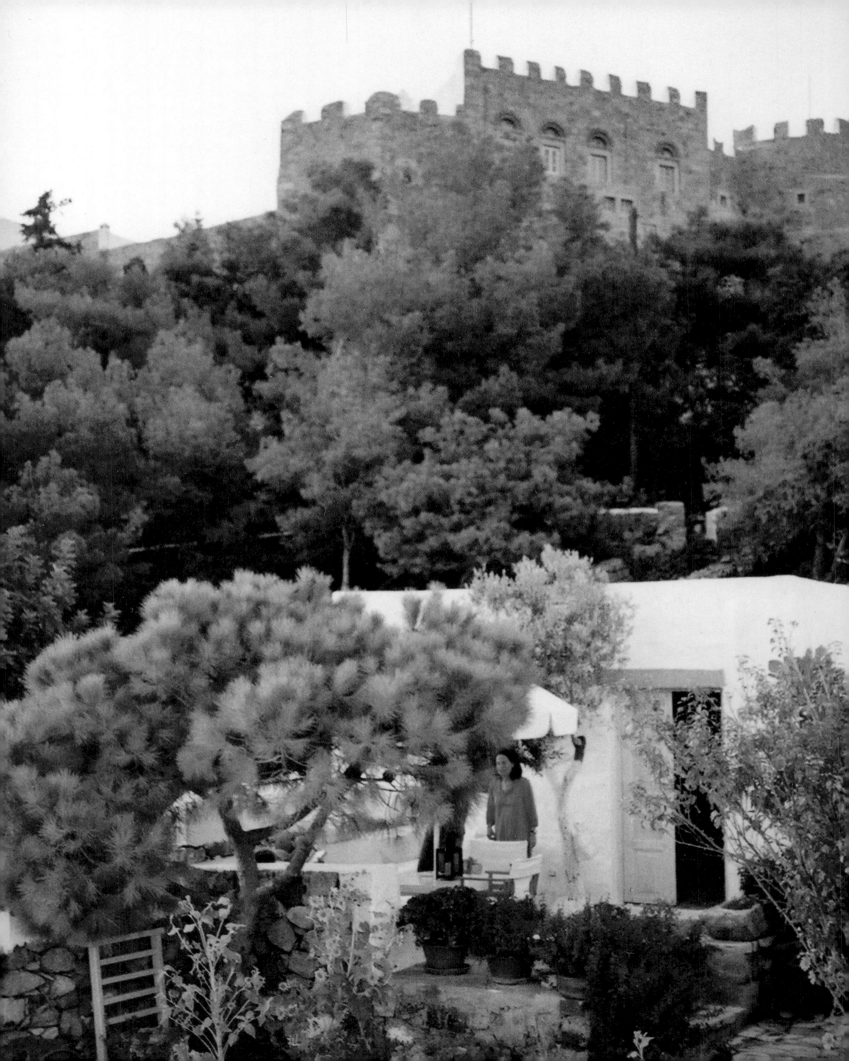

We never cut ties with Greece, which we regularly visited. But little by little we went there more often, eventually coming to live there full-time. At first, we stayed with our friend Christina, and then in a pied-à-terre in the old town of Plaka, and then in a light-filled apartment in Kolonaki. We arrived to find a Greece that had greatly evolved since our youth. We created our foundation, Eliza, which raises awareness about mistreated children. Through its establishment we had the opportunity to meet new people and to have countless interactions with creative, passionate Greeks.

Then, there is our vacation home on the island of Patmos: our paradise that is beloved by the entire family. With our ages increasing, we focused our activities. There were still trips, of course, but more carefully targeted. Encounters with new people, to be sure, but less numerous and more enriching. Our second daughter, Olga, married one of my nephews, Aimone of Savoie-Aosta. They gave us three grandchildren: Umberto, Amedeo, and Isabela. These five creatures of God constitute our joy and happiness.

Marina and I keep our eyes and ears open. We are always ready to achieve new goals. The words "old age" and "retirement" have no meaning for us.

Opposite: Marina in the courtyard of our house on Patmos, in the shadow of the ancient monastery. There are only two luxuries on this island: the view and the light. I think our house has managed to have both.

Overleaf: Alexandra and James Brown followed us to Patmos. They bought some land in a magnificent spot, with this rustic old house on it, full of atmosphere.

On the harbour at Scala on Patmos. I am savouring the most trashy Italian magazine with great enjoyment.

My son-in-law and nephew, the Duke of Aosta. He is a self-made man,
courageous and enterprising, cultivated and generous.

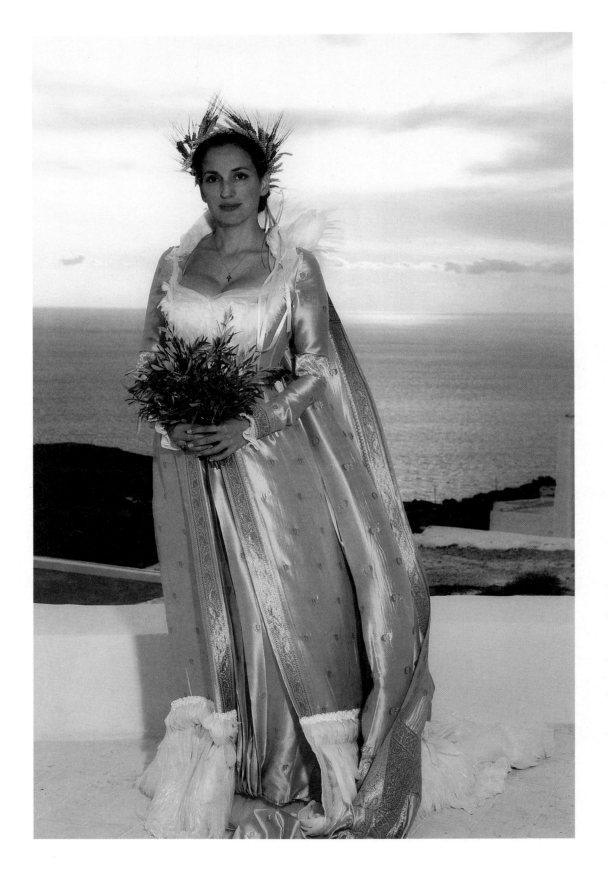

Olga's wedding to my nephew Aimone of Savoy, now Duke of Aosta. It happened on Patmos with only a few guests. Hugely atmospheric and with this island as its extraordinary backdrop. Olga wears an extraordinary wedding dress, designed and created for her by Prada. Instead of the tiara that princesses usually wear, she had one made for her with ears of wheat, which better suited the setting. She had her photograph taken on our terrace. This beautiful photo is by Marina.

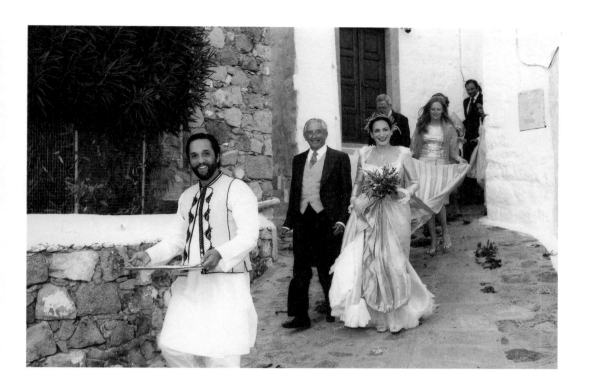

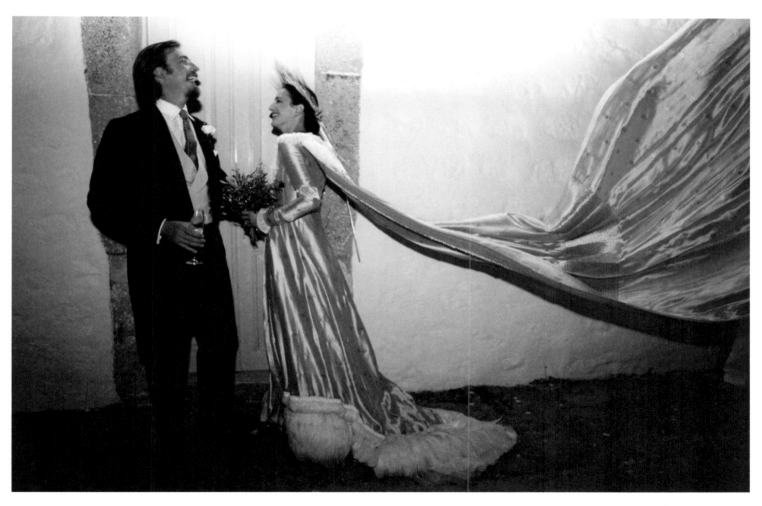

Me accompanying her to the church, with her Persian lifelong friend Ahmad Sardar walking in front of us.

The bride and groom relaxing after the ceremony, champagne glasses in hand, as the wind lifts Olga's long train.

Activities on Patmos. Marina painting Ahmad Sardar. Our holidays never involve endless hours lying on the beach, which bores me to death. Marina paints. I write, in this wonderfully inspiring setting.

Our second grandson, Darius, who has a big personality and a big heart.

Our son-in-law Nicolas Mirzayantz, posing for Marina while wearing a kilim.

In front of the wall of our lane on Patmos. A few friends had come to see us. From left to right: Prince Nicholas and Princess Sveva of Russia. He was the patriarch of the imperial family, the one who knew the most about the Romanovs' past. A very tall and very noble descendant of the tsars. Then a Lebanese friend, Germaine Labarthe. Then Princess Catherine Aga Khan with her daughter-in-law. Then me with my cousin King Simeon II of Bulgaria and his wife. Lastly Prince Sadruddin Aga Khan.

The breakfast table at the Browns' in Patmos. Degenhart, then Dagmar on the knees of Abdel Tajouti, the nanny, a Moroccan painter of great talent and of refined company. Around the table, we can also see Samantha McEwen; not only have I known her since she was born, but she is also a distinguished artist and the daughter of another distinguished artist, Roderick McEwen. The gentleman in a white shirt is Sebastien de Courtois, a writer, a journalist, and a traveler with whom I have discovered many fascinating places. He is also stimulating company.

Me with one of my best friends, Ömer Koç. A Turkish citizen who, with his family, owns his country's biggest consortium. But beyond that, he is an immensely intelligent person, a first-class bibliophile and an amazing collector. He extends the most generous hospitality. He knows how to welcome guests like nobody else. He is exciting and always full of surprises. It is a treat to spend time with him.

Overleaf: We bought a dilapidated house which one day Marina secretly started to restore. The house is now a masterpiece because of her initiative and designs. She gave it to me for my 60th birthday. It's her best present ever, a blessed place that the whole family—starting with me—is crazy about and comes to every year with never-ending delight. A few dozen metres from the house is a chapel for which our cook Maria has the key. I call it my oratory, because I go there every day, light candles, think, meditate, and take advantage of the place's serenity and positive energy. Decorated with magnificent old icons, it has the most inspiring and spiritual atmosphere.

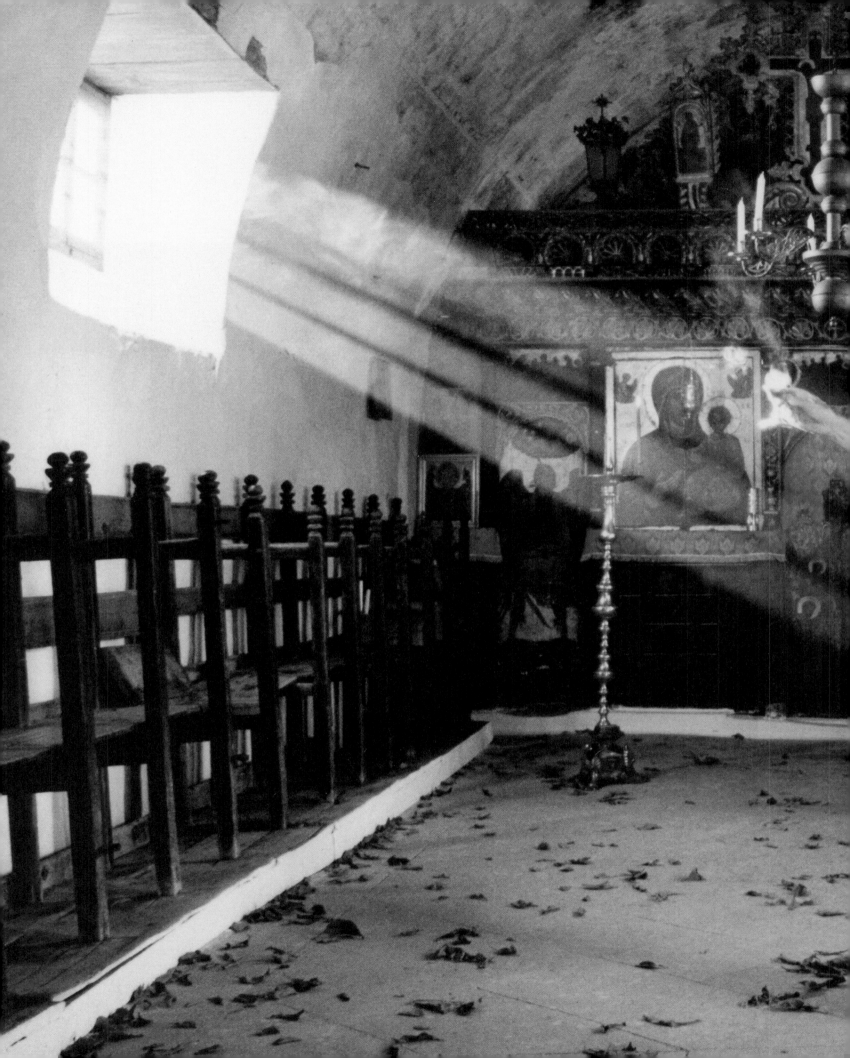

Although we'd visited Mexico several times as tourists, we only truly discovered it thanks to the Brown family, who were living near the city of Oaxaca, on a large farm in the middle of the countryside. What expeditions and discoveries we enjoyed, coming every year to spend a few weeks in this paradise of a place. Next to this giant cactus, Alexandra Brown with her daughter Dagmar. I'm mad about Mexico, its monuments, its landscapes, its cuisine, and above all its inhabitants. I find them one of the most sophisticated peoples that I've met.

Still in Mexico. Among the people at the Browns', near Oaxaca, was little Fabiola, the cook's daughter. She was small but brilliantly intelligent and also rather mischievous. Thoroughly Amerindian in appearance, she was quite fascinating.

We went to Xilitla with the Browns, to visit the famous garden of Edward James. He was an enormously wealthy Englishman who claimed to be the illegitimate son of King Edward VII. He shone in Europe and was one of the most important collectors, known by all the Surrealist painters. Then one day he went to Mexico, to a completely remote and wonderfully wild spot north of Mexico City, and created this garden in the jungle, blending the natural plants and waterfalls with ultra-modern sculptures that would go on to inspire many artists. An extraordinary character whose adventurous and fantastical life is mirrored in this completely atypical, strange and enticing place.

I've always loved travel. And I've travelled all my life: near, far, everywhere. Nemrut Dağı is one of the world's most extraordinary places. It is in a particularly wild region of southern Turkey. A very tall mountain, on the summit of which stand gigantic statues of half-Greek, half-Oriental deities, and in the middle a peak made of piled-up stone fragments beneath which the tomb of a king of Commagene—the region's name at the time—is believed to lie. It is impossible to excavate because if anyone were to start removing the stone fragments, the whole mound would collapse. The view from the high terraces of these sanctuaries reveals the vast, splendid landscape that these millennia-old deities are contemplating.

The site of Tanis, in the Nile Delta, has not undergone much excavation. Enough, though, for marvels from several periods to have been discovered. There is generally nobody there exploring these ruins which, for me, possess a great sense of poetry, like a bust of Pharaoh poking out of the sand, or a foot that is more than 2,000 years old lying forgotten in a corner.

The Siwa Oasis in Egypt, where the Oracle of Amun was revealed to Alexander the Great. An extraordinary place overloaded with atmosphere and energy. When you walk in the surrounding desert, you find both pharaonic remains and human skulls. Who these belonged to remains a mystery, but they must be very old.

Nemrut Dağı again, with Georges Antaki, the noble Syrian who has been my friend for more than 52 years. His kingdom, his fief, is the famously beautiful city of Aleppo.

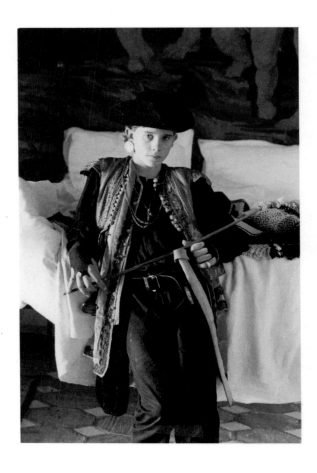

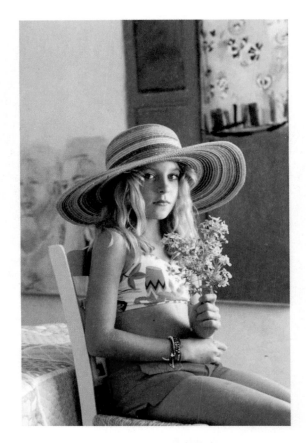

The Browns' children. Cosmas, whose ambition was to become a
pirate. An ambition that I fully encouraged him to pursue.

Dagmar, already stunning even at such a young age, posing for Marina.

Degenhart with his hairstyle at the time. The head of his boarding school
looked at this mass of hair at the end of the year and said, with classic English
understatement, "Perhaps next year a slight trim."

Two and two. My four grandchildren. First Tigran and Darius growing up, and then Umberto and Amedeo. Some of them reached quite impressive heights. Their ancestors were also very tall.

Our granddaughter Isabella, the last in the brood, starting to grow up and already wanting to be a fashion icon, as you can see in the photo.

Me taking my morning tea looking out over the wetlands of Kerala, the state in southwest India. So green and so magical, like all of India.

Fivos Tsaravopoulos, a young man who came up with the idea of rediscovering the old pathways in the Greek countryside and on the islands that used to be used by countryfolk to go from village to village, or from a village to a beach or other sort of place. These "calderimi" are often hundreds or thousands of years old. He restores them and opens them up to tourism, developing local produce in parallel and above all striving to extend the Greek tourist season beyond the all-too-brief July–August period. A tireless worker. A great friend, and most of all someone who knows Greece like nobody else, and with whom I love exploring it.

Prince Sadruddin Aga Khan posing for Marina, who took his portrait in this outfit. He is one of the only people I've ever envied. Not for his wealth or his collections. But for what he was: handsome, of noble birth, intelligent, cultivated, amusing, generous, human, and a delightful friend. Quite simply, he had everything anyone could ever dream of.

Marina and I found ourselves in Provence, in Eygalières, at our friends' the Tiztzes. Wolfgang and his wife, Anne de Boismillon, a famous French journalist, are among the most important collectors of contemporary art, and they are also the most hospitable friends.

Two friends. The famous American artist Kiki Smith, photographed by Lynn Davies. We encountered both of these women in Piedmont for an art exhibition.

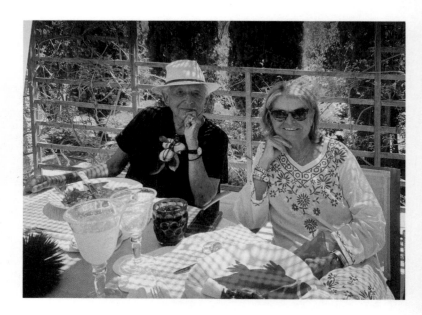

Cy Twombly. I enjoyed his company tremendously. He made me think of a great southern lord from back then. He had a very aristocratic appearance and a very particular accent. In the photo, he is having a discussion with our hostess, Paola Iliori, who had one of the most beautiful houses north of Rome.

Jethro Goldsmith, Jimmy's son and my nephew, with his pet, a friendly wild boar, and his lovely bride.

Me with a hat on. I am with Irini Lemos in her gorgeous villa on Spetses. She is the daughter of my Greek family's doctor. Her husband Nikolas belongs to an important family of Greek ship-owners. Both are welcoming and generous.

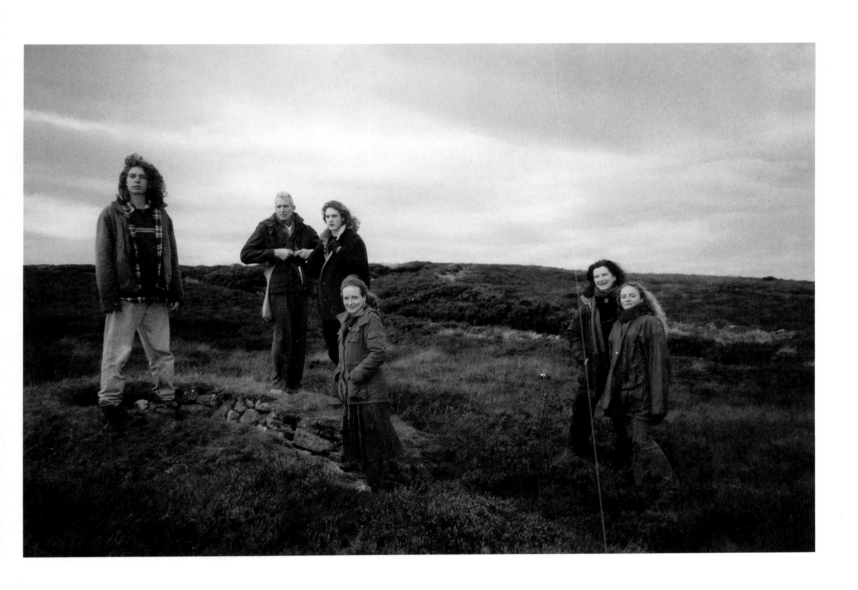

The Browns—Dad, Mum and the three children—in Scotland. We were invited by my friend Angelika, Dowager Countess of Cawdor. When I went into her castle, not knowing quite where she was, I noticed that she served excellent French wines and that the heating was wonderfully comforting. I immediately said, "She isn't Scottish." And indeed, she comes from a grand Bohemian family. Widow of Lord Cawdor, it was by marriage that she came to own the castle that Macbeth built, 300 years after his death. Seriously though, as Shakespeare's play states, Macbeth was Thane of Cawdor, and owned land there, but the castle was of course built later.

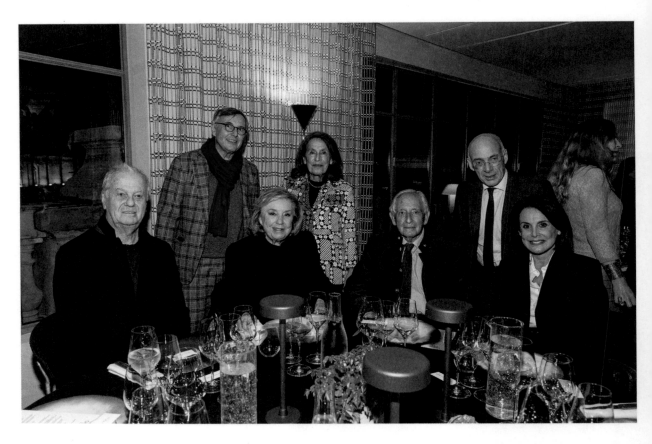

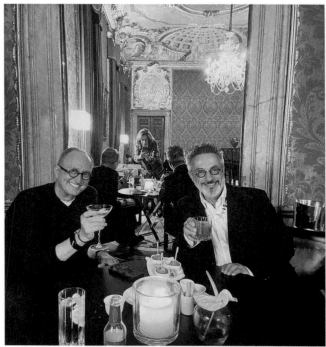

Upstairs, dinner at the Bourse du Commerce after a vernissage at Pierre Passebon's. We were invited by Maryvonne Pinault, whose husband had just restored the building sumptuously. From left to right: Jacques Grange, Pierre Passebon, Madame Pinault, Marina, and myself with the Baron and Baroness de Gunzburg.

Peter Speliopoulos and Robert Turner. The first, of Greek origin as his name indicates, was an important figure in fashion. Here is one with whom I like to discuss. He is always interested in everything and knows everything: politics, history... He always has fascinating opinions. Robert comes from an old family of Baton Rouge and is a major patron of the arts, who subsidizes entire sublime productions of the Metropolitan Opera.

At the wedding of the Crown Prince of Albania in Tirana, to which we were invited. Three illustrious guests were my cousin Grand Duchess Maria Vladimirovna of Russia, another cousin Princess Gloria of Thurn and Taxis, and her ravishing daughter.

Marina with one of the world's leading contemporary art experts, Tobias Meyer, in his very colourful New York apartment. Chatting with Tobias is always instructive and exciting. He knows everyone, he clearly knows his profession like no other and his opinions are always exceptionally intelligent and original.

Two very dear friends, Alexander Sharaf and Guillaume Lestrange. Guillaume's family owned numerous castles but lost all of them. Yet this enterprising, energetic, inventive aristocrat could not care less, hence this cheerfully makeshift hut where he was living in Normandy. Alexander's family had palaces in Egypt that it had lost, but he and his family, on his instigation, found a magnificent haunted château in France, and Alexander made it an exceptional place.

Our five grandchildren. The young Savoys on the left and the young Mirzayantzes on the right, flanking Marina in the middle. As I said in the introduction, these divine creatures bring us such happiness.

Isabella on the balcony of their house in Moscow. In the background, the glittering capital. Since then, Olga and her family have left Russia to move to Milan. Russia was the country where they spent so many happy years.

On the terrace of our house in Patmos, Alexandra carries a lantern at night.

The most important member of the Savoie-Aoste family:
George, the Russian corgi, posing with dignity on a Louis XV sofa.

Olga and Aimone at a Moscow gala.

Amedeo, my grandchild, is comfortable on a nice old sofa in the middle
of the garden of the Puglie property of his parents.

Two of my grandchildren: the eldest, Tigran, focused on his studies while being comfortable; Umberto practicing the violin, for which he has a true talent, in one of his favourite outfits.

Alexandra and Nicolas on the Greek sea. Both of them deeply enjoy our country and try to come as often as possible.

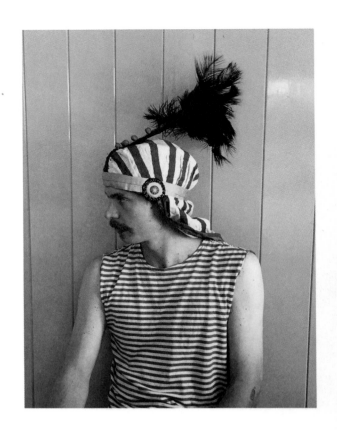

Degenhart Brown posing for Marina with an extraordinary headdress. He himself is extraordinary. Ever since he was little, I predicted a bright future for him. He has become the foremost authority on African culture and a voodoo professor.

Dagmar Brown and her fiancé Paul Malle. They are beautiful, young, and dynamic. They got married in March 2023 in the city of Oaxaca.

The three Brown children, Cosmas, Dagmar, and Degenhart, in the family home at Mérida in Yucatán, which replaced the Oaxaca farm. Two years before, their parents had died in an inexplicable car accident in Mexico. The children displayed extraordinary dignity, courage and unity, which filled all of their friends with admiration.

Cosmas Brown with his fiancée, Georgie. He is my godchild, of whom I am very proud because he is becoming an incredibly talented artist. She is half-Chinese from Taiwan and shows an extraordinary sense of initiative as well as a taste for business.

Aimone and Umberto in their house at Giuggianello in Puglia. My daughter Olga and my son-in-law bought this crumbling manor house and worked wonders on it, making it immensely beautiful and welcoming. We are always happy to spend Christmas and other delightful holidays there.

Diane von Furstenberg. During a cruise, she made a stop in Patmos, where we had the great pleasure of having lunch with our dear friend whose career and success are also extraordinary. Behind her, our great friend from Patmos, Alexandre Duke of Carcacci.

Myself with my two grandchildren, Tigran and Darius, during an excursion at sea between Ikaria and Patmos. What an extraordinary experience. This photo was taken by our son-in-law Nicolas, himself a passionate amateur photographer. He is the only one of us who successfully exhibits his photos.

My nephew Paul's wife, Marie-Chantal princess of Greece, on her father's sailboat with her eldest son, Konstantin.

Myself and my nephew, Prince Paul of Greece, on the deck of his father-in-law's sailboat.

Myself with my great friend Yannis Koutsis on the balcony of his manor in Spetses. He belongs to one of the most prominent families on the island. They played a great role in the revolution for independence. He is cultivated and is the biggest expert on butterflies in all the Balkans, and he has an irresistible sense of humour.

Christina Kyriakopoulos. She is one of our very best friends. Marina and I knew her separately before our wedding and attended hers, which happened a few months before ours. Fidelity and generosity are her mottoes.

Our personal paradise, our house on Patmos, where all the weeks we spend are enchanting and blessed.

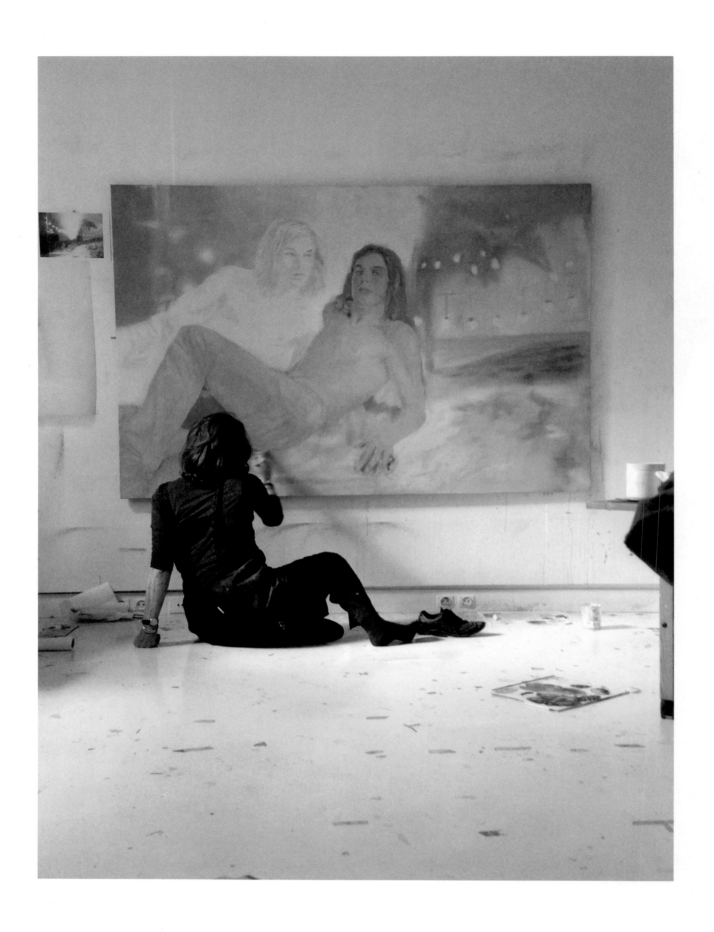

Marina painting a young model from the École des Beaux-Arts, who himself was a painter, as well as Joan of Arc's great-great-great-nephew.

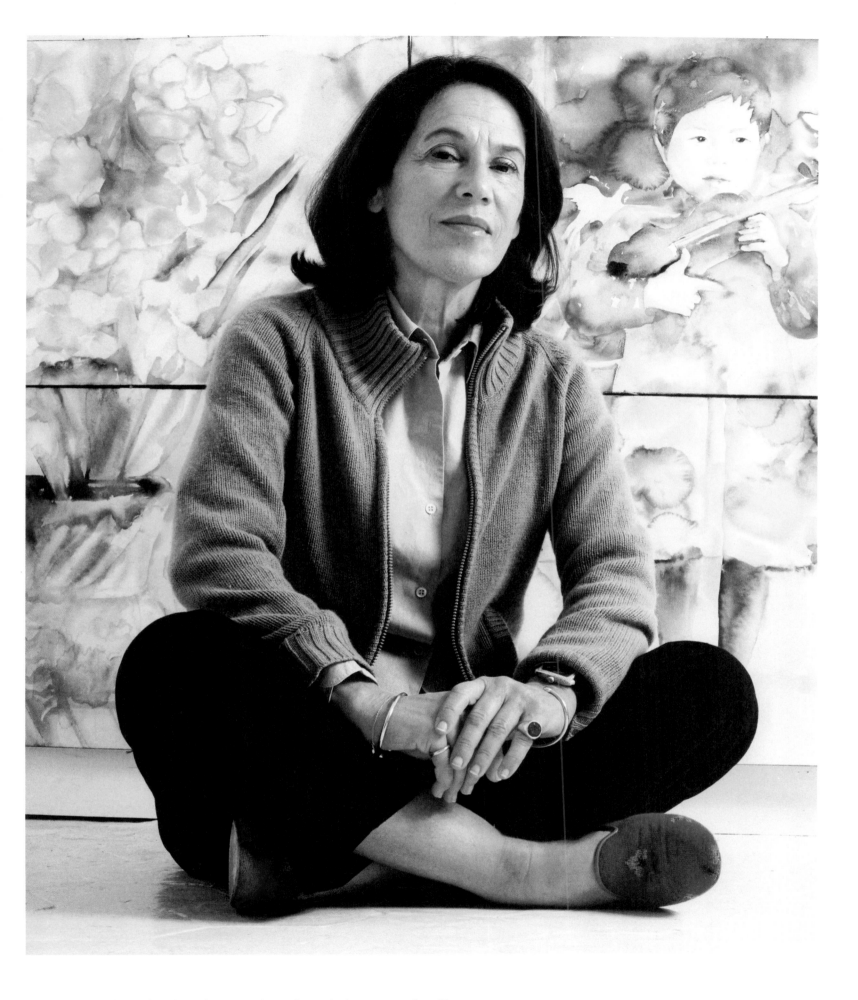

Marina at work in her studio, taking a few minutes' pause from painting to recentre herself.

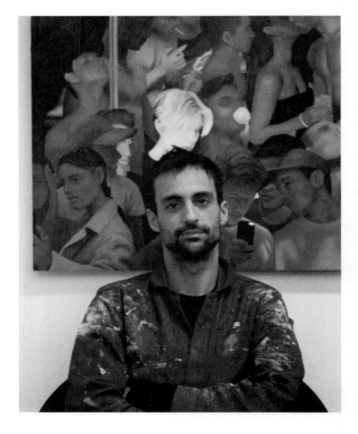

In Mexico at the Browns', with the New York art world visiting. On the right, Helen Marden; then Jane Rosenblum, Marina, Alexandra Brown, and Judy Hudson.

Gérard and Jacqueline Bremond in front of a work by Marina. Both of them mix intelligence, culture, creativity, and success.

Cyril found another assistant for Marina, a very young painter called Jean Claracq, who has been hugely successful over the last few years. He is likewise a cultivated, intelligent person who is delightful company. Here he is in front of one of his works.

Marina's assistant, the painter Cyril Tricaud. A professor at the Beaux Arts, he has a universal knowledge of painting. He is the most refined, charming, pleasant company imaginable. He has become a great friend.

The Benaki Museum in Athens organised a huge retrospective
of Marina's entire oeuvre. It was the occasion for celebrations in
honour of an entire life dedicated to art.

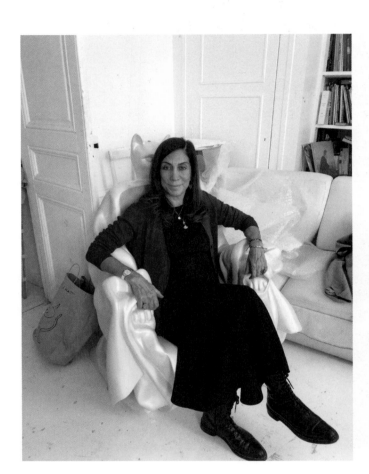

Ileana Makri is the daughter of Konstantinos Karamanlis's minister, the famous Takos Makris. She is very like him in her intelligence and determination. She is a jewellery designer with impeccable taste, but above all is one of the most active members of our foundation fighting child abuse.

My niece Laure Boulay de la Meurthe had two children with Jimmy Goldsmith, the elder of whom, Charlotte, married a Scottish-born artist-designer, Philip Colbert. Over just a few years this young couple achieved extraordinary creative success across the domains: film, photography, sculpture, fashion, objets d'art, etc. They are quite simply incandescent. Tireless energy and at the same time a sense of joy and enthusiasm and an unparalleled zest for life.

Marina with Paloma Picasso, whom we've known for a long time. We lost touch and found each other again, and she is still just as captivating.

Pierre Passebon is full of imagination and has the most
wonderful gallery in Paris. He is a marvelous friend.

A whirling dervish resting. This strange dance was invented by one of my favourite heroes, the great Muslim mystic Rumi. For him, it was a way of communicating with the universe and penetrating the mysteries of the world around us. Still today, dervishes continue the tradition that began in the 13th century.

It is always a pleasure, a delight, and an excitement to discover new parts of India. India, which is endless. Once, we went to the Deccan, the center of the country, and we found these very old and immensely beautiful sultanates.

Again, one of the Islamic Deccan sultanates.

Our daughter Alexandra in one of the gateways of Delhi's Red Fort.

Me at my favourite monument in Cairo, the Sultan Hasan Mosque. Apparently this religious sanctuary gives off so much positive energy that all mechanical timekeeping devices go crazy when taken inside it. I go there every time I'm staying in Cairo, to meditate, to think, and to enjoy its prodigious architecture and extraordinary serenity.

Brigitte Macron invited us one day to have a quiet lunch at the Élysée Palace along with our Prime Minister's wife, Mareva Mitsotakis. After the lunch, she took me to visit the restoration work that was going on at the palace.

Wedding of the crown prince of Albania in Tirana. Me with two very close friends: Stephane Berne, a writer, a journalist, a benefactor, and a huge star of French television; and Frédèric Mitterand, former minister of culture, television presenter, fabulous writer, and forever friend. We three are over-decorated for the occasion.

Thaddaeus Ropac is not only one of the most famous and successful gallerists of our era, but also a tireless, generous, delightful host. He provided this breakfast for us in his garden. He himself is sheltering Princess Michael of Kent from the rain that has just started, while my old friend Eliette von Karajan is sheltering me with her umbrella. With Eliette too, we have a connection forged through decades of friendship and laughter.

In the Palais Royal, nowadays the Ministry of Culture, where I was decorated with the French "Ordre des Arts et des Lettres." In the middle of the photo is Dominique Senequier, one of the most important women in world finance and a friend who inspires trust. On the left, my niece, Adelaide de Clermont-Tonnerre, director of the magazine *Point de Vue et Images*, and a greatly talented writer with a bright future.

Marina and I arriving for a gala evening in Greece for my cousin King Constantine's fiftieth wedding anniversary.

Marina hand in hand with Peter Marino, the famous architect. When we knew him in New York, he would be wearing a blue suit and dark tie, impeccable and conventional. Then there was a sudden transformation, since which he only ever appears in leather, while still remaining just as amusing, intelligent, and cultivated.

Marina triumphant, posing on a sculpture by Erwin Wurm.

Me posing in our Paris apartment in front of the portrait of my father by László, the celebrated interwar portraitist, sitting on the throne that Niki de Saint Phalle created for me, hence the whimsical crown.

Overleaf: A few years ago we made a trip to India which culminated in the paradise that is Maheshwar. An enormous fortress dominated by a charming little palace and gardens above the sacred Narmada River. Our two families came to join us, as did our adoptive family the Browns. Thus the photo shows our two daughters, our two sons-in-law and all our grandchildren—except for Isabella, who emphatically refused to pose. The entire Brown family. At the back, wearing an orange shirt and grey waistcoat, our host there, Prince Richard Holkar, a descendant of the Maharajas of Indore, creators of this architectural marvel, and the most generous and welcoming of friends.

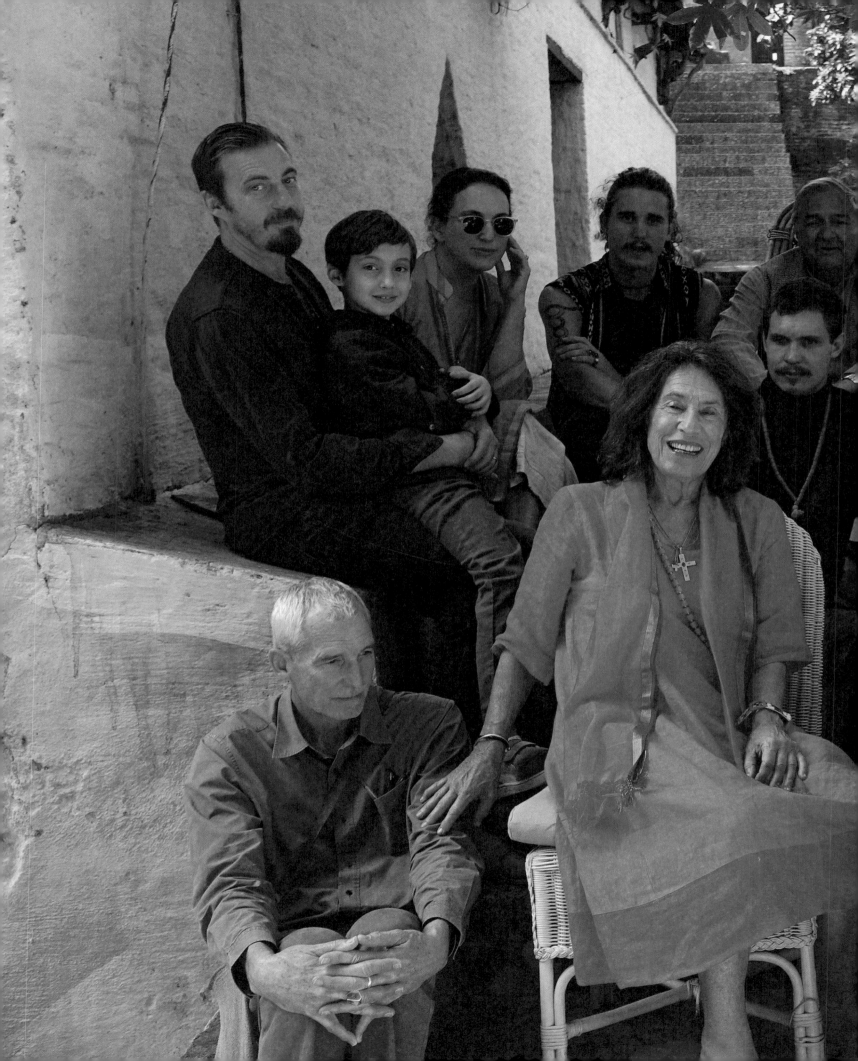

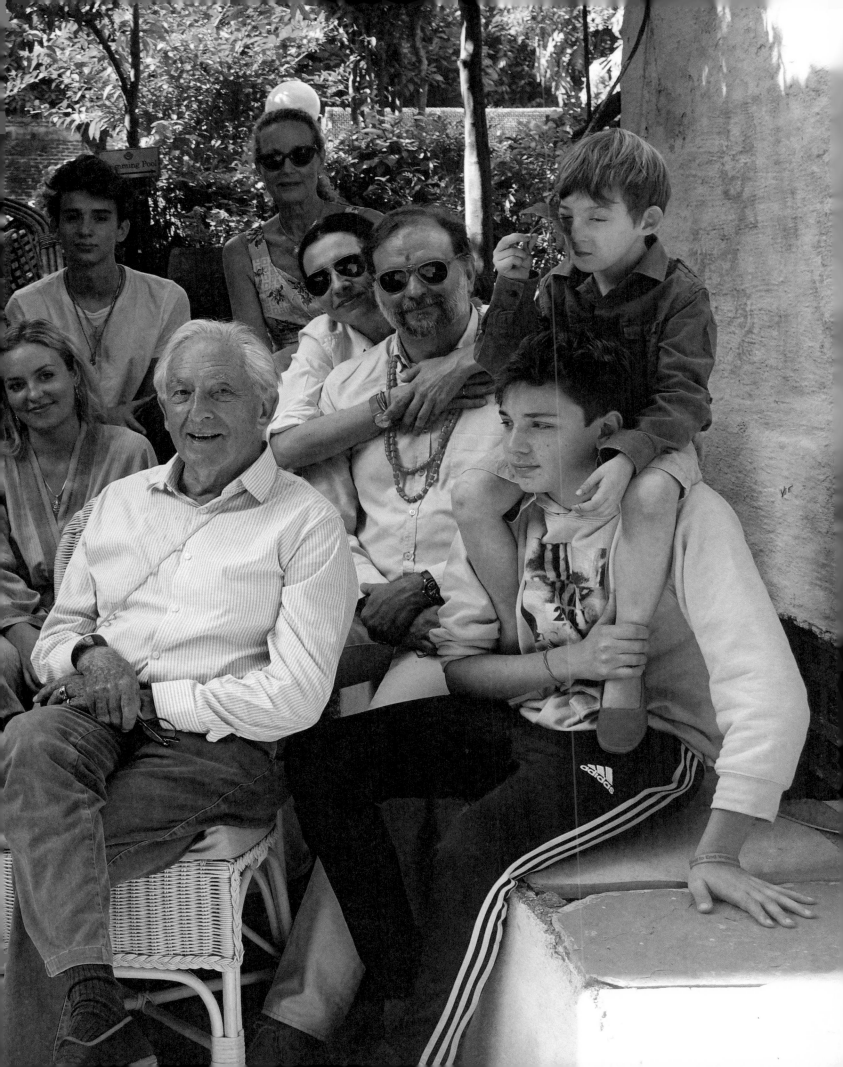

BIBLIOGRAPHY
HRH PRINCE MICHAEL OF GREECE

Andronic, Orban, 1976

Avec ou sans Couronne, Stock, 2019

Bourbon-Orléans, A Family Album, Rosvall, 2010

Ces femmes de l'au-dela, Plon, 1995

Eddy & Hélène... an impossible match, Rosvall, 2013

Joyaux des Tsars, Presses de la Renaissance, 2006

L'impératrice des adieux, Plomb, 1998

L'ogre, quand Napoléon faisait trembler l'Europe, Orban, 1986

La Bouboulina, Plon, 1993

La conjuration de Jeanne, XO, 2002

La Crète Epave de l'Atlantide, Orban, 1971

La Grèce, Nathan, 1986

La nuit blanche de Saint-Pétersbourg, Flammarion, 2014

La nuit du sérail, Orban, 1982

Le dernier Sultan, Orban, 1991

Le mystère d'Alexandre le Grand, with Stéphane Allix, Flammarion, 2014

Le palais de larmes, Orban, 1988

Le Rajah Bourbon, Lattès, 2007

Le ruban noir de Lady Beresford, XO, 2005

Le vol du Régent, Lattès, 2008

Living with Ghosts, Norton, 1996

Louis XIV, L'envers du soleil, Orban, 1979

Mémoires insolites, XO, 2004

Mes aventuriers excentriques, Stock, 2021

Mon album de famille, Perrin, 1996

Portrait et séduction, Lechet, 1992

Quand Napoléon faisait trembler l'Europe, XO, 2002

Romans orientaux, Plon, 2000

The Empress of Farewells, Atlantic, 2002

The Rani of Jhansi, Rupa, 2013

The Royal House of Greece, Weidenfeld & Nicolson, 1990

Une promenade singuliere à travers l'histoire, Lattès, 2012

Voices of light, voix de lumière, voies de lumière, La hutte, 2012

ACKNOWLEDGMENTS
HRH PRINCE MICHAEL OF GREECE

First of all I want to thank Hamish Bowles. He liked my photo album project. He encouraged me, and in five minutes he had found the art director and the publisher. He is the driving force behind this project.

The art director and editor Thomas Persson is the genius who gives all his grace and talent to the Acne Paper publications. He got excited about my project and my photographic material and, together with the designer Fred Birdsall, made the book a masterpiece with poetry and originality.

There is also my publisher Charles Miers and his editor Jacob Lehman. They liked the project. They told me so. I liked it. It was a very interesting experience to work with professionals of their quality.

I also thank for her immense help my wife, Marina. She has the eye of an artist. Finally, our friend Anne de Boismilon helped me a lot with her brilliant suggestions of a great professional. Above all, I want to thank all these countless characters, men, women, children, who without wanting to, posed for this album and make up all its greatness.

The choice of photographs that was made by Thomas Persson and myself has nothing to do with my degree of friendship, affection, or intimacy with their models. Other criteria have governed this choice: the quality of the photos, their originality, and above all the aesthetics. Do aesthetics and friendship go hand in hand? They do, provided that each makes concessions.

First published in the United States of America in 2023
by Rizzoli International Publications, Inc.
300 park Avenue South
New York, NY 10010
www.rizzoliusa.com

All images courtesy HRH Prince Michael of Greece, with
grateful acknowledgment of the photographers, noting:
page 105 © Lee Miller; page 244 © Robert Mapplethorpe
Foundation; page 250 photograph by Tseng Kwong Chi
© Muna Tseng Dance Projects, Inc., New York; page 262
© Slim Aarons; pages 266 and 299 © Justin Creedy Smith;
page 281 © Patrick Landmann; page 293 © Tina Barney;
page 300 © The Helmut Newton Estate / Maconochie
Photography.

Publisher: Charles Miers
Editor: Jacob Lehman
Production Director: Kaija Markoe
Managing Editor: Lynn Scrabis
Proofreader: Stephanie Cash
Translators: Abigail Grater, Victorine Lamothe

Art Director: Thomas Persson
Design: Fred Birdsall studio
Art Director Assistant: Arian De Vos
Design Assistant: Stephen Hickson

Library of Congress Control Number: 2023936531
ISBN: 978-0-8478-7343-2

2023 2024 2025 2026 / 10 9 8 7 6 5 4 3 2 1

Printed in Italy

SLIPCASE, FRONT
Marina and me on the beach of Long Island.
My great great uncle, the Duke of Aumale, son of
 Louis-Philippe, King of the French, with his sons
 and entourage.
Our wedding in the Royal Palace of Athens,
 February 7, 1965.
Myself, photographed by Marina.
Marina in her studio. She started her career long before
 I started mine.
Two years after the wedding we embarked on a long
 honeymoon of three months in Asia, hence this photo
 of Rajasthan, India.
Myself with my daughters in Syrian attire on the terrace
 of a rented house in Spetses.

SLIPCASE, REVERSE
Alexandra and James Brown in their house in Patmos.
My mother, Françoise of France, princess Christophe
 of Greece, in the garden of her house in Rome.
Alexandra and her husband, Nicolas; myself; and my
 daughter Olga in the background, all dressed for a
 costume party at Kensington palace.
My grandmother Isabelle of France, Duchess of Guise,
 who played such an important role in my life and
 my upbringing.
My granddaughter, Isabella of Savoy-Aosta, a future
 ballerina assoluta.
Olga and Aimone in their best attire for a wedding in
 St Petersburg.
My father, prince Christophe of Greece, with his Rolls-
 Royce, ready to start his honeymoon with my mother.
Our great friend for thirty years, the artist Niki de Saint-
 Phalle, photographed by Marina.

DUST JACKET
My favourite portrait by my favourite painter, Marina,
 my wife.